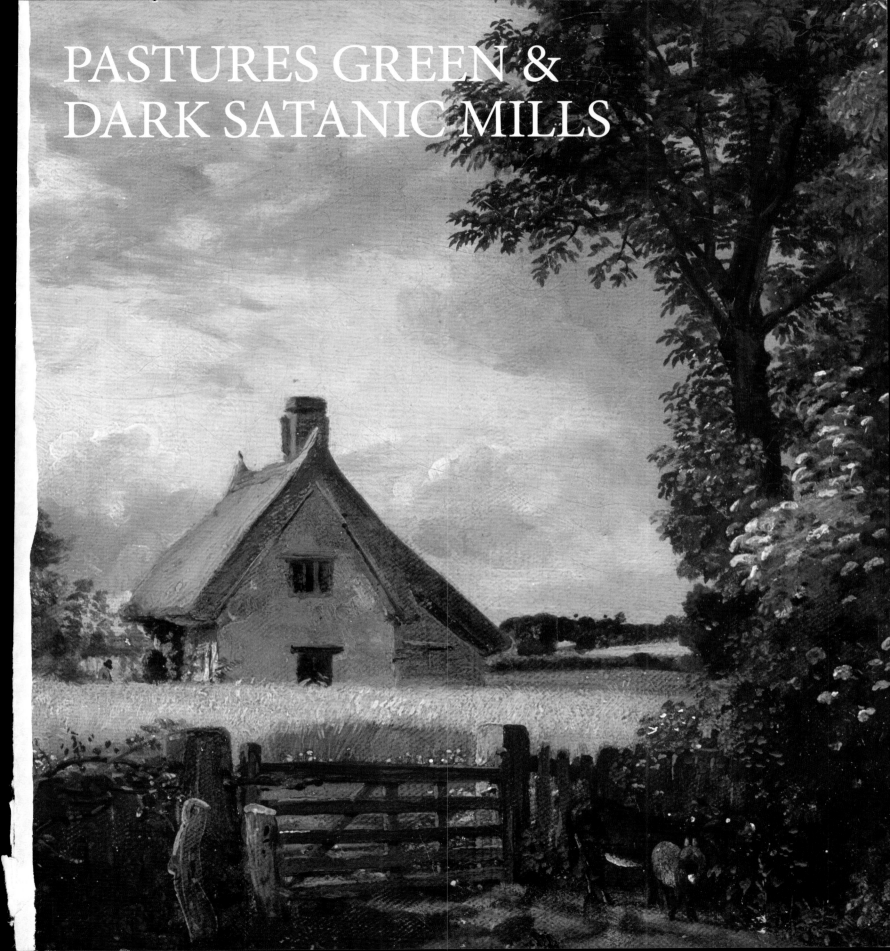

PASTURES GREEN &
DARK SATANIC MILLS

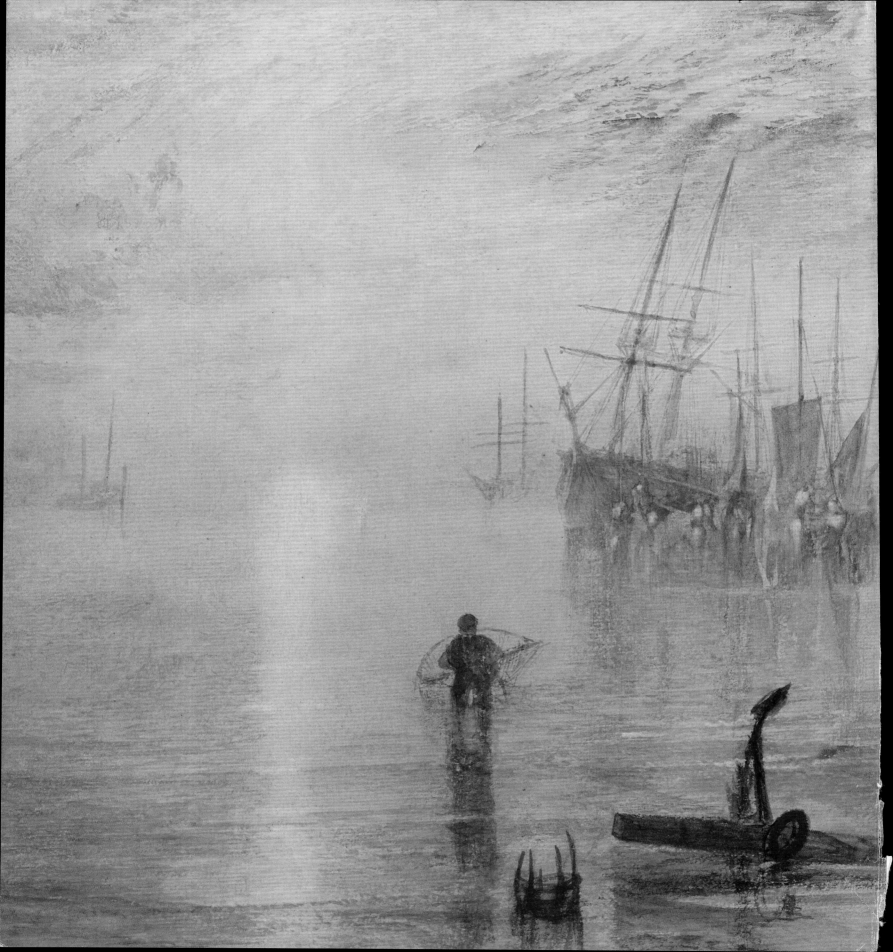

PASTURES GREEN & DARK SATANIC MILLS
The British Passion for Landscape

Tim Barringer and Oliver Fairclough

American Federation of Arts, New York
in association with D Giles Limited, London

This catalogue is published in conjunction with *Pastures Green & Dark Satanic Mills: The British Passion for Landscape*, an exhibition organized by the American Federation of Arts and Amgueddfa Cymru–National Museum Wales.

The AFA is grateful to the following for their generous support of the exhibition, tour, and catalogue:

The JFM Foundation
The Donald and Maria Cox Trust
The Marc Fitch Fund

MARC FITCH FUND

In-kind support is provided by Barbara and Richard S. Lane and Christie's.

The AFA Founders Circle, Benefactors Circle, and National Patron Members are instrumental in providing funds that help the AFA organize and tour exhibitions to communities around the world.

The American Federation of Arts is a nonprofit institution that organizes art exhibitions for presentation in museums around the world, publishes exhibition catalogues, and develops educational programs.

Guest Curators Tim Barringer and Oliver Fairclough

For the American Federation of Arts
Publications Manager: Audrey Walen
Interim Publications Manager: Kate Norment
Managing Curator: Suzanne Ramljak

For D Giles Limited
Copyedited and proofread by Sarah Kane
Designed by Anikst Design, London

Produced by GILES, an imprint of D Giles Limited, London
Printed and bound in China

Front cover
Thomas Gainsborough, *Rocky Wooded Landscape with Rustic Lovers, Herdsman, and Cows*, 1771–74 (cat. no. 4, detail)

Back cover
Graham Sutherland, *Road at Porthclais with Setting Sun*, 1975 (cat. no. 73, detail)

Half-title page
John Constable, *A Cottage in a Cornfield*, 1817 (cat. no. 33, detail)

Frontispiece
Joseph Mallord William Turner, *Flint Castle*, 1835 (cat. no. 22, detail)

Page 5
Thomas Hornor, *Rolling Mills*, 1817/1819? (cat. no. 53, detail)

Page 6
Stanley Spencer, *Snowdon from Llanfrothen*, 1938 (cat. no. 49, detail)

First published in 2014 by the American Federation of Arts in association with D Giles Limited, London. All rights reserved. No part of the contents of this book may be reproduced, stored in a retrievable system, or transmitted in any form or by any means without the written permission of the American Federation of Arts and D Giles Limited.

10 9 8 7 6 5 4 3 2 1

American Federation of Arts
305 East 47th Street, 10th Floor
New York, NY 10017
www.afaweb.org

D Giles Limited
4 Crescent Stables
139 Upper Richmond Road
London SW15 2TN
England
www.gilesltd.com

Hardcover ISBN: 978-1-907804-34-2
Softcover ISBN: 978-1-885444-43-1

Library of Congress Cataloging-in-Publication Data
Pastures green and dark satanic mills : the British passion for landscape / Tim Barringer, Oliver Fairclough.
 pages cm
Includes bibliographical references and index.
ISBN 978-1-907804-34-2 (hardback) — ISBN 978-1-885444-43-1 (softcover)
1. Landscapes in art—Exhibitions. 2. Landscape painting, British—Exhibitions. 3. Landscape photography—Great Britain—Exhibitions. 4. Earthworks (Art)—Great Britain—Exhibitions. 5. Art—Wales—Cardiff—Exhibitions. 6. National Museum Wales—Exhibitions. I. Barringer, T. J., author. Pastures green and dark satanic mills. II. Fairclough, Oliver, author. Hen Gymru fynyddig, paradwys y bardd. III. American Federation of Arts. IV. National Museum Wales. V. Norton Museum of Art, host institution. VI. Frick Art & Historical Center, host institution. VII. Utah Museum of Fine Arts, host institution. VIII. Princeton University Art Museum, host institution.
N8214.5.G7P37 2014
704.9'43607442987—dc23
 2014014851

Exhibition Itinerary
Norton Museum of Art, West Palm Beach, Florida
December 23, 2014–April 5, 2015

The Frick Art and Historical Center, Pittsburgh, Pennsylvania
May 7–August 2, 2015

Utah Museum of Fine Arts, Salt Lake City, Utah
August 27–December 13, 2015

Princeton University Art Museum, Princeton, New Jersey
January 23–April 24, 2016

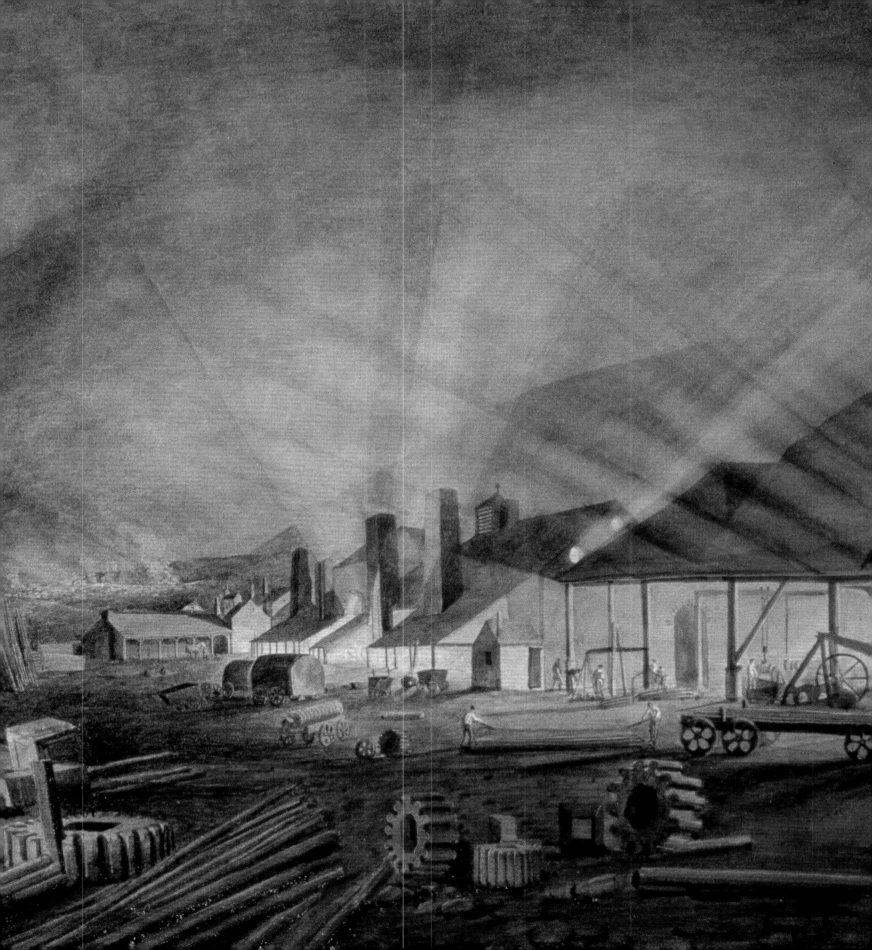

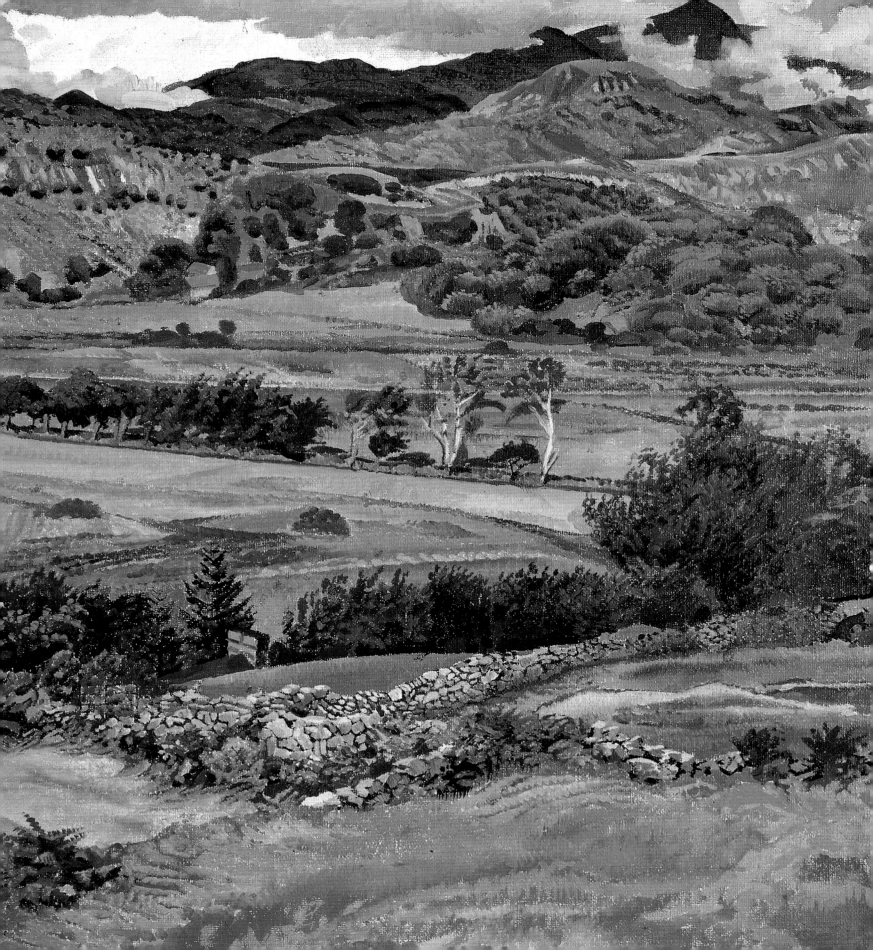

Contents

9 Foreword

13 Acknowledgments

14 Pastures Green and Dark Satanic Mills
Tim Barringer

44 "Hen Gymru fynyddig, paradwys y bardd":
Wales and the Evolution of Landscape Art in Britain
Oliver Fairclough

56 Catalogue

218 Notes

222 Selected Bibliography

227 Index

231 Photo Credits

Foreword

The traditional hierarchy of painting genres in the Renaissance assigned a relatively low status to landscape art, which was seen as lacking the drama and moral weight inherent in history painting. In Britain, however, where the involvement of the state in the arts came late, this belittling of landscape as an art form was never really reflected in the careers of artists or in the taste of their patrons. As Tim Barringer's essay in this publication reveals, the British have had a passion for landscape art since at least the 1700s, and both the land and concern for its sustainability continue to inspire artists in new ways to this day. *Pastures Green & Dark Satanic Mills* traces that passion from the arcadian visions of the eighteenth century, through the spontaneity of "impressions" by J. M. W. Turner and his contemporaries in the new and especially British medium of watercolor, to the nostalgia of the mid-twentieth-century Neo-Romantics, and finally to the environmentally conscious land art of the present day.

The exhibition is drawn entirely from the collections of Amgueddfa Cymru–National Museum Wales. When it was founded in 1907, the museum was charged with the collection, display, and study of the art, history, and natural sciences of Wales, and although its role has broadened over the years, it is especially rich in landscape painting of all kinds. This is fitting, as Wales has been seen as a land of outstanding natural beauty since the Romantic period of the late 1700s. Artists came from all over Britain and beyond to paint its mountains and the castles that are the picturesque relics of medieval conquest and oppression. However, parts of Wales were also among the first areas in Britain to be heavily industrialized. Mining, quarrying, and the smelting of iron and copper developed rapidly here starting in the eighteenth century. The astonishing transformation that industrialization had on the land and the lives of its people inspired the painters of the age. Representations of both the unchanging countryside and the fires of the new factories form the basis of this exhibition.

During his years in Rome in the 1750s, Richard Wilson developed a syncretic style that transformed the future development of landscape painting; since that time, artists from Wales have traveled widely. Their work is broadly represented here, as is that of European artists such as Claude Monet and Alfred Sisley who found inspiration or refuge in England and Wales at turning points in their careers.

Amgueddfa Cymru–National Museum Wales is proud of its art collections. With the help of the Welsh government, our funding body, and many other supporters, our art galleries were redesigned and extended in 2007–11 to create the National Museum of Art for Wales, with a strong emphasis on modern and contemporary art. Since the museum's redesign, our audience for art has increased by about a quarter, to nearly half a million visitors a year. My hope is that this touring exhibition will add to the reputation and stature of our collections. I also trust that it will inspire some of its viewers to visit Wales for themselves.

Since Wales achieved a significant degree of self-government in 1999, it has embarked on a

Richard Wilson, *Dinas Bran Castle, near Llangollen*, early 1770s (cat. no. 3, detail)

process of nation building. A central element of this has been the creation of new national institutions that both represent and reflect upon the diverse histories and identities of Wales. Here in Cardiff, our next task is to redevelop our pioneering open-air museum at St. Fagans to become a truly national museum of history, telling the stories of the peoples of Wales from the earliest Neanderthal remains in 230,000 BC to the present day, and complementing the images of the Welsh landscape that make up much of this exhibition.

This catalogue draws on the accumulated work of the staff of Amgueddfa Cymru–National Museum Wales over the last hundred years, and my first thanks must be to former colleagues—among them John Ingamells, Peter Hughes, David Fraser Jenkins, Peter Cannon-Brookes, James Holloway, Timothy Stevens, Mark Evans, Kate Lowry, Juliet Carey, Helen Walters, and Ann Sumner—who brought many of the paintings in this exhibition into our collection, or contributed to our understanding of them. We have also benefitted greatly from the input of many other scholars on the works shown here, especially Luke Hermann, John House, Ian Worrall, Greg Smith, Peter Lord, and Robert Meyrick.

We are especially grateful to Tim Barringer, Paul Mellon Professor of the History of Art at Yale University, who co-curated the exhibition with us, and who writes eloquently here about the pivotal role of landscape painting in British art.

Donors and supporters contribute hugely to the character of any museum collection. At Amgueddfa Cymru we are particularly fortunate to have received the great bequest of Margaret and Gwendoline Davies, part of which was shown in a previous collaboration with the American Federation of Arts (*Turner to Cézanne: Masterpieces from the Davies Collection*, which toured in 2009–10); several paintings from the Davies bequest are included in the present exhibition. It will also be clear from this catalogue how important the support of the Art Fund has always been to us. Since 1993, we have had a particularly close and rewarding relation-ship with the Derek Williams Trust, which has supported many of our acquisitions of modern and contemporary art. The trust also collects on its own account, and has kindly allowed us to include some of its works in the exhibition.

Here in Wales, the exhibition was overseen initially by Michael Tooby, and then by Mark Richards, Deputy Director General. Oliver Fairclough, Keeper of Art, co-curated the exhibition and has contributed to this publication. Many of the individual catalogue entries were written by Bryony Dawkes, Partnership Projects Curator. Others are the work of Nicholas Thornton, Head of Fine Art; Bethany McIntyre, Senior Curator, Prints and Drawings; Melissa Munro, Senior Curator, Contemporary Art; Anne Pritchard, Senior Curator, Historic Art; Charlotte Topsfield, former Assistant Curator, Prints and Drawings, now of the National Galleries of Scotland; and John R. Kenyon, former Librarian at the National Museum. The exhibition also includes several mid-nineteenth-century photographs from the collections of the Department

of History, described here by Mark Etheridge, Curator, Industry. The works were conserved and prepared by Adam Webster, Chief Conservator, Art and Natural Sciences; Emily O'Reilly, Principal Conservator, Paper; Rebecca Ellison and Katy Sanders, Paintings Conservators; Lee Jones, Senior Art Technician; and Aled Williams, Art Technician. The exhibition was managed by Angela Gaffney, National Partnerships Manager. We are also grateful for the support of Clare Smith, Collections Manager; Sally Carter, Senior Documentation Officer; Robin Maggs, Photography Officer; Becky Brumbill, Image Management Officer; and Bethan Jones, Scanning Officer.

Finally, it has been a pleasure and a privilege to work for a second time with our friends and colleagues at the American Federation of Arts during the lengthy development of this project. Our heartfelt thanks go especially to Pauline Willis, Director; Anna Hayes Evenhouse, Associate Director for Exhibitions; and Suzanne Ramljak, Curator of Exhibitions.

David Anderson
Director General, Amgueddfa Cymru–National Museum Wales

Acknowledgments

Over the course of hundreds of years, Britain's contributions to the history of landscape painting have been substantial and enduring. British artists such as Thomas Gainsborough, John Constable, and J. M. W. Turner have become synonymous with the genre. *Pastures Green & Dark Satanic Mills: The British Passion for Landscape* pays tribute to the primacy of the land in Britain's art history, and in the imagination of its people.

The exhibition is also a testament to the rich collections of Amgueddfa Cymru–National Museum Wales. This marks the AFA's second fruitful collaboration with this distinguished museum, following the successful tour of *Turner to Cézanne: Masterpieces from the Davies Collection*, in 2009–10. It is gratifying for us to renew our partnership with Wales's National Museum, and to help share its superb holdings with viewers across the United States.

We are grateful to Oliver Fairclough, Keeper of Art at Amgueddfa Cymru–National Museum Wales, who served as the exhibition's co-curator along with Tim Barringer, Paul Mellon Professor of the History of Art at Yale University. The curators' strong vision for the exhibition and their essays in this catalogue provide new insights into the subject of landscape painting in Britain. We would also like to recognize Angela Gaffney, National Partnerships Manager at National Museum Wales, who oversaw the organization of the exhibition.

The staff of the AFA deserve appreciation for their exceptional work on behalf of the exhibition and publication. I would like to acknowledge the contributions of Anna Hayes Evenhouse, Associate Director for Exhibitions; Suzanne Ramljak, Curator of Exhibitions; Audrey Walen, Publications Manager; Kate Norment, Interim Publications Manager; Shira Backer, Curatorial Assistant; and Elizabeth Abbarno, Registrar. We would also like to acknowledge Misha Anikst for his sensitive and skillful book design, and Dan Giles and his excellent staff at D Giles Limited, which served as our co-publisher on this project.

Critical funding for exhibition development and tour management was provided by the JFM Foundation and Mrs. Donald M. Cox, to whom we are deeply grateful. We extend our gratitude to the Marc Fitch Fund for substantial support of the exhibition catalogue, and to Barbara and Richard S. Lane and Christie's for their in-kind support.

Finally, we recognize the museums presenting this important exhibition: the Norton Museum of Art, West Palm Beach; the Frick Art and Historical Center, Pittsburgh; the Utah Museum of Fine Arts, Salt Lake City; and the Princeton University Art Museum. It has been a great pleasure to work with each of these institutions, and we thank them for being such professional and enthusiastic partners.

Pauline Willis
Director, American Federation of Arts

Robert Polhill Bevan,
*Maples at Cuckfield,
Sussex*, 1914 (cat. no. 71,
detail)

Pastures Green and
Dark Satanic Mills

Tim Barringer

Although he was no landscape painter, William Blake presciently contrasted "England's green and pleasant land" with the "dark satanic mills" of the Industrial Revolution in his introduction to *Milton* (1804–10). The tension between these two opposites—nature and culture, country and city—would play a dominant role in British artistic and literary culture for two centuries. This exhibition explores the genre of landscape in painting, photography, and land art, and reveals the richness and complexity with which British artists responded to the new circumstances of modernity. It argues that the emergence of a modern, industrial environment generated a heightened awareness of the natural world and, with it, a passion for landscape.

Blake, born in 1757 in London, lived within sight of the city's first great steam-powered factory, Albion Mills (see fig. 1), an unmistakable emblem of modernity. He well understood the terrible human cost of industrialization: the Chimney Sweeper in his *Songs of Experience* sings "notes of woe" in a dark urban landscape flecked with brown rain (fig. 2). Blake may have been among the crowd celebrating the destruction of the Albion Mills in 1791; though the mills were admired by the middle class as a marvel of technology, London's poor considered them a gargantuan symbol of oppression. A massive panoramic painting made from the roof of the mills (fig. 1), and displayed by Robert and Henry Aston Barker in a specially erected round building at Leicester Square, emphasized the harsh, geometric modernity of the mills and celebrated the dynamism of London, a world city whose economic and political might encompassed much of the globe.

Yet in the darkness of his rooms near the Thames in Lambeth, Blake could also summon up a contrasting world of natural bliss: *Songs of Innocence* includes "Infant Joy," in which a child is mysteriously cradled within the sweeping curves of a flower (fig. 3). Nature and culture, innocence and experience, rural and urban, agricultural and industrial—Blake called them the "contrary states of the human soul"—these have been structuring binaries of the British imagination since the moment people began to leave the land in search of work and prosperity in towns and cities. In the world's first industrial nation, small and densely populated, representations of rural life and landscape became the most cherished of visual productions. In the landscape paintings of Thomas Gainsborough, John Constable, J. M. W. Turner, and the Pre-Raphaelites—all seen at their finest in this exhibition—British painting reached a golden age. But each of these artists balanced a fervent love of nature with an anxious suspicion of the encroachments of modernity. There were ironies to this antipathy, since their ability to make a living as artists in London was directly linked to the city's new status as the seat of a global industrial economy. It is the central thesis of this exhibition that visions of nature are at their most intense when the viewer inhabits an urban, industrial world: indeed, it is only when thrown into contrast by the emergence of urban modernity that rural life can be glimpsed as an idyll.

Visitors to the British Isles toward the end of the nineteenth century, such as the Impressionist painters Claude Monet and Camille Pissarro, emulated the British tradition of sketching in the open air.

Joseph Wright of Derby, *Arkwright's Cotton Mills by Night*, ca. 1782–83 (fig. 6, detail)

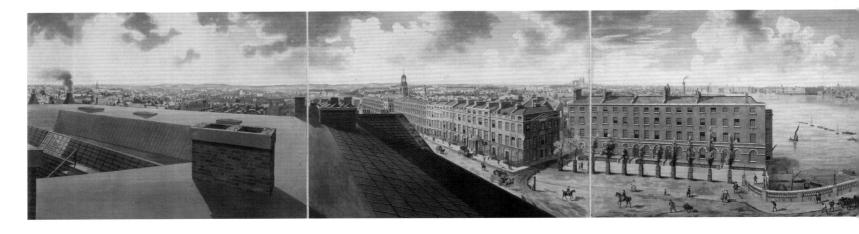

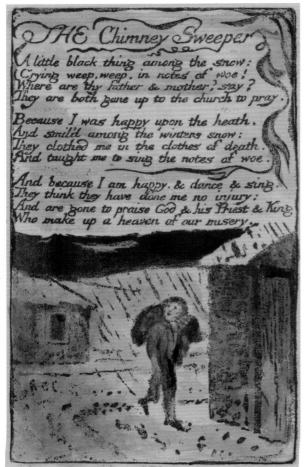

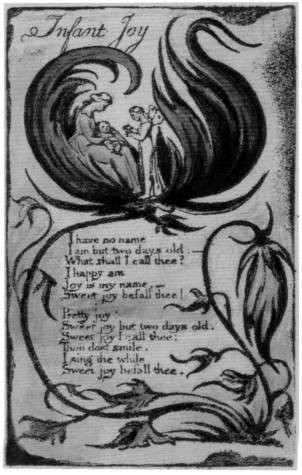

Fig. 1 (above). Henry Aston Barker (1774–1856) and Frederick Birnie, after Robert Barker (1739–1806). *Panoramic View of London* (London, 1792–93). Six hand-colored aquatints, 19 ¼ × 134 ⅝ in. (49 × 342 cm) overall. Yale Center for British Art, New Haven

Fig. 2 (far left). William Blake (1757–1827). "The Chimney Sweeper," plate 41 from *Songs of Innocence and of Experience*, 1789–94. Relief etching with ink and watercolor, 7 ⅛ × 5 in. (18.1 × 12.7 cm). Yale Center for British Art, New Haven, Paul Mellon Collection

Fig. 3 (left). William Blake (1757–1827). "Infant Joy," plate 23 from *Songs of Innocence and of Experience*, 1789–94. Relief etching with ink and watercolor, sheet 7 ⅛ × 5 in. (18.1 × 12.7 cm). Yale Center for British Art, New Haven, Paul Mellon Collection

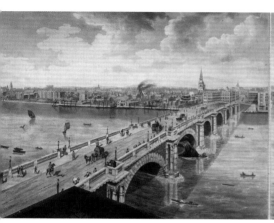

Yet they turned away from Britain's pastoral scenery, beloved of local artists, favoring the smoke and dynamism of modern London and producing works that revealed the strange beauty of this new world. Continental avant-garde painting, enthusiastically collected and exhibited by British patrons, influenced the development of British art in turn, offering a range of practices from the broken brushwork of Impressionism to the radical visual strategies of Cubism and Surrealism. In the twentieth century, a bittersweet dialogue developed between the allure of a cosmopolitan, transnational modernism and the persistence of stubborn local artistic traditions, rooted in the particularities of the British countryside.

The relationship between industry and art has, historically, been deeply ambiguous. While the prosperity generated by industry funded art collecting on a grand scale, it was widely agreed that the industrial city, characterized by smokestacks and canals, social problems and unrest, lacked aesthetic appeal. As Oliver Fairclough notes in his essay in this volume, Wales was a crucible of the Industrial Revolution, led by mining, iron and steel production, and shipbuilding, but the region also includes some of the most spectacular and unspoiled

landscape in the British Isles. This juxtaposition of urban and rural parallels other binaries: wealthy cities versus poverty-stricken countryside; ugly, crowded, and polluted urban spaces versus the sublime, unpopulated, and pristine wilderness. Such paradoxes are evident in the collections gathered at National Museum Wales. These derive in large measure from the profits made by Welsh entrepreneurs during the Industrial Revolution; yet, as the exhibition demonstrates, the museum's finest works celebrate nature untouched by the incursions of the urban and the modern. A much smaller group of paintings—sometimes shocking in their intensity—do engage with the city and the fiery scenes of labor within it, revealing in the satanic mills of the nineteenth century a sublime, if melancholy, beauty.

The disappearance of the red glow of steelworking from the Welsh cityscape during the 1980s, as from other manufacturing heartlands of Britain—such as Birmingham, Sheffield, Manchester, and Glasgow—heralded a painful transition into a postindustrial world, marked by high unemployment and political instability. Yet amid the ruins of industry, a new generation of British artists has emerged, passionately concerned about ecology,

conservation, and the planet's future. Many young artists now work with organic materials and in rural locations. Whether consciously or not, they are perpetuating the traditions of picturesque nature worship that are at the heart of this exhibition. The tension between the urban and the rural continues to be a fundamental, generative force in British life.

An Age of Paradox

A curious and unstable mixture of tradition and innovation characterized late eighteenth- and early nineteenth-century Britain. This was the great era of the English country estate, with the aristocracy and gentry at the height of their power and wealth. But even such symbols of unchanging dynastic power were underpinned by radical change. New techniques in farming, the result of scientific approaches to agriculture, led to increased profits for landowners; many chose to spend their wealth on Grand Tours of France and Italy, and on assembling art collections to be displayed in sumptuous country houses or fashionable London residences.

Though many of Britain's elite treasured their country seats, this was also a moment of burgeoning economic growth in towns and cities. Factories belching dark smoke and streets of poorly built red-brick houses began to replace villages and country estates as the typical environment experienced by the majority of Britons. By 1829, George Cruikshank would portray "the march of bricks and mortar" as an unstoppable force, with serried ranks of marching building materials displacing terrified

trees, haystacks, and livestock (fig. 4). The factory system, based on the division of labor, allowed for mass production of commodities and drew great numbers to the developing cities. Canals, snaking across hills and valleys, opened up a national distribution system, supplying coal to factories and food to cities. British textiles, cheaply produced by machines, began to dominate world markets. New techniques in manufacturing and marketing brought ceramics from the Staffordshire potteries, such as those of Josiah Wedgwood, to world prominence. By the 1830s, the railway network had begun spreading across the country, and steam technology was applied widely across the spectrum of industrial production. London became one of the largest cities on earth, the center of a global economic system, with a powerful, independent middle class, and a level of political freedom unmatched anywhere in Europe.

Britain's place in the world was also changing rapidly. By the end of the Seven Years' War in 1763, the British Empire had grown exponentially, with vast sums of money entering the country as a result of the labor of enslaved Africans in the Caribbean and the American colonies. Trade with Asia was booming, and the British East India Company was becoming a major territorial power in South Asia as well as an economic behemoth. By 1815, with the defeat of Napoleon, Britain became the major European power, with unrivaled naval power and a trading empire that stretched from Australasia to India, South Africa, the Caribbean, and Canada. The process of commercial and imperial expansion

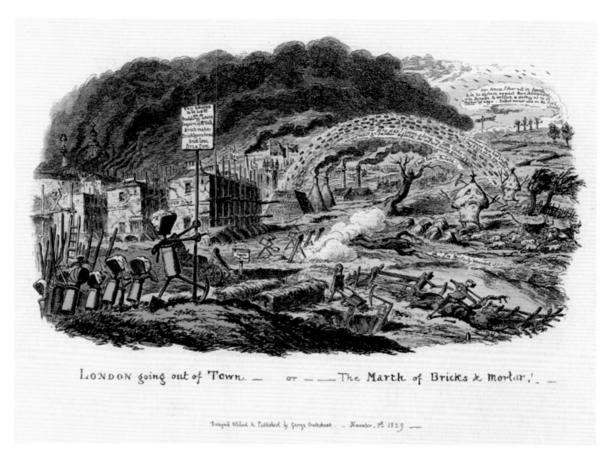

LONDON going out of Town. — or — The March of Bricks & Mortar.' —

Fig. 4. George Cruikshank (1792–1878). *London going out of Town, or the March of Bricks and Mortar*, 1829. Hand-colored etching, 10 ⅞ × 14 ¾ in. (27.7 × 37.6 cm). The British Museum, London

continued throughout the nineteenth century, though by the 1850s other nations—France, the German states, and the United States—showed signs of challenging Britain's status as the world's greatest industrial power.

Visions of Arcadia

Eighteenth-century British collectors, flush with the profits of the new scientific agriculture, as well as of industry and the slave trade, developed a taste for paintings by the Old Masters and for classical sculpture. Perhaps the greatest collector in Welsh history, Sir Watkin Williams-Wynn (1749–1789) inherited—at the age of five months—estates of over 100,000 acres in north Wales and the border counties. After attending Oriel College, Oxford, he completed his studies by taking a lavish Grand Tour, through France to Italy, culminating in extended periods in Rome and Naples, which lasted from May 1768 to February 1769. For Williams-Wynn, as for

many of the grandees of his era, the tour was formative. He collected paintings, sculptures, and musical scores to bring back to Winnstay, his country estate in Denbighshire in southeast Wales.[1] A portrait of Williams-Wynn (red-haired, at left), in conversation with fellow travelers Thomas Apperley and Captain Edward Hamilton, was commissioned from the foremost portraitist in Rome, Pompeo Batoni (fig. 5). It records the genial sociability, as well as the scholarly preoccupations, of the young "milordi" (as the Italians called them, teasingly adapting the English words "my lords").

In Italy and France, as well as in London, Williams-Wynn would have had opportunities to see the work of the most admired landscape painter of the previous century, the French academician Claude Gellée (1604/5–1682), known as Claude Lorrain. Claude's works, such as *Landscape with St. Philip Baptizing the Eunuch* (1678, cat. no. 1), are memorable not for the figure painting in the

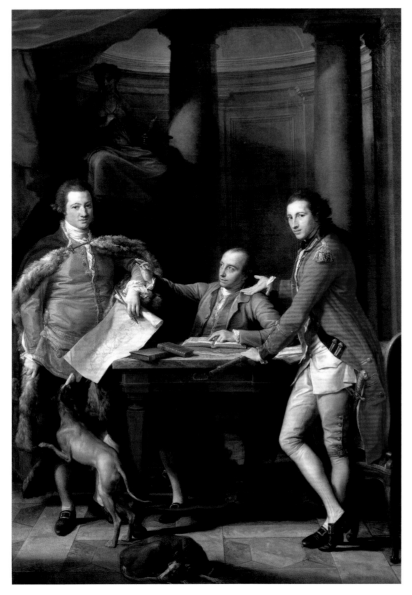

foreground but for the artist's rendering of the hazy distances of the Roman Campagna, its lakes and ruins. Utilizing elements of the landscape observed in Italy, Claude fashioned a vision of arcadia that entranced European painters and collectors for generations. His compositions, each subtly different, broadly conformed to a formula of his own devising. Strong vertical elements at each side, usually trees, frame the view, while the eye is drawn from a dark green, shadowy foreground through striations of light and dark until it finally reaches the horizon, where the tonality fades to a pale blue. This technique

for suggesting distance within a painting—known as atmospheric perspective—would be employed by artists from Claude's day until the invention of photography and beyond.

Decades after his death, Claude taught the British how to view landscape. His influence, moreover, was not confined to the medium of painting: across the British Isles, gardeners strove to recreate Claudean landscapes on the grounds of country estates. In an act of conspicuous consumption, fertile land was taken out of production and appropriated for aesthetic pleasure. Perhaps the greatest of the Claudean gardeners was Lancelot "Capability" Brown (1716–1783). He created sweeping vistas of open grassland interrupted by lakes, which were often gracefully surmounted by classical bridges. Clumps of trees, positioned as in Claude's compositions, framed the views. Landscape gardens came to resemble paintings—the literal meaning of the term "picturesque." At Stowe, the landscape garden is adorned with "temples" echoing structures found on the Appian Way outside Rome. They were designed by leading architects, such as William Kent; the grounds, in turn, were shaped by Charles Bridgeman and Capability Brown. The result is a Claudean arcadia in southwestern England.

The Welsh artist Richard Wilson spent an extended period in Rome between 1750 and 1757, during which time he abandoned a career as a fashionable portraitist and developed an austere and dignified form of landscape painting profoundly influenced by Claude. He returned home determined to make a living as a landscape painter and became perhaps the first artist to do so in the British

Fig. 5. Pompeo Batoni (1707–1787). *Sir Watkin Williams-Wynn (1749–1789), Thomas Apperley (1734–1819), and Captain Edward Hamilton*, 1768–72. Oil on canvas, 113 ¾ × 77 ⅛ in. (289 × 196 cm). Amgueddfa Cymru–National Museum Wales; purchased, 1947, NMW A 78

Isles. In his native Wales, under the patronage of Sir Watkin Williams-Wynn, Wilson created in 1770 a group of magnificent canvases celebrating the area around his patron's seat at Winnstay, whose grounds were laid out by Capability Brown. *Dinas Bran Castle, near Llangollen* (cat. no. 3) shares Claude's strong horizontal framing devices and receding bands of light and dark. But the landscape is distinctively Welsh, and the castle, Dinas Bran, rises dramatically under a cloudy Northern sky. Wilson drastically reshaped Welsh topography to suit the Claudean mode of composition: Dinas Bran is located near the River Dee, as Wilson's painting suggests, but it is hemmed in by hills; the lush, flat fields to the right are also Wilson's invention. The figures in the foreground, however, are Wynn's own tenants: modern peasants have replaced the classical shepherds of Claude.

If Wilson was closely identified with the aristocracy, his fellow landscape painter Joseph Wright, known as Wright of Derby, relied largely on the patronage of the new industrial classes.[2] He was fascinated by scenes of scientific experimentation and of labor: his instincts were those of the Enlightenment, the age of reason.[3] Wright's oil painting of Arkwright's Mill represents one of the paradigmatic sites of the Industrial Revolution, where technological innovations and new methods of organizing labor resulted in vastly increased productivity. For Wright, the mill's massive scale and eerie gaslight illumination made it a thing of wonder (fig. 6). Yet Wright, too, took the Grand Tour and was able to distill from the famous view of

Lake Albano, in the Roman hinterlands, a tranquil arcadia where time seems to stand still (cat. no. 7).

Picturesque Prospects

If Wilson and Wright both emulated Claude, other British artists turned to the more tempestuous example of another seventeenth-century master, Salvator Rosa (1615–1673). Rosa's work abounds in narrative incident, in scenes of danger and disaster. His landscapes are windswept and rocky, the surfaces of his paintings rough and troubled. Emotions run high, and banditti are often seen among the mountains. The turbulent style of the Neapolitan painter, exemplified by *Rocky Landscape with Herdsmen and Cattle* (cat. no. 2), was clearly familiar to the Welsh artist Thomas Jones, whose Rosa-esque masterpiece *The Bard* (cat. no. 5) was first exhibited in 1774.[4] Bards, the traditional druidic poets of ancient Wales, came to symbolize the artist as a prophetic creative figure cast out from society. This work laments the legendary massacre of the bards by the oppressive English king Edward I: their livid corpses can be seen in the middle ground. Jones seems to have conflated the Welsh medieval bards with the ancient Druids, who are suggested by the presence of Stonehenge in the background. The work is based on a poem by Thomas Gray, in which the last bard ("the Bard"), despairing, is about to throw himself to his death, an emblem of the sufferings of the artist in an unsympathetic world. The work thus looks both backward into the ancient past and forward to the nineteenth century's ideals of artistic identity. The tortured Rosa-esque

Fig. 6. Joseph Wright of Derby (1734–1797). *Arkwright's Cotton Mills by Night*, ca. 1782–83. Oil on canvas, 39 ¼ × 49 ½ in. (99.7 × 125.7 cm). Private collection

landscape expresses the Bard's despair; macrocosm and microcosm are bound together.

For Thomas Gainsborough, landscape painting was a labor of love that offered a release from the demands of the art market and the pressures of modern society. At the beginning of his career, around 1750, he had created memorable studies of the Suffolk landscape in a fresh, matter-of-fact style derived from Dutch paintings of the previous century. Throughout his career, however, Gainsborough achieved prosperity as a portrait painter, moving to fashionable Bath and then to London. Despite this worldly success, he professed a wish "to take my Viol da Gam and walk off to some sweet Village where I can paint Landskips and enjoy the fag End of Life in quietness & ease."[5] In his view, landscape painting represented true artistic creativity, in contrast to the market-based production of portraits. In his maturity, Gainsborough formulated

a distinctive vision of the rural world, with feathery trees, rich, lustrous shadows, and cattle watering in limpid pools. *Rocky Wooded Landscape with Rustic Lovers, Herdsman, and Cows* (cat. no. 4), painted in 1771–74, is one of his finest achievements in the genre. Subtle and luminous layers of paint are freely applied to create the feeling of a perfect afternoon in the country, an idyll of young love and rural simplicity. The composition pays homage to Claude, but classical poise has been surrendered to the erotic and sensuous frisson of the Rococo.

During this period, artists found new markets for their work through public exhibitions, a development that liberated them from relying solely on the direct patronage of aristocratic collectors. The Society of Artists and, after 1768, the Royal Academy of Arts held public exhibitions that served as a shop window for collectors as well as a public forum to demonstrate the achievements of British artists. Oil

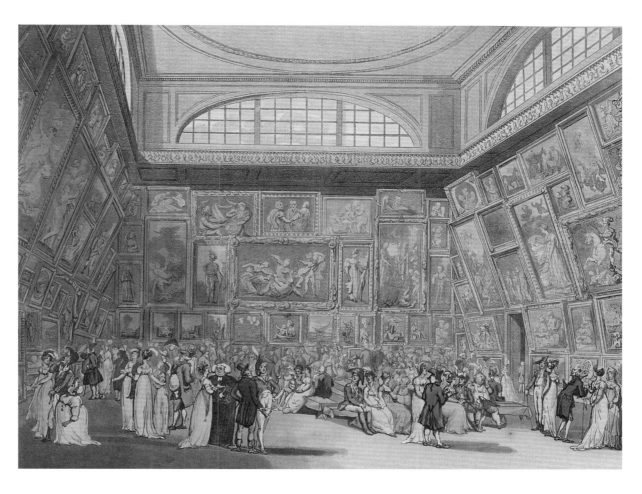

Fig. 7. After Augustus Charles Pugin (ca. 1762–1832) and Thomas Rowlandson (1756/57–1827). "Exhibition Room, Somerset House," plate 2 from *Microcosm of London* (London: Rudolph Ackermann, 1808). Hand-colored etching, 9 ¼ × 11 ⅛ in. (23.5 × 28.3 cm). The British Museum, London

painting was without question the dominant medium, and artists increasingly strove to command the academy's crowded gallery space at Somerset House with larger and more powerful compositions (fig. 7). However, at the same time, watercolor, a medium previously used mainly for preparatory works, came into its own as artists increasingly valued the spontaneity of sketches made on the spot. The Grand Tourist would sketch ancient ruins in watercolor, usually under the supervision of a tutor, an artist who thus secured a free passage to Italy. Larger watercolors were also exhibited, elaborately framed, and several societies were founded with the intention of challenging the supremacy of oil painting. The use of colored washes, applied with a very wet brush, served perfectly to represent the rainstorms and cloudy skies of the British Isles.[6]

During the long period of hostilities following the French Revolution of 1789, it was no longer considered safe to travel in continental Europe: the great days of the Grand Tour were over. Artists and their patrons alike began to turn instead to parts of the British Isles that were remote from London. Local historians and antiquarians had for generations celebrated the ancient monuments that spoke of Britain's history, but the glories of the landscape itself were widely admired by well-educated tourists only after the circulation of illustrated texts by the Reverend William Gilpin, known as picturesque tours.[7] These led the reader to sparsely populated wilderness regions of Britain including the Welsh mountains, the English Lake District, and the Scottish Highlands. Gilpin conveyed the delights of local scenery through an aesthetic that combined Claude's wooded prospects and distant rivers with Rosa's spectacle of mountain and fell. Tourists would make use of a "Claude glass," whose oval, reflective surface was colored to give an "Old Master" effect of dark

varnish. The skilled viewer could position himself to view the real landscape in the glass, making sure to obtain a view with trees at either side, a water feature or historical monument in the middle ground, and a receding vista leading the eye to the horizon.

Watercolor painters traveled extensively in search of subject matter for paintings destined for the London exhibitions. Thomas Girtin, an indefatigable traveler before his death at twenty-seven cut short a career of great promise, toured the north of England, visiting many places never before considered worthy of artistic representation. Among his finest achievements, however, are the dramatic watercolors deriving from tours to Wales in 1798 and 1800. *Near Beddgelert* (cat. no. 10), worked up in 1799 from sketches made the previous year, captures the massiveness of the Welsh mountains, their rocky screes and thundering waterfalls, in a landscape almost bare of trees. Humanity can be detected only in a vignette in the middle ground in which tiny figures follow the bend of a lonely road leading to the river; the viewer can imagine their feelings of awe in the face of nature on this mighty scale. Girtin's ability to suggest massive spaces, even in relatively small watercolors, reveals his mastery of the medium. His work is notable for broad washes of strong, sober colors—browns and mossy greens—typical of the British landscape.

Industry, too, became a topic of picturesque fascination. John "Warwick" Smith and Thomas Sandby were among the first to focus on the transformation of the landscape though commercial endeavor. Smith produced a detailed watercolor (1792, cat. no. 52) in which the reassuring image of a bridge over peaceful water is disrupted by a dramatic row of chimneys belching dark smoke that blots out a clear evening sky. An inscription on the mount, perhaps in the artist's hand, reads: "The Forest Works, for smelting copper, near Swansea. Evening effect, from the smoke of many furnaces in full working." Such a sight was novel; Warwick Smith clearly marveled at the power of the industrial image, emphasizing the contrast of nature and culture—smooth and rough, clean and filthy, beautiful and sublime. The scene is an awesome manifestation of human energy and enterprise.

As industrialization transformed the British Isles throughout the nineteenth century, producing widespread despoliation, artists largely eschewed depictions of industry. Practitioners of the picturesque watercolor did, however, embrace one conspicuous aspect of industrialization in the Victorian era—the railroad. David Cox, a great chronicler of the windswept mountain country of Wales (though himself a native of Harborne, near the English industrial city of Birmingham), incorporated the silhouette of a distant locomotive speeding across a coastal plain in a watercolor of about 1850 (cat. no. 12). Artists, including Cox, were quick to use the railway network to reach far-flung destinations, and the locomotive's plume of smoke was soon naturalized as a feature of the British landscape.

The craze for picturesque travel became so widespread that it attracted the eye of satirists. Thomas Rowlandson depicted the traveling artist as a beleaguered, scrawny figure on horseback

struggling to manage his easel, portfolio, palette, and coffeepot as well as an umbrella to fend off the torrential rain (1799, cat. no. 13). The image suggests that sunnier climes, or the warmth of the studio, might be preferable to the picturesque tour. The satirical writer William Combe created a character who was consumed to the point of obsession by the search for the picturesque, but sadly bereft of talent. Doctor Syntax, a Don Quixote of the picturesque, encountered many hardships during his travels, falling into lakes, being chased by bulls, getting lost, and mistaking humdrum features of the landscape for historical monuments (cat. no. 14).

Turner and the Sublime

In the sheer range of his talents and ambitions, J. M. W. Turner is unparalleled in the history of landscape painting. He magisterially continued earlier landscape traditions, self-consciously emulating Claude and Richard Wilson, and traveling to Italy and to mountainous regions of Britain and the Continent. In strong contrast to the limpid calm of Claude and Wilson, however, Turner's master-pieces, such as *The Morning after the Wreck* (cat. no. 24), are essays in the sublime—art that suggests the futility of human endeavor in the face of nature's awesome power. Turner's work directly influenced painters of the American sublime such as Thomas Cole and Frederic Church. In the late canvases of the 1840s, Turner evolved an esoteric visual language that prefigured many later developments in art from Impressionism to Abstract Expressionism, an artistic movement also associated with the sublime.

Turner began as a painter of picturesque watercolors, a medium in which he excelled, and his imaginative and technical range would extend beyond the dreams of his predecessors. His astonishing technical prowess in watercolor encompassed myriad techniques. Luminous washes give way to passages of vivid detail; the white of the paper is often revealed by scratches made with his notoriously long and filthy thumbnail. *Marford Mill* (ca. 1794–95, cat. no. 16), completed before Turner was twenty, demonstrates his mastery of the picturesque style; the subject is an old water-powered flour mill in rural Derbyshire, quite different from the modern, steam-powered equip-ment visible at the Albion Mills in London, a short walk from where Turner grew up. His observant eye has captured the crumbling surfaces of the tumble-down structure. The addition of a figure fishing in the mill pond in the upper left adds a sense of repose. Yet we can see the foaming water that turns the mill-wheel, as the miller looks on anxiously from an upper floor of the building. In a highly finished work made a few years later, *Transept of Ewenny Priory, Glamorganshire* (ca. 1797, cat. no. 17), Turner's distinc-tive character is more clearly visible. He breaks all the rules of watercolor technique, improvising brilliantly to give the effect of light penetrating the dark interior of the ancient structure. Turner achieves an aura of sacredness, but simultaneously undermines it by including a bizarre jumble of refuse in the fore-ground. In a passage that evinces both humor and pathos, oblivious chickens peck at grain beside the tomb of a medieval knight. The ancient church is now being used as a henhouse. Bold and provocative,

profound and light-hearted, Turner both celebrated and subverted the conventions of the picturesque.

Turner's finest effects would exceed anything that had been attempted in landscape painting before. Despite his humble origins as the son of a barber in Covent Garden and his lack of formal education, Turner harbored profound intellectual ambitions.[8] He believed that landscape, as a genre, could challenge the hegemony of history painting (figural works in which great religious, mythological, or political events were depicted), and was not afraid to confront great themes—the rise and fall of civilizations, the processes of nature, questions of life and death—in the medium of landscape. In 1757, Edmund Burke had published a treatise on the concept of the sublime, which he defined in psychological terms:

> Whatever is fitted in any sort to excite the ideas of pain and danger, that is to say, whatever is in any sort terrible, or is conversant about terrible objects, or operates in a manner analogous to terror, is a source of the sublime; that is, it is productive of the strongest emotion which the mind is capable of feeling. I say the strongest emotion, because I am satisfied the ideas of pain are much more powerful than those which enter on the part of pleasure.[9]

Mountain scenery, characterized by grandeur of scale and presenting many hazards for the traveler, epitomized the Burkean sublime and held a lifelong fascination for Turner. The Alps, which he crossed, like the Grand Tourists of a few decades earlier, in a rickety coach, provided him with the greatest thrill. A brief cessation of hostilities between Britain and France allowed Turner to visit France and Italy in 1802. *Source of the Arveiron* (cat. no. 19), a magnificent watercolor of about 1803, distills his experience of the Alps on that trip.[10] Employing a typical device of the landscape sublime, Turner places small figures in the foreground to reveal by contrast the majesty of the scenery. Prominent in the composition are rocky precipices from which one false step could lead to an agonizing death. According to Burke's theory, a work of art that takes us close to such possibilities will be more powerful than one that embraces us with the deep sense of repose offered by Claude. To add a final Burkean touch, Turner placed a vicious blue-and-white-striped snake on a boulder in the foreground, adding his signature in a rhyming position further to the left.

Turner's later oil paintings pushed the medium to the very limits of legibility, surrendering firm statement to all-consuming atmosphere. *The Morning after the Wreck* brings the Burkean fear of death into an everyday setting. As the golden sun rises through the lingering vapors of a violent storm, we struggle, like the figures on the beach, to discern what wreckage and driftwood is being dragged ashore: have any sailors survived? The range of textures and colors fills the viewer with both dread of the shipwreck and exhilaration at the beauty of nature. Most haunting of all is the shadowy outline of a ship on the horizon, lost in the mist or run aground.

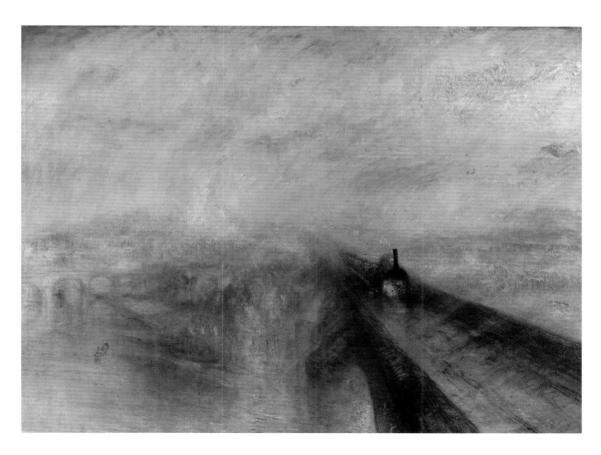

Fig. 8. Joseph Mallord William Turner (1775–1851). *Rain, Steam, and Speed—The Great Western Railway*, 1844. Oil on canvas, 35 ⅞ × 48 in. (91 × 121.8 cm). The National Gallery, London; Turner Bequest, 1856

Turner did not turn his back on technology and modernity. Fascinated by the changes in perception made possible by traveling at speed through the landscape, he embraced train travel not only as a convenient means of transit but as a new experiential category. *Rain, Steam, and Speed* (1844) depicts the Maidenhead Bridge of the newly constructed Great Western Railway, with a magnificent wide-gauge locomotive powering across it (fig. 8). Although the coal fire that heated the boiler could not be seen from the front of the train, Turner makes it visible; by turns heroic and daemonic, the train's progress through a rainstorm is contrasted with that of a hare, the fastest moving of creatures. Evoked with a flash of Turner's brush, it dashes ahead down the tracks. The painting leaves as an open question the debate between nature and culture; swept up in the speed of change, the viewer must consider what the technology of the future will bring: utopia or dystopia?

Few artists in Britain were brave enough to follow Turner in the art of the sublime. One of

them was the Victorian visionary Henry C. Whaite, painter of a grandiose composition based on *Pilgrim's Progress* of which only fragments survive. Even in their current state, these works reveal a considerable, if eccentric, talent. Like Turner, Whaite was willing to mix close observation of nature with passages proceeding purely from his imagination, as when he set the heavenly host above a richly evoked and highly specific landscape (cat. no. 25). In *Kinchinjunga from Darjeeling* (cat. no. 27), Whaite's contemporary Edward Lear, the world traveler and writer of nonsense verse, created a spectacular panorama depicting the very edge of the British Empire in India. The sublime peaks of the Himalayas dwarf the tiny figures of tea-pickers to the left. While the foreground speaks of a Victorian wish to classify and catalogue every detail in the world, the distant mountains seem to occupy a spiritual realm beyond the reach of scientific observation.

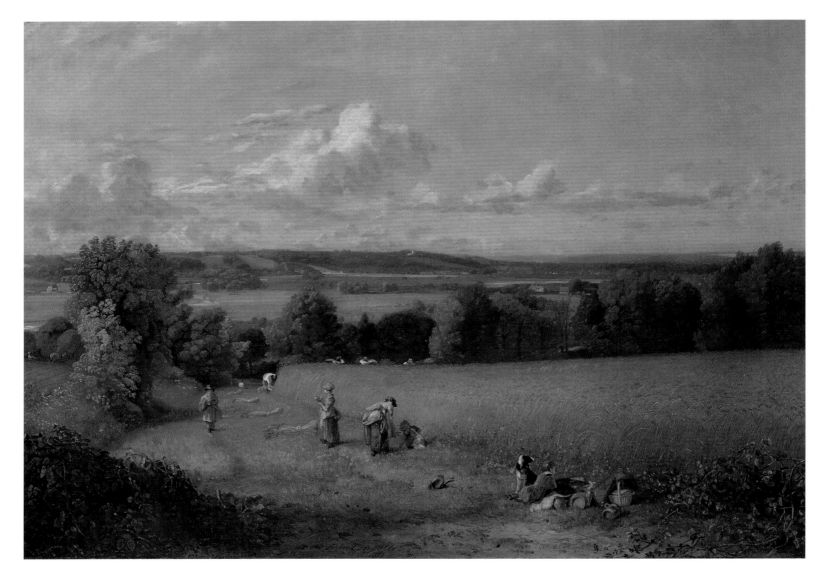

Fig. 9. John Constable (1776–1837). *The Wheatfield*, 1816. Oil on canvas, 21 ⅛ × 30 ⅜ in. (53.7 × 77.2 cm). Sterling and Francine Clark Art Institute, Williamstown, Massachusetts; gift of the Manton Foundation in memory of Sir Edwin and Lady Manton, 2007.8.27

Truth to Nature

If Turner and Blake represent a visionary strand in British art, this is matched by a strong and persistent tendency to reject generalization and idealization, and to focus instead on the direct and detailed depiction of the world. This longstanding commitment to the real in preference to the ideal—perhaps linked to Protestant rejection of religious iconography—produced, over a long period of time, representations of the natural world that are crisp and almost clinical in character. In a very early drawing of the Welsh port of Tenby, from 1678, the cultured amateur Francis Place employed a calm, documentary style, which reveals many felicitous details of local life and landscape (cat. no. 29). Place was a close associate of Wenceslaus Hollar (1607–1677), the Prague-born topographical engraver who produced maps and superbly detailed engravings of London scenery in this period. The broad sweep of Place's view of Tenby, across two sheets of paper, is typical of the "prospect view," a genre of topographical image that became popular in Britain and across its empire in the eighteenth century. Tiny flicks of the pen evoke the quotidian details of life on the beach. This work is one of many sketches of ports and villages that Place made during a tour of the Welsh coast, attending throughout to the commonplace over the exceptional.

Similar directness, but greater wealth of incident, characterize Richard Wilson's early oil painting *Dover Castle* (ca. 1746–47, cat. no. 30). Where his later, Italianate works, such as *Dinas Bran Castle, near Llangollen*, embrace Claudean poetics, *Dover Castle* bears the imprint of Dutch painting of the previous century, with its pale, even light and concern for topographical accuracy. The intricate interplay of the slate roofs of the modest houses in Dover contrasts with the dour bulk of the castle in the distance. Wilson includes a self-portrait, the seated figure of an artist in the left foreground, impassively chronicling the scene before him.

Artists associated with the Grand Tour often made sketches of breathtaking precision, even if these works occupied a low position in the hierarchy of aesthetic value. Thomas Jones, for example, who created the theatrical historical landscape *The Bard* (1774, cat. no. 5), was capable of painting with startling directness. *A View in Radnorshire*, a study made in the vicinity of the family property that Jones inherited from his brother in 1787, is both documentary and expressive, a study of the play of clouds and light on a blustery Welsh day, but also a landscape that reveals personal associations (ca. 1776, cat. no. 31). Jones is now remembered above all for a group of small studies made from the window of his lodgings in Naples in 1782 (cat. no. 32); unknown for almost two centuries, these works have been celebrated in recent years as forerunners of modern painting.[11] Masterly in his analysis of everyday sights, Jones found a bold geometry in the simple buildings, as well as pathos in the marks of

time and decay. We may even see, in the flat white rectangles he dispassionately reproduces, a prescient self-reflexivity about the medium of painting and its ground, the primed canvas.

Jones and Wilson were inveterate travelers, keen to follow the established routes of the Grand Tour in order to acquire knowledge of antiquity and modern Europe. Turner's restless peregrinations in search of the sublime were of a different order, propelled by the energy of modern London, and other artists—such as Wilson's student William Hodges—traveled to the peripheries of the British Empire, in India and Australia, in search of novel subject matter. By contrast, John Constable grew up in the fastness of rural East Anglia, the son of a prosperous miller. Though Constable's visual sensibilities were informed by Claude, and by his interest in the English landscape born of the picturesque, Constable forthrightly refused to travel in search of subject matter. His greatest works draw their subjects from within walking distance of his birthplace in the village of East Bergholt. These scenes, he said, "made me a painter."[12] Many of his early works were painted in the fields, directly from the motif. *A Cottage in a Cornfield* (cat. no. 33), a composition memorable for its extreme geometric simplicity, was originally conceived in 1815, the year in which British forces finally defeated Napoleon at Waterloo. The year's rich harvest was seen by some as a divine blessing, and Constable painted the reapers at work in a large canvas substantially finished on the spot, *The Wheatfield* (fig. 9).[13] Both works pay tribute to his native East Anglia, finding poetry in the details

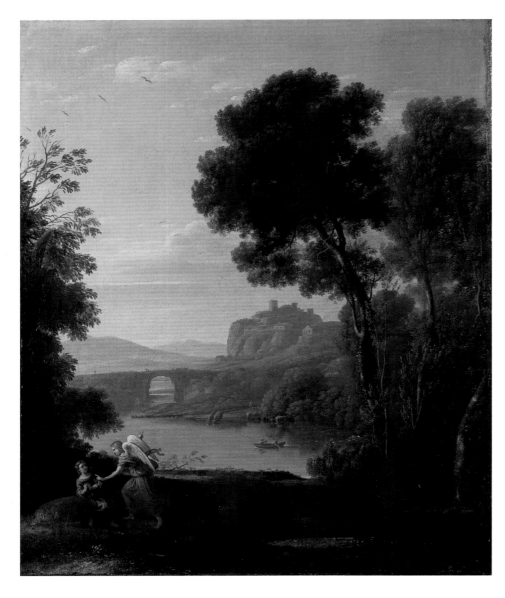

Fig. 10. Claude Gellée, Le Lorrain (1604/5–1682). *Landscape with Hagar and the Angel*, 1646. Oil on canvas mounted on wood, 20 ½ × 16 ⅝ in. (52.2 × 42.3 cm). The National Gallery, London; presented by Sir George Beaumont, 1828

of rural scenery, and capturing with uncanny exactitude momentary shifts in the local cloudscape. Despite the modest dimensions of *A Cottage in a Cornfield*, Constable may have conceived of it as a response to Claude's masterpiece *Landscape with Hagar and the Angel*, in the collection of Constable's friend Sir George Beaumont (fig. 10). The humble content of Constable's painting—gate, donkey, cottage, and a field of wheat still a little too green to harvest—reminds us of the originality of his venture. Constable's fresh, direct, and spontaneous application of paint implicitly critiqued the artifice and over-elaboration of many contemporary works. In fact,

however, this painting represents Constable's second thoughts on the composition, a larger version having been abandoned as unsatisfactory. The apparent ease and spontaneity of Constable's works were hard-won.

Constable was a bitter opponent of industrialization and the social changes it brought about. A firm believer in traditional social hierarchy, the artist was adamant in his rejection of democracy, and even inveighed against the modest increase in the size of the voting public allowed by the 1832 Reform Act.[14] He foresaw the collapse of Great Britain under mob rule. In *Hadleigh Castle, The Mouth of the Thames— Morning after a Stormy Night* (1829, fig. 11), the last of his major "six-footers," Constable offered a bleak vision of a ruinous Britain, his emotional turmoil registered in the rough and turbulent brushwork.

During the nineteenth century, the speed of technological change increased. In the 1840s, as "railway mania" saw the network expand across the British Isles, scientific advances also affected the visual sphere. Photography, announced in 1839, constituted a paradigm shift in representation. The detailed images recorded through the camera—the "pencil of nature"—became a powerful stimulus to landscape artists. The daguerreotype, a process producing a silver image on a sensitized silver-coated copper plate, was introduced in January 1839 by the French artist Louis-Jacques-Mandé Daguerre; the following year, William Henry Fox Talbot unveiled his calotype process, which produced photographic prints on paper.[15] At first, the calotype was largely the province of gentlemen amateurs. Two exceptional early practitioners were the Welshmen Reverend

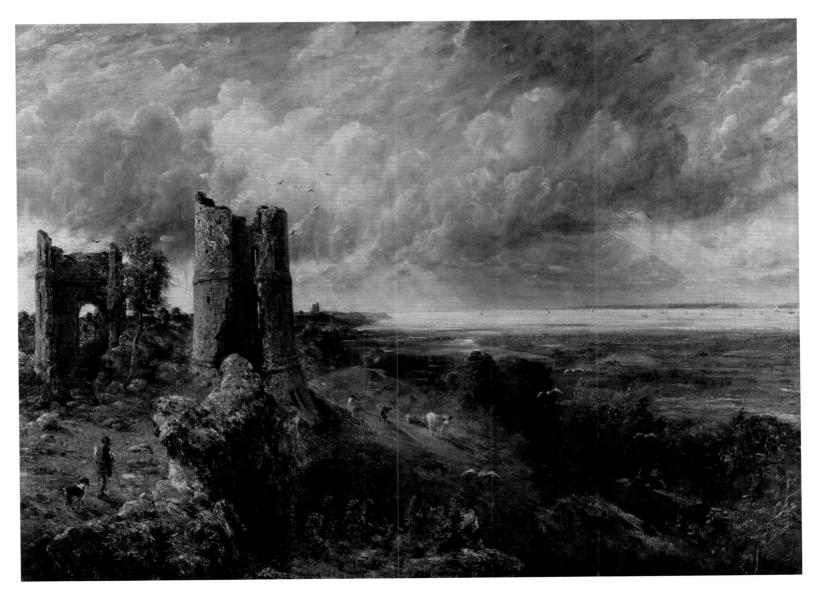

Fig. 11. John Constable (1776–1837). *Hadleigh Castle, The Mouth of the Thames—Morning after a Stormy Night*, 1829. Oil on canvas, 48 × 64 ¾ in. (121.9 × 164.5 cm). Yale Center for British Art, New Haven, Paul Mellon Collection

Calvert Richard Jones, a friend and collaborator of Talbot, and John Dillwyn Llewelyn.[16] Their work explored the potential of the new medium of photography, employing not only its preternatural clarity of detail but also its textural complexity and even its washed-out and mysterious appearance. Calvert Jones used Talbot's technique of the salted paper print from a calotype negative. *Study of Two Gentlemen in Front of Heathfield*, ca. 1846, captures the numinous, experimental quality of early photography (cat. no. 37). Two figures in stovepipe hats—men of leisure, but stiffly posed—emerge from an indistinct landscape. In the 1850s, Llewelyn

adopted the collodion process, which produced sharper focus and richer shadows. The intertwined branches of *The Owl's Oak, Penllergare* (ca. 1854, cat. no. 42) are transcribed with minute precision, yet these are no mere botanical specimens. Llewelyn's artistry imbues them with a seemingly animated quality. The photograph's sharpest focus falls on the ivy-clad trunk in the middle ground. Would a Victorian imagination have caught a suggestion of Gethsemane from the three fence posts picked out in sunshine to the right of the brook?

For artists coming to maturity in the 1840s, the influence of photography was unavoidable: the new

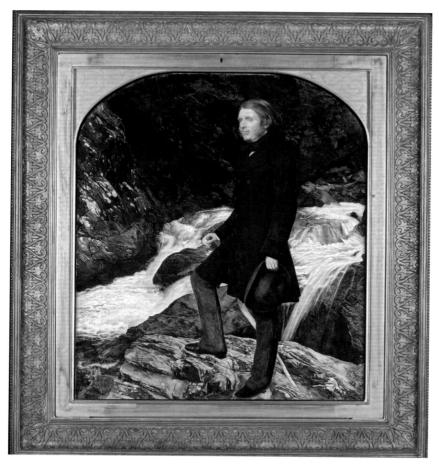

Fig. 12. John Everett Millais (1829–1896). *Portrait of John Ruskin*, 1853–54. Oil on canvas, 31 × 26 ¾ in. (78.7 × 68 cm). Ashmolean Museum, University of Oxford

technology affected every aspect of visuality. Ford Madox Brown and John Brett, members of the Pre-Raphaelite circle, viewed the world with a new, uncanny precision, mimicking the unflinching gaze of the camera. Yet the influence flowed in both directions: photographers like Llewelyn were clearly influenced by Pre-Raphaelite painting. Photographers and painters alike read the works of John Ruskin, the critic of art and society, whose *Modern Painters* (volume 1), published in 1843, was a manifesto for the realistic representation of natural forms.[17] The Pre-Raphaelite Brotherhood, founded in 1848, rebelled against the artistic conventions of the day, aiming to return to the freshness and purity of early Renaissance painting. With the support of Ruskin from 1851, the artists followed an explicit agenda of "truth to nature": in Ruskin's words, "rejecting nothing, selecting nothing . . . and rejoicing always in the truth." John Everett Millais, the most technically brilliant of

the Pre-Raphaelites, completed a portrait of Ruskin in 1854; the work is a manifesto piece, putting Ruskin's theory into practice (fig. 12). Madox Brown, a highly original though querulous figure who never joined the Pre-Raphaelite Brotherhood, claimed to have been the first to conceive of this realist agenda. *View from Shorn Ridgway, Kent* (cat. no. 34), dating from the earliest days of the Pre-Raphaelite Brotherhood, is a fragment of nature observed with sharp fidelity. It was a study for Brown's large painting *Chaucer at the Court of Edward III*. The artist labored for years to ensure that every detail of his historical reconstruction was perfectly observed outdoors in bright sunshine.

William Dyce, older than the Pre-Raphaelites, reconsidered his own practice in light of their brilliantly detailed and finely wrought canvases. *Welsh Landscape with Two Women Knitting* (cat. no. 35) is a penetrating study of the rocks and mountain scenery of the Conwy Valley, where Dyce spent six weeks making studies in the autumn of 1860. He added figures of Welsh women in traditional dress, painted with meticulous precision and the clarity of a daguerreotype.[18] Dyce's painting is uncannily atmospheric, seeming to instill cycles of time— geological time, the time of day and year, and the late point in the cycle of the women's lives—with philosophical, if not religious, import. John Brett, a protégé of Ruskin, was a more straightforward painter; for him, nature itself was a sufficiently captivating subject. He remained faithful to the Pre-Raphaelite style throughout his life. Brilliant color and close observation of geological and meteorological detail are apparent in *Forest Cove, Cardigan Bay*

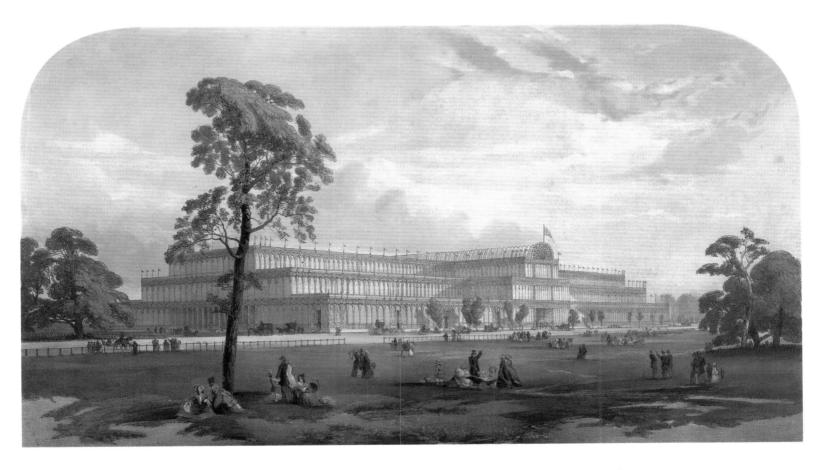

Fig. 13. "General View of the Exterior of the Building," from *Dickinsons' Comprehensive Pictures of the Great Exhibition of 1851* (London: Dickinson Brothers, 1854). Hand-colored chromolithograph, 18 ⅛ × 24 ⅜ in. (46 × 62 cm). Yale Center for British Art, New Haven

(cat. no. 36), painted in 1883, three decades after Brett's first Pre-Raphaelite works.

Although Ruskin's reputation rested on his vivid art criticism, aesthetic and moral issues were interwoven in his thinking, and his later works engaged more directly with social and ethical problems. His beliefs, shaped by Romantic poetry, by picturesque landscape paintings (especially those of Turner), and by Evangelical religion, centered on a heightened appreciation of natural beauty. A profound opponent of the "slavery" of industrial work and the ugliness of the modern city, Ruskin proposed a return to the craft production of the Middle Ages. A pioneering ecological campaigner, he lamented the despoliation of nature caused by industrial expansion. His dark essay "The Storm Cloud of the Nineteenth Century" described a black, polluting "manufacturer's mist" that was both a physical and a moral blight on the nation.[19]

Victorian and Modern

London was the capital of the nineteenth century: no other European capital came close to its importance as a financial center, as a hub of trade, or as a sheer accretion of human beings. Its population grew from just over a million in 1801 to 2.3 million in 1851 and 6.2 million in 1901. In 1851, a decisive year for Great Britain marking a settlement of capitalism after the social unrest of the previous decade, the Great Exhibition of the Industry of All Nations took place at the Crystal Palace, a vast temporary structure erected for the event. The Great Exhibition was a massive demonstration of Britain's industrial might and a showcase for the achievements of the Industrial Revolution. Intriguingly, representations of this most modern of buildings, created from prefabricated glass and iron components, were still couched in the rhetoric of the Claudean landscape (fig. 13).

Fig. 14. William Lionel Wyllie (1851–1931). *Toil, Glitter, Grime and Wealth on a Flowing Tide*, 1883. Oil on canvas, 45 ½ × 65 in. (115.6 × 165.1 cm). Tate, London; presented by the Trustees of the Chantrey Bequest 1883

The industrial cities of Victorian Britain generated vast wealth for the few and provided low-paid employment for the many. Economic cycles of boom and bust led to periods of great hardship, and, as Ruskin despairingly chronicled, the physical environment was degraded by smoke and other industrial pollution. For Ruskin, the industrial scene was so hideous as to be unacceptable as subject matter for the painter, and the Pre-Raphaelites largely eschewed it. Yet a new generation of artists found an awesome power in the vivid contrasts of light and dark and the enormous energies of the manufacturing districts. The American painter Lionel Walden acquired a sophisticated technique in oil painting during his training in Paris; he found his muse, however, in the modern sublimity of industrial Cardiff. A century after Joseph Wright had admired both the gas lamps of Arkwright's Mill and the natural pyrotechnics of Vesuvius, Walden brought a gothic, Dickensian sensibility to the dark, windswept landscape of Cardiff's metalworking area. Burke had written in 1757 that red and black were colors characteristic of the sublime, and it is these tones that dominate Walden's daemonic nocturne *Steelworks, Cardiff, at Night* (1895–97, cat. no. 54). Produced on the spot, Walden's small panel captures a modern dystopia with thrilling visual intensity. The large painting he created in the studio transforms the sketch into an operatic spectacle (cat. no. 55). The eye is drawn into the composition along railway tracks glistening in the rain. A locomotive approaches, silhouetted against smokestacks illuminated by the vermilion glow of the blast furnaces, bringing coal or taking away the

finished steel bars. Walden, perhaps the last of the picturesque tourists, was fascinated—or haunted—by the spectacle of modernity.

Relative to the Welsh cities, London had been a far more common subject, especially for visiting artists who, for centuries, had pursued British patronage. Holbein, Rubens, Canaletto, and a host of lesser artists had visited the city. Few, however, noticed the arrival in 1870 of the then-obscure French painters Claude Monet and Camille Pissarro, who came primarily as a means of avoiding the draft in the Franco-Prussian War. The two painters brought with them the preoccupations that would shortly take on the name Impressionism. Rather than emphasizing the monumental, ceremonial aspects of the city, or the human interactions of its inhabitants, as Victorian artists had done, Monet, like the American expatriate James McNeill Whistler, was fascinated by London's misty atmosphere and the shipping traffic on the River Thames. Monet's *The Pool of London* (1871, cat. no. 60) employs a palette of variegated grays applied directly onto the canvas, rather as Constable had done in his oil sketches. Monet was uninterested in the elaborate finish achieved by British artists of the period, as in William Lionel Wyllie's *Toil, Glitter, Grime and Wealth on a Flowing Tide* (fig. 14). Much of the specificity of Wyllie is lost, but Monet transcribes the gritty energy of the Pool of London with broad, energetic strokes of the brush. Monet offers a subjective, personal response to the scene, a noting down of its visual impact; unlike Wyllie, he is uninterested in the lives and endeavors of the boatmen, the precise details of shipping and architecture, or the historical

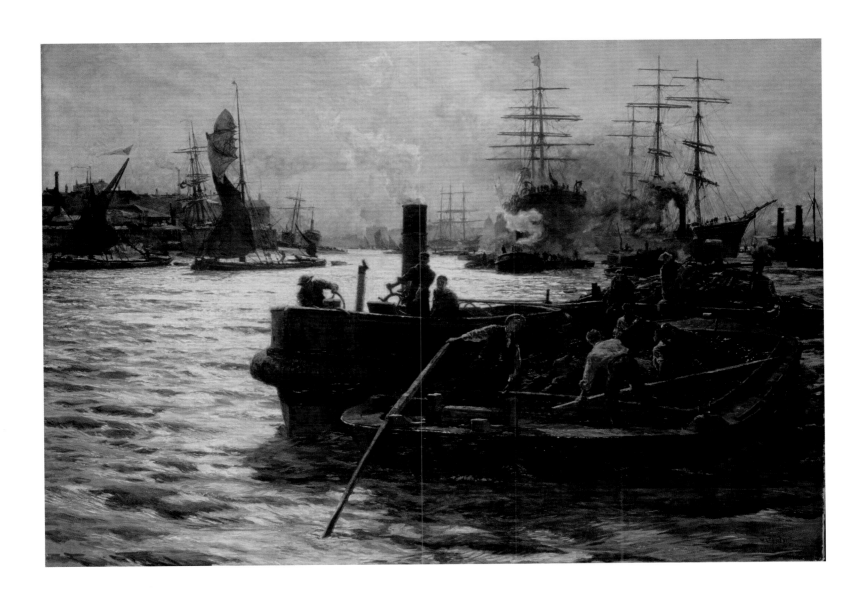

associations of the scene. Monet was interested in visual effects. He later wrote:

> What I like most about London is the fog. How could the English painters of the nineteenth century have painted its houses brick by brick? Those fellows painted bricks that they didn't see, that they couldn't see. . . . It's the fog which gives London its marvelous breadth. Its regular, massive blocks become grandiose in this mysterious cloak.[20]

If Monet wanted to distinguish himself from the mainstream painters of Victorian Britain, Pissarro, writing to his son Lucien, nonetheless acknowledged the influence of the picturesque tradition and the work of earlier British artists on the two visitors:

> The watercolors and paintings of Turner and Constable, the canvases of Old Crome, have certainly had influence upon us. . . . [W]e were struck chiefly by the landscape painters, who shared more in our aim with regard to "plein air," light and fugitive effects.[21]

Monet returned to London in 1899, and visited the following two years as well. Now the grand bourgeois, he stayed at the Savoy Hotel and utilized the panoramic views from his room on the fifth floor, taking the bend in the Thames at Westminster as subject matter for a series of canvases. In Monet's later works, which were to some extent affected by his deteriorating eyesight, the landscape becomes devoid of solid topographical features: the evocation of atmosphere,

achieved by taking maximum advantage of the properties of oil paint, becomes an end in itself. In *Charing Cross Bridge* (1902, cat. no. 61), Monet's swift brushwork provides a startling equivalent to the scudding movement of the clouds and the smoke of a train crossing Hungerford Bridge, the colors vibrantly mixing on the canvas before the viewer's eyes.

Charing Cross Bridge was purchased by the British collector Margaret Davies in 1913, the very moment that modernist styles began to exert a sudden and dramatic influence on British art. Despite Monet's occasional presence in London, French avant-garde painting was largely unknown to the British public until a series of exhibitions in 1910 to 1912 brought waves of new art to the British capital in quick succession, to the delight of some and the bafflement of others. The breakthrough exhibition *Manet and the Post-Impressionists* was mounted by the critic and curator Roger Fry in 1910 at the Grafton Galleries; the effect was described by literary critic Desmond McCarthy as "the Art-Quake of 1910."[22] While the reactionary press derided the exhibitions, the young Welsh-born painters Augustus John and J. D. Innes found in the bold colors and dynamic painterly gestures of Van Gogh, Gauguin, and even Matisse new possibilities for the representation of the British landscape. Suddenly, British painters were deploying exuberant colors with thick, dramatic brushstrokes. While the Pre-Raphaelites had explored the chromatic spectrum in their landscapes, the deep, lustrous purple of Innes's evening sketch of the shadows of *Arenig* (ca. 1911–12, cat. no. 69)—a mountain in the Snowdonia region of Wales, beloved of landscape

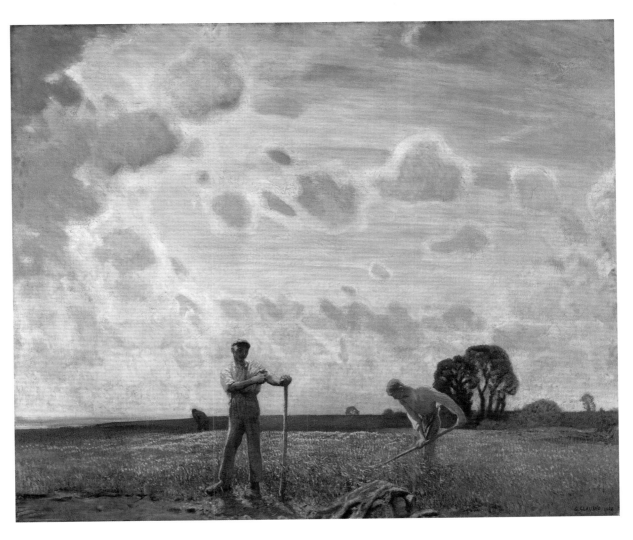

Fig. 15. George Clausen (1852–1944). *In the Fields in June*, 1914. Oil on canvas, 72 × 84 ⅛ in. (183 × 213.7 cm). Amgueddfa Cymru–National Museum Wales; purchased, 1914, NMW A 176

painters since Richard Wilson—is informed primarily by Post-Impressionism.

The collection of National Museum Wales is rich in justly renowned Impressionist work of the finest quality, but it also includes paintings by lesser-known artists made around 1900 that are deserving of reassessment. The Edwardian painter Charles Sims, for instance, captured a child's-eye view of a day by the seaside in his fresh and breezy canvas *The Kite* (ca. 1910, cat. no. 66), where brushstrokes dash the paint around the canvas as the sand might move in the wind. Laura Knight, in *The Cornish Coast* (ca. 1917, cat. no. 68), gives a sense of the forthright character and ambitions of two young middle-class women out for a walk on the cliffs—women who, like herself, faced a society still reluctant to abandon traditional gender roles. Against the expectations of a woman artist at the time, Knight creates a bold, theatrical design with powerful blocks of color true to the windswept coastal landscape of Cornwall. George Clausen, a generation older than Knight, was well aware of Impressionism from its inception, but evolved his own, subtle approach to painting from nature in the 1880s. A simple study, *Apple Blossom* (cat. no. 64), made directly from the motif on a small piece of millboard in 1885, is an intimate work that captures the animation of natural forms. Later in his career, in works like *In the Fields in June* (fig. 15), Clausen produced canvases of a heroic scale in which traditional rural work is celebrated. Months later, men such as the field workers Clausen painted would face mechanized slaughter in the trenches of the First World War.

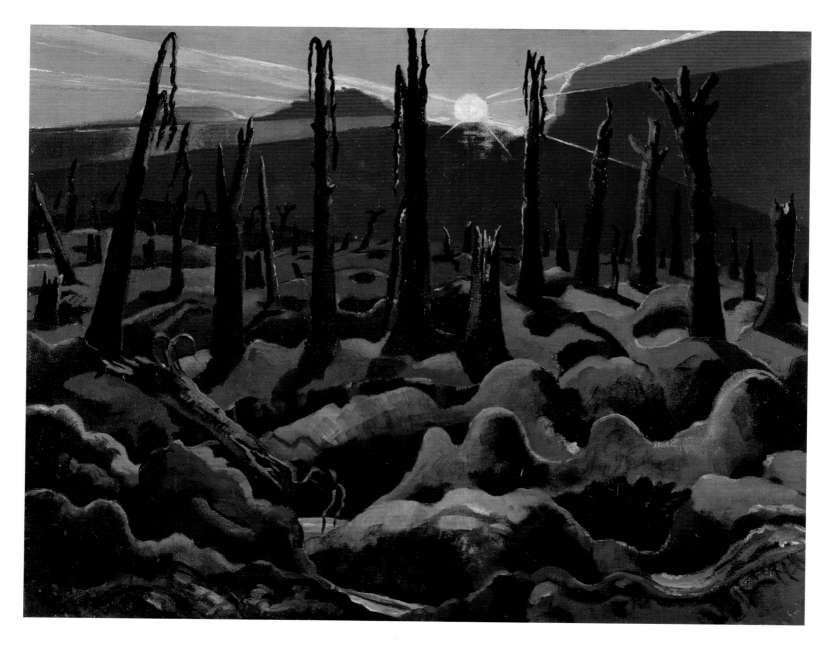

Fig. 16. Paul Nash (1889–1946).
We are Making a New World,
1918. Oil on canvas, 28 × 36 in.
(71.1 × 91.4 cm). Imperial War
Museums, London

Neo-Romantic to Post-Modern

No aspect of British culture in the twentieth
century escaped the shadows of the two world
wars. Landscape painting provided both a medium
for harrowing representations of the battlefield and
a protected space in which an ideal image of Britain—
a vision of what was being fought for—could be
nurtured. The representation of land and landscape
had always been ideologically charged, but in the
twentieth century it took on an elevated emotional
importance. A striking emblem of the effects of

war on the landscape is found in Paul Nash's
ironically titled *We are Making a New World* of
1918. Every hint of life is lost in an apocalyptic
vision of total despoliation (fig. 16). Brown replaces
green; red replaces blue; death replaces life. A
fallen tree among the trenches stands for the
millions of fallen men.

After the Great War, many British artists turned
away from what became perceived as "Continental"
avant-garde developments and reassessed the local
traditions of British art, rediscovering forgotten

artists and examining again the work of Gains-borough, Constable, and Turner. Publications and exhibitions on the work of William Blake and Samuel Palmer during the 1920s supported the revival of interest in these artists.[23] As it became clear that a second world war was approaching and that Nazi invasion was a real threat, the landscape came to symbolize all that was valuable in British culture. In a literal sense, the British relied on the land during the blockades of this period; suburban householders were encouraged to "dig for Victory" by planting vegetables, while Land Girls replaced male agricultural laborers drafted for combat. Evelyn Dunbar, one of the few women to be appointed an official war artist by the British government, created a boldly naive, realist image of hay-bailing, with an all-female workforce (cat. no. 78). Despite the gray skies, there is a utopian element to this image, implying that the war facilitated the removal of restrictions on the actions of women. Cedric Morris, the son of a wealthy Welsh industri-alist, painted extensively in south Wales, but spent much of his life in the eastern counties of England. In 1940, as Britain faced seemingly insuperable odds in the war, Morris produced *Stoke-by-Nayland Church* (cat. no. 79), a self-conscious homage to John Constable, who had sketched and painted the building extensively in 1810–14. The celebrated fifteenth-century tower appears clearly in Morris's painting, seeming as natural to the landscape as the two jays in the foreground.

After an exhibition in 1926, the nineteenth-century Romantic painter Samuel Palmer enjoyed sudden prominence. The exhibition inspired a group led by Graham Sutherland and John Piper to espouse what has been called Neo-Romanticism, a return to the traditions of Constable and Turner, but inflected by modernism and by the experience of modern life. The resulting work, often dark and brooding in tone, returned to traditional pictur-esque subjects. A work like Palmer's *The Rising of the Skylark* (cat. no. 72), from around 1843, could seem in the 1930s to enshrine a lost world of inno-cence. Palmer, whose greatest influence was the mystical poet-printmaker William Blake, with whom we began, was deeply rooted in English literary traditions, and subtitled *The Rising of the Skylark* with lines from John Milton:

> To hear the Lark begin his flight,
> And singing startle the dull night,
> From his watch-towre in the skies,
> Till the dappled dawn doth rise.[24]

Palmer includes the small figure of a scholar, dressed in his robe, who steps outside his cottage to hear the song of the lark and to embrace the transcendent spectacle of the sunrise.

By the 1930s, such a vision seemed both impossi-bly distant in time and profoundly desirable—the pastoral was an unattainable ideal, but a powerful one nonetheless. Paul Nash, a veteran of the First World War, provided the most explicit vision of the brokenness of pastoral England in the early days of the Second World War, *Totes Meer*—a German phrase meaning "dead sea" (fig. 17). It is no sea that

we confront, however, but the mangled wreckage of Nazi fighters brought down during the Battle of Britain. The English landscape is reduced to a brown strip in the margins of the composition; yet the sky reveals a harvest moon quoted from the early work of Palmer (and borrowed by Palmer himself from wood-engraved illustrations to Virgil made by William Blake).[25]

The artist John Piper wrote of his love of Blake and Palmer in a modest but influential publication, *British Romantic Artists*, published in the darkest wartime days, in 1942, in a popular series devoted to "Britain in Pictures." As he was completing the book, Piper created the small ink, watercolor, and bodycolor drawing *Grongar Hill with Paxton's Tower in the Distance* (cat. no. 74). Despite its modest proportions, this imaginative tour de force is a palimpsest of literary and visual influences, a compendium of Welsh and, more generally, British cultural references. It could almost be a requiem for a nation about to meet its end at the hands of Nazi barbarism. Grongar Hill was the subject of a topographical poem by the genteel Welsh-born poet John Dyer, written in 1726. Dyer had himself been on the Grand Tour and returned, like Richard Wilson and Joseph Wright, with a knowledge of Italian pastoral conventions. But his poetry was inspired by the local landscape of his youth:

> Grongar Hill invites my song,
> Draw the landskip bright and strong;
> Grongar, in whose mossy cells
> Sweetly-musing Quiet dwells.[26]

Piper's painting is built up from mossy cells of color, broken by one splash of light. The white, crenellated monument that dominates this landscape, Paxton's Tower, is a three-cornered Neo-Gothic folly erected in memory of Lord Nelson in 1809, celebrating his victory over Napoleon's fleet at Trafalgar. Piper recalled this moment of national and imperial triumph at the nadir of national fortunes—a rhetorical strategy also adopted to great effect by Winston Churchill in his wartime speeches. Piper was capable of a nostalgic approach to British heritage that by the time of his death in 1992 had come to seem conservative: his evocation of *Garden Follies at Stowe* (cat. no. 75), made in the tough years of postwar austerity, revisit wistfully the opulence of the Georgian country house. But despite its small size, *Grongar Hill* is a more complex and powerful work than *Garden Follies at Stowe*. It seems to distill something of the energy of legend and myth let loose by Thomas Jones in *The Bard* (cat. no. 5), and matches darkness and foreboding with visionary light that breaks through in the sky, a thin line of white bodycolor dazzling in its effect.

During the war, sustained bombing by the Luftwaffe had changed the face of Britain's cities, and London had been severely hit, with great loss of life. After 1945, a shattered nation began the long process of reconstruction. Bomb sites and building sites characterized the postwar cityscape. These became an important subject for two painters whose family origins lie in the Jewish communities of Eastern and Central Europe, but whose lives have been spent in London. Leon Kossoff was born

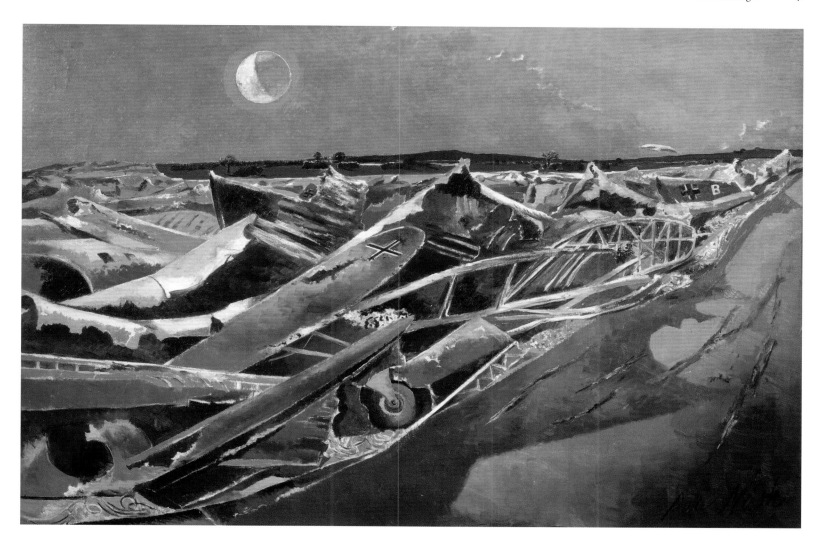

Fig. 17. Paul Nash (1889–1946). *Totes Meer* (Dead Sea), 1940–41. Oil on canvas, 40 × 60 in. (101.6 × 152.4 cm). Tate, London; presented by the War Artists Advisory Committee 1946

in Islington, London, to Russian parents in 1926, while Frank Auerbach's parents sent him to London from Berlin as a boy in 1939. Unlike Monet, Pissarro, or Oskar Kokoschka, who painted a series of vibrant studies of the Thames when he visited London in the 1920s, Kossoff and Auerbach are Londoners whose engagement with the city has been profound, intimate, and lifelong. Both painters have created richly impastoed, expressionistic paintings of suburban London subjects that earned them leadership of what has become known as the School of London.[27] While Kossoff's Willesden Green is an anonymous stretch of suburbia animated by his brush (1991, cat. no. 82), Auerbach's *Park Village East—Winter* (1998–99, cat. no. 83) represents a choice part of John Nash's

scheme of Metropolitan Improvements of the 1820s, in which two quasi-rural villages, complete with picturesque cottages, were fabricated in a newly developed section of London adjacent to Regent's Park. The quirky buildings, beloved of the nascent architectural conservation movement of the 1960s, are surrounded by full-grown trees. Eschewing architectural detail, Auerbach reveals with powerful and brightly colored brushstrokes the integration of nature and culture, under a dun London sky. The landscape may be one of postwar austerity, but the brushwork is exuberant, suggesting links to earlier German Expressionist painters and to members of the postwar New York School such as Willem de Kooning. The fortress Britain of the interwar years had opened up once again to

become an entrepôt of people and ideas from across the world.

The postwar years saw the cycle of global industrial development enter a new phase. As competition from overseas threatened Britain's heavy industries, the large-scale manufacturing plants of the Victorian era gradually fell out of production. By the late 1960s, industrial cities were marked by the abandoned hulks of the once-mighty textile mills. As the reign of heavy industry came to an end in the ensuing decades, commentators became acutely aware of the toll it had taken on the environment, expanding on a theme already present in the writings of the Romantic poets and of John Ruskin.[28]

The rise of modern environmentalism has given a new urgency to landscape art in recent decades. Rather than making representations of the landscape, artists have started to use the landscape as a medium. For example, Richard Long, the English Conceptual artist, documents in his work long walks—peregrinations in the landscape that are the modern descendants of the picturesque tour. Long's American counterparts pioneered a form of land art notable for massive earthworks, such as Robert Smithson's *Spiral Jetty* (1970, Box Elder, Utah), or such formidable manipulations of natural phenomena as Walter de Maria's *Lightning Field* (1977, Catron County, New Mexico). Long's work is, by contrast, largely handmade, deriving from extended periods of solitary exposure to nature. Long quite self-consciously chooses to work in Snowdonia, the epitome of the Welsh sublime made famous by

Wilson, Cox, and Turner, who visited in 1798. Rather than sketching the landscape, however, Long subtly alters it, rather as the feet of picturesque tourists—or their present-day descendants, ramblers and hikers—also do. Long's footsteps themselves make their mark, and some of his earliest works were formed by the temporary indentations his feet made in reeds or in fields of grass (as in *A Line Made by Walking, England, 1968*).[29] Long's works, like those of the picturesque era, are the deposits of pilgrimages into nature. But Long also adjusts the position of stones, creating sculptures in situ from the ancient materials of the Welsh mountains. He then documents these works through photography, a medium established among these hills and valleys for a century and a half. *Snowdonia Stones* (2006, cat. no. 85) records a walk of five days' duration—something highly unusual in the era of the SUV, but very familiar to the likes of Rowlandson's Doctor Syntax. Long's photograph is a resonant act of homage: Turner, Girtin, and Cox can be detected in the scudding clouds and Pre-Raphaelite detail in the sharply lit distant fellside; in the foreground, Ruskin's dark intellect broods on the rocks. And in the middle, the standing stones, perhaps erected or adjusted by Long himself, remind us of Thomas Jones's wild rendering of Stonehenge, transported to Wales as the home of the last bard. Long's role, in some sense, is bardic: he reveals the poetry inherent in the landscape, eloquently bewailing its demise in the face of new technologies and climate change.

Long is deeply aware of history. One of his journeys took him from Windmill Hill to

Coalbrookdale, significant because, as he noted, "Windmill Hill folk were the first inhabitants of England to make permanent changes in the landscape." His walk took him from deep archaeological time to the inception of industrialization: the Iron Bridge at Coalbrookdale, the first of its kind in the world, was opened in 1780, a monument of the Industrial Revolution. In addition to his local concerns, Long adds a global, postcolonial perspective to the picturesque tour: moving beyond the purview of Gilpin or Doctor Syntax, but echoing the hemispheric reach of their contemporary Captain Cook (and his team of artists, which included William Hodges), Long has traveled to Japan, to the Sahara, and to Iceland, among other places.

If Long represents a contemporary equivalent of the picturesque tourist, the Welsh artist David Nash more closely follows the model of John Constable. He began his career by taking much of his inspiration from the area near his home and studio in Blaenau Ffestiniog in Wales and has continued to engage deeply with the local landscape throughout his career. Among Nash's most celebrated works is a "planting piece," *Ash Dome* (1977–), a ring of twenty-two ash trees growing near his home in Wales. Like the gardens of Capability Brown, this is a living artwork, continuing to grow, to be influenced by changes in weather and the environment. Learning from local farmers, Nash has become an expert in the husbandry of trees, and he relishes the constant changes in his living sculptures. Like Long, Nash uses photography as an important adjunct to his practice, not only recording but interpreting each piece (cat. nos. 87, 88). He is also a powerful and discerning draftsman, whose large-scale drawings of trees, while achieving considerable formal refinement, preserve a primeval sense of life. His work is an intervention in the landscape as well as a powerful statement against deforestation, harking back, ultimately, to the rural world, which preceded the industrial era and which, indeed, preceded the presence of man himself. With these haunting works, landscape art has come full circle.

"Hen Gymru fynyddig, paradwys y bardd":[1] Wales and the Evolution of Landscape Art in Britain

Oliver Fairclough

Many of the paintings, watercolors, and early photographs in this exhibition are images of the landscape and monuments of Wales, and all form part of the collections of Amgueddfa Cymru, Wales's National Museum.[2] Wales (fig. 1) is the mountainous western peninsula of the island of Britain bordered by the Irish Sea, and incorporated by conquest into the Kingdom of England in the thirteenth century. Until the late nineteenth century, Wales had its own distinct language, with most of its people speaking only Welsh. Sparsely populated and with some of the most beautiful natural landscape in Europe, Wales has had a significant impact on Britons' relationship with the natural environment over the last three hundred years.

More specific to this exhibition, the country has also played a key role in the development of landscape art in Britain since the mid-eighteenth century. Wales has bred great artists—Richard Wilson (1713/14–1782), often celebrated as "the father of English painting,"[3] was actually a Welshman from Penegoes in Montgomeryshire[4]—and, as an area of great natural beauty, it has been a key source of inspiration for artists who have made their way there from the rest of Britain and beyond. This story may begin with the picturesque tourist painters of the late eighteenth century traveling in search of spectacular natural scenery, but it also encompasses the land artists of the late twentieth century, such as Richard Long and David Nash, who has made his home in Blaenau Ffestiniog.

Wales is a land of green hills—about a quarter of its landmass of 8,000 square miles is above 1,000 feet, though only in Snowdonia in the northwest do the mountains exceed 3,000 feet—and of long, winding river valleys. It contains three of the United Kingdom's fifteen national parks, areas protected for their outstanding landscape. Though the impact of industrialization was keenly felt in Wales, it was limited in its geographical scope. More people made their living in mines, quarries, and factories than in agriculture as early as 1851, but these activities were largely confined to the coal- and iron-producing areas of the southeast and the northeast; to the slate quarries of Snowdonia; and to the metal-smelting industries of the lower Swansea valley, which produced some of the worst industrial pollution in Britain. These landscapes, deeply affected by human activity, were also captured by artists.

Outside of these industrial, and now often postindustrial, areas, present-day Wales is a relatively impoverished land of small scattered settlements and upland farms. Tourism is central to the economy: Wales has long drawn English and foreign visitors, who came on foot, by horse, and by train before the age of the automobile. The late eighteenth-century cult of the picturesque is inseparably linked to the development of the Welsh tour, which guided the traveler around Wales in the footsteps of the gentleman antiquarian and naturalist Thomas Pennant (1726–1798). Following Pennant from viewpoint to viewpoint, travelers went from ruined castles and abbeys to mountains, waterfalls, and lakes. Although some early tourists gave the impression of traveling through a land empty of people, others idealized the *gwerin*, the ordinary people of Wales, as the

John Piper, *Devil's Kitchen*, 1946–47 (fig. 7, detail)

ANGLESEY

Conwy

Flint

Caernarvon

Snowdon ▲

Betws-y-coed

Blaenau
Ffestiniog

Llangollen

Bala

Barmouth

Cadair Idris ▲

St. Davids

Llandeilo

Merthyr Tydfil

Tenby

Chepstow

Swansea

Caerphilly

Newport

Cardiff

descendants of the hardy pastoralists of classical antiquity living in harmony with the natural world. From the radical London orator John Thelwall (1764–1834) in the 1790s to the hippies of Tipi Valley in the 1970s, people have come to Wales seeking self-sufficiency and a more holistic relationship with the natural world. As many Welsh people have a powerful sense of their own place, the landscape of Wales is seen as something to be cherished and protected. As a result, the degradation of the landscape evokes particularly strong feelings, which are reflected by artists. Environmentalism plays a significant role in the work of artists such as Terry Setch (b. 1936), whose recent work is inspired by, and even incorporates, the trash washed up on the beach near his home at Penarth in south Wales.

At the beginning of the eighteenth century, Wales was little visited by travelers; indeed, the concept of travel undertaken for information or pleasure rather than out of economic or political necessity was still in its infancy. The few Englishmen, such as Daniel Defoe (ca. 1660–1731), who did come to Wales and record their impressions thoroughly disliked the experience.[5] They found the country backward, and judged it incapable of economic or visual improvement. They complained about atrocious roads and squalid inns. They found the mountains "horrible" and the incomprehensible Welsh language "barbarous." But by the 1750s, attitudes were beginning to change as a consequence of an intellectual rediscovery of the history and culture of ancient Wales, which was prized as coeval with that of the Mediterranean world.[6] This "Celtic revival"

Fig. 1 (opposite). Map of Wales, illustrating the principal places visited by late eighteenth-century travelers

Fig. 2. British School, attributed to Thomas Smith (d. 1719). *View of Margam House, Glamorgan, Looking North*, ca. 1690. Oil on canvas, 44 ½ × 39 ⅜ in. (113.1 × 100 cm). Amgueddfa Cymru–National Museum Wales; purchased with the assistance of the Heritage Lottery Fund and the Art Fund, 2012, NMW A 29925

was initiated by a small group of Welsh antiquarians, but it soon attracted the interest of a number of English scholars and poets: Thomas Gray (1716–1771), for example, celebrated the suicidal resistance of the Welsh to foreign invaders in his 1757 poem *The Bard*. Some pioneering aristocratic travelers (many, such as George, Lord Lyttleton [1709–1773], with an interest in the aesthetics of landscape gardening) began to

record their enthusiasm for the "grandeur" and "magnificence" of the Welsh mountains.[7]

What of the visuals arts? Prior to the 1740s a few artists had visited Wales either to draw its medieval monuments (cat. nos. 28, 29) or to record the houses and gardens of the gentry (fig. 2). These works celebrated family history and pride in ownership of the land, but were devoid of any deeper moral or

Fig. 3. Anton Raphael Mengs (1728–1779). *Richard Wilson (1713/14–1782)*, 1752. Oil on canvas, 33 ¼ × 29 ⅝ in. (84.6 × 72.5 cm). Amgueddfa Cymru–National Museum Wales; purchased with the assistance of the Art Fund, 1947, NMW A 113

philosophical intent. The way artists looked at Wales was to be revolutionized by Richard Wilson, who also transformed the course of landscape painting in Britain (fig. 3). Wilson was born and brought up in north Wales, and although he was apprenticed to a London portrait painter in 1730, landscape played a significant role in his early practice. *Dover Castle* (cat. no. 30), of about 1746, demonstrates Wilson's familiarity with Dutch topographical painting of the seventeenth century. The first of a number of paintings by Wilson of Caernarvon Castle in north Wales also probably dates from the mid-1740s.[8] This, like Wilson's later pictures of Welsh subjects in the 1760s, presents Edward I's great Gothic fortress, which Pennant called "the most magnificent badge of our subjection,"[9] as an ordered, harmonious, and classical ideal. In 1750, Wilson left London for Italy, where over the next six years he was to reach artistic maturity as a painter of the classical landscape in the Grand Manner. As well as drawing ancient sites in and around Rome, often in the company of fellow artists from France and Germany, Wilson was profoundly influenced by the work of landscape painters of the previous century, especially Claude (cat. no. 1) and Salvator Rosa (cat. no. 2), which he saw in the city's palazzi. Returning to London in 1756, Wilson did much to create a market for pictures of Grand Tour locations such as Tivoli and Lake Nemi, as well as for history paintings.

Wilson also popularized British views, including a number set in his native Wales. He seems to have begun *Dinas Bran Castle, near Llangollen* (cat. no. 3) as a view of Tivoli, only to change his mind and add the distinctive silhouette of the ruined Welsh castle atop a hill. What mattered to Wilson, evidently, was not topographical accuracy but mood, atmosphere, and light. Such pictures also appealed to the buoyant sense of patriotism that was a powerful factor in British life in the years following the great victories in the Seven Years' War of 1756–63. These works sometimes invoked foreign models, but they also asserted that Britain had its own national story to rival that of Rome. Although Wilson's practice and reputation declined sharply in the mid-1770s, he had a profound influence on younger contemporaries and on artists of the generation of Turner and Constable. *The Lake of Albano* (cat. no. 7), painted by Joseph Wright of Derby in 1790, years after his own visit to Italy, is a reimagining of a location painted by Wilson, and was long misattributed to him. John Inigo Richards's *Chepstow Castle* (ca. 1776, cat. no. 6) is essentially a

Fig. 4. Samuel Hieronymous Grimm (1733–1794). *Caernarvon Castle*, 1777. Mixed media on card, 15 ¹¹⁄₁₆ × 24 in. (39.8 × 61 cm). Amgueddfa Cymru–National Museum Wales; purchased, 1923, NMW A 3366

Wilsonian composition, though it lacks his golden Italianate light and feeling for mass and shade.

In 1775 a set of six engravings of Welsh views by Wilson published by John Boydell sold well, raising awareness of Wales's scenic possibilities. By now, both artists and travelers were coming to Wales in search of the picturesque. The Reverend William Gilpin (1724–1804) made his tour in 1770,[10] with the object of "examining the face of a country by the rules of picturesque beauty."[11] He was able to make use of a well-developed boat service that descended the River Wye from Ross to Chepstow; Thomas Gray had made the journey only a few weeks before and described it as a "succession of nameless wonders."[12] Gilpin found "the whole is such a display of picturesque scenery that is beyond any commendation."[13] The two-day trip included the spectacular ruins of Goodrich Castle

and of Tintern Abbey, as well as the wooded cliffs of the river's gorge and the landscaped grounds of Piercefield Park. The journey's end was the town of Chepstow, with its great castle and Norman church. A longer north Wales tour was also pioneered in the 1770s.[14] Its popularity owed much to Thomas Pennant's *A Tour in Wales*, published in 1778, which was to be followed over the next fifty years by dozens of similar guidebooks.

Gentlemen of means sometimes brought a professional artist with them on their tours. Pennant, for example, employed his servant Moses Griffith (1749–1819) to make extra illustrations of his tours.[15] Henry Penruddocke Wyndham (1736–1819) traveled in Wales in 1774 and 1777, accompanied on the second occasion by the Swiss watercolorist Samuel Hieronymous Grimm (1733–1794) (fig. 4).[16] The first

such tour of north Wales was made in the summer of 1771 by the art collector and patron Sir Watkin Williams-Wynn (1749–1789) (fig. 5), whose party of fourteen included the artist Paul Sandby (1731–1809).[17] The two-week journey provided the subjects for Sandby's *XII Views in North Wales*, a set of aquatints published in 1776 and dedicated to Sir Watkin. Along with Caernarvon and Harlech Castles and the mountains of Snowdonia, Sandby's subjects included *The Iron Forge between Dolgelli and Barmouth* (cat. no. 50). North Wales was now not only sublime and romantic; parts were also seen as the home of useful industry. Many more such industrial images were to follow at the end of the eighteenth century as the copper mine at Parys Mountain on Anglesey (cat. no. 51) and the ironworks of Merthyr Tydfil (cat. no. 53) grew in size, until their massive scale seemed to rival that of the natural landscape.

Britain's many years of war with France between 1793 and 1815 made European travel impossible for much of this period, and the Welsh tour became increasingly popular as a result. In this time, a near-standard itinerary developed. The traveler—sometimes in stages, on successive visits—made a circuit from Chepstow and Tintern Abbey in the southeast, to the castles of Cardiff and Caerphilly, and onward to Swansea, Llandeilo, Tenby, and Pembroke in the west. Travelers then headed north along the coast of Cardigan Bay to Aberystwyth, where Uvedale Price (1747–1829)[18] built a castellated house on the seafront in 1794, and to Hafod, where Price's friend Thomas Johnes (1748–1816) created

a vast picturesque landscape in the Cardiganshire hills.[19] The traveler often continued to Harlech Castle and to Barmouth before ascending Cadair Idris, the southernmost of the mountains of Snowdonia. Caernarvon, the greatest of the castles built by Edward I to control his Welsh conquests, was also an essential stopping-off point. From there, the traveler could cross the Menai Straits (bridged only in 1826) to Anglesey before exploring Snowdon (if possible, climbing the mountain to reach the summit at sunrise), Beddgelert (to mourn the faithful if fictional hound),[20] and Llanberis ("a wild and Romantic Vale"[21] with the ruins of Dolbadarn Castle). The route ran east from there to the Conwy Valley, the Vale of Clwyd, and Llangollen,[22] where the River Dee led tourists back into England. Some made the journey on horseback or by horse-drawn coach, but others chose to walk. The Welsh tour often proved daunting (cat. no. 13), but it provided a huge range of subjects to artists, especially those using the recently developed technique of painting directly in watercolor to express emotion and atmosphere. J. M. W. Turner made five visits to Wales between 1792 and 1800.[23] His *Ewenny Priory* (cat. no. 17) is a large exhibition watercolor worked up from a drawing made during a tour of south Wales in 1795, a journey that also provided the inspiration for *Llandeilo Bridge and Dynevor Castle* (cat. no. 18). Turner's contemporary Thomas Girtin made a tour of north Wales in 1798, which provided a color sketch for his monumental *Near Beddgelert* (cat. no. 10), exhibited to great acclaim at the Royal Academy the following year.[24]

Fig. 5. Paul Sandby (1731–1809). *Sir Watkin Williams-Wynn Sketching*, 1777. Mixed media on paper, 5 ¼ × 4 ¾ in. (13.4 × 11.1 cm). Amgueddfa Cymru–National Museum Wales; purchased, 1963, NMW A 3988

Improved road and rail links helped bring a wave of "post-Turner" artists to north Wales after 1830. One of the most influential of these was the Birmingham painter David Cox (cat. no. 12), who in 1844 made the first of many summer visits to Betws-y-coed in the heart of the Conwy Valley. The village was rapturously described in Thomas Roscoe's *Wanderings and Excursions in North Wales* (1836),[25] and Cox's presence attracted other aspiring painters to the area.[26] Many came from Manchester or Liverpool, from which north Wales was now an easily accessible sketching ground, but others came from places as far afield as Norway and the United States. Betws-y-coed has been described as Britain's first artists' colony, as a number of visiting painters chose to make permanent homes in the area. One of these was Henry Clarence Whaite (cat. nos. 25, 26), a Manchester-born artist on the edge of the Pre-Raphaelite circle.[27] Many other more significant figures in the mid-Victorian art world also painted in the mountains of north Wales. These included William Dyce (cat. no. 35), who made a

single visit to Llanrwst in 1860; the Pre-Raphaelite marine artist John Brett (cat. no. 36), who visited Wales frequently between 1866 and 1891, producing dozens of images of its dramatic, rocky coastline;[28] and watercolorist Alfred William Hunt. Like Charles Darwin, who had traveled in Wales in 1831, all three artists were fascinated by the area's extraordinary and ancient geology, which evoked the unimaginable scale and power of the forces of nature.

Along with the rest of Britain, Wales increasingly attracted artists from abroad during the nineteenth century, some of whom painted traditional picturesque subjects. The German Romantic artist Carl-Gustavus Carus, for instance, accompanied the King of Saxony on a visit in 1844 and made paintings of Warwick Castle, Fingal's Cave on the Scottish Island of Staffa, and Tintern Abbey by moonlight.[29] Others, such as Lionel Walden (cat. nos. 54, 55), a French-trained American who worked in Cardiff during the 1890s, painted Wales's great new docks and steelworks. Having spent a few months in the London suburbs in 1874, Alfred Sisley returned to Britain in 1897, staying for three months in south Wales, and painting at Penarth on the edge of Cardiff, and at Langland Bay (cat. no. 63).[30]

Mid-Victorian photographers also came to north Wales in search of the sublime. Francis Bedford (1816–1894) photographed the scenery around Betws-y-coed in the summer of 1856, and Roger Fenton (cat. nos. 46–48) followed a year later, having already photographed at Raglan Castle and other sites in Monmouthshire.[31] South Wales, too, played a crucial role in the early development of photography

Fig. 6. Benjamin Williams Leader (1831–1923). *On the Llugwy below Capel Curig*, 1903. Oil on canvas, 36 ⅛ × 56 in. (91.7 × 142.2 cm). Amgueddfa Cymru–National Museum Wales; given by the Hon. Arnold Palmer, 1949, NMW A 4945

in Britain. William Henry Fox Talbot (1800–1877), often credited with the invention of photography, was a frequent visitor to Margam in Glamorgan, the home of his cousin Christopher Rice Mansel Talbot (1803–1890), and the estate was the subject of some of his earliest experimental photographs, made in 1839–43. Talbot introduced his friend Calvert Richard Jones (cat. nos. 37–40), a mathematician, musician, watercolorist, and clergyman, to photography.[32] Jones, working in Britain and abroad, became one of the few Britons to produce a substantial body of calotypes (a process developed by Fox Talbot that used paper coated with silver iodide). Talbot's brother-in-law John Dillwyn Llewelyn (cat. nos. 41–45) was also a pioneering photographer (one of his innovations was a camera shutter that allowed him to capture movement at approximately one-twenty-fifth of a second) whose earliest

daguerreotype is dated 1840.[33] Although he gave up photography in the late 1850s, several thousand of his calotype and wet collodion negatives survive, many of them images taken on his estate of Penllergare, near Swansea, and around the south Wales coast.

By the time it was recorded by these early photographers, Wales was undergoing rapid social and economic change. Industrialization had created and enriched the iron and coal communities of the south and the northeast, which now grew with astonishing speed, changing the landscape of these areas forever. Meanwhile, increasing prosperity fostered a growing sense of identity and a desire for national institutions. Eventually, the emergence of a block of Welsh Nonconformist Liberal MPs in the late nineteenth century would make public institutions such as a national museum a political possibility. Both

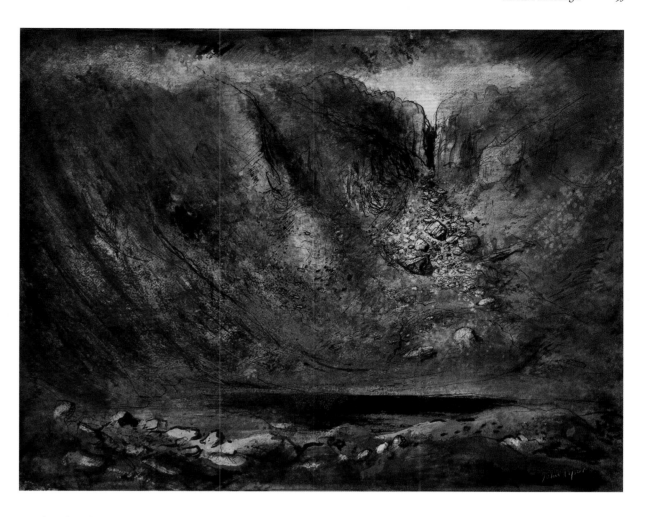

Fig. 7. John Piper (1903–1992). *Devil's Kitchen,* 1946–47. Mixed media on paper, 21 7/16 × 27 in. (54.4 × 68.7 cm). Amgueddfa Cymru–National Museum Wales; purchased, 1983, NMW A 1766

Scotland and Ireland already had national museums, founded in 1854 and 1877 respectively. In 1905, the British Government finally conceded the principle of creating a national museum and a national library for Wales. The museum was to be located in Cardiff, already the largest center of population, though the city has only been the official capital of Wales since 1955. Although Edinburgh and Dublin also had separate national art galleries, the National Museum of Wales, which received its Royal Charter in 1907, was to be a museum of natural sciences, archaeology, history, and the arts. It was charged with both "the complete illustration" of the art of Wales and the collecting of art more widely. The museum's first Keeper of Art, Isaac Williams (1875–1939), took up his post in 1914 and was supported by the sculptor Sir William Goscombe John (1860–1952), a long-standing member of the museum's governing council and an influential figure in the late nineteenth-century Welsh cultural revival that had brought the museum into existence.[34] In the eyes of the museum's early leaders, the art history of Wales began with Richard Wilson, and the first major work of art purchased by the National Museum was a version of Wilson's *Caernarvon Castle,* acquired for £380 in 1913.[35] Other early acquisitions of Wilson's work are included here (cat. nos. 3, 30). Williams also built up a fine collection of topographical prints and drawings, but he seems to have had little interest in contemporary art.

During this time, painters like Benjamin Williams Leader (1831–1923) continued to paint the hills and rivers around Betws-y-coed, much as artists had done for decades (fig. 6). However, two younger artists from Wales who were both familiar with current trends in French art—James Dickson Innes (cat. no. 69) and

Augustus John (cat. no. 70)—would bring the intense color and the rapid, expressive brushwork of the Fauves (the "wild beasts" of the French avant-garde) to the mountains of north Wales.[36] Innes discovered Mount Arenig, near Bala, during a tour of north Wales in 1910, and the mountain became his inspiration and his "spiritual home." He painted it repeatedly, responding to changing weather conditions and seeking moments of revelation in the transitory effects of light. In 1911, Innes returned to Arenig with Augustus John. Their relationship was mutually beneficial: John was inspired by Innes's vision and intensity, and Innes was deeply influenced by John's idiosyncratic technique. This Post-Impressionist episode in Welsh painting was to be brief: Innes died of tuberculosis in August 1914, just as the First World War was beginning, and John went on to support a celebrated bohemian lifestyle through the mass production of society portraits.

Augustus John was a favorite artist of two of the National Museum's principal benefactors, Gwendoline Davies (1882–1952) and Margaret Davies (1884–1963). These two sisters were among the most significant early British collectors of Impressionism.[37] After inheriting a fortune made by their grandfather from south Wales coal, the sisters began to collect art in 1908. Initially their taste was for Turner, Corot, and Barbizon landscape painters, but in 1912 they encountered Monet's Venetian paintings of four years earlier. They acquired several of these, and were inspired to add more works by Monet and by the other Impressionist painters: Margaret Davies bought *Charing Cross Bridge* (cat. no. 61) the following year.

The Davies sisters never married and were leading members of the Calvinistic Methodist Church, an austere Protestant sect unique to Wales. Perhaps for this reason theirs is primarily a collection of landscape paintings, and "modern life" subjects such as cafés and bars are entirely absent. The sisters' bequests in 1952 and 1963 transformed the scale and ambition of the National Museum's art collection, which was already strong in progressive British art of the years around 1900 (for example, cat. nos. 64–68).

Several of the British artists of the 1920s and 1930s associated with the modernist Seven and Five Society, such as Cedric Morris (cat. nos. 58, 79) and David Jones (1895–1974), had family links to Wales, and worked there on occasion. It was the artists associated with the British Neo-Romantic movement, however, who took a renewed interest in the possibilities of the Welsh landscape in the decade between the late 1930s and the late 1940s. Graham Sutherland, who first worked in Pembrokeshire in 1934, was profoundly influenced by the country's strange landscapes of river estuaries and hidden valleys, and his art was reinvigorated when he returned there after a long absence in 1967.[38] John Piper (cat. no. 74) worked in south Wales in the late 1930s, and produced his own reimagining of the Snowdonia landscape of the north Wales tour in a body of work (fig. 7) made there between 1943 and 1950.[39] Both Piper and Sutherland were official war artists, and the Neo-Romantic movement was motivated in part by the threat of invasion and destruction through bombing during the Second World War. A younger generation also began to make landscape art in Wales during the war: John Minton (cat. no. 77), John Craxton

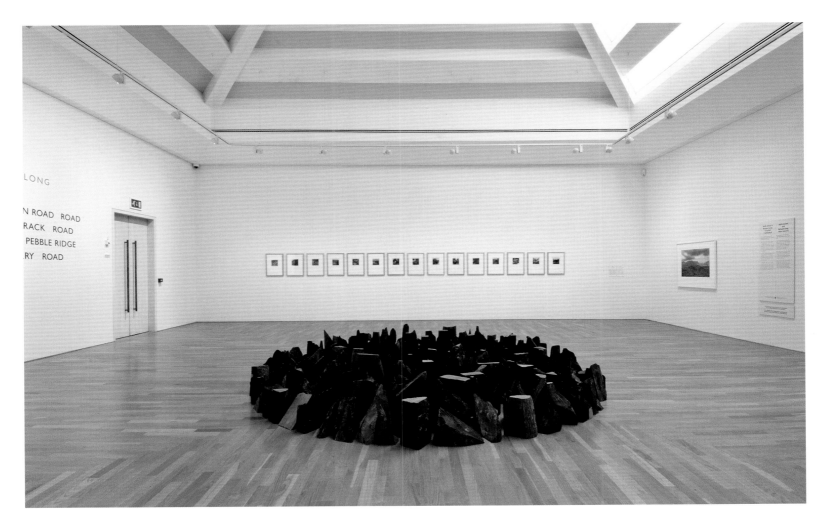

Fig. 8. Richard Long (b. 1945). *Blaenau Ffestiniog Circle*, 2011. Welsh slate, h. 23 ¼ (59 cm), diam. 12 ft. 13 ½ in. (4 m). Amgueddfa Cymru–National Museum Wales; purchased with the assistance of the Art Fund and of the Derek Williams Trust, 2011, NMW A 24418

(cat. no. 76), Keith Vaughan (1912–1977), and Lucian Freud (1922–2011), among others. The National Museum is especially strong in Neo-Romantic art, and holds Sutherland's personal collection of his work, given by his own foundation in 1989.[40]

Having been an inspiration to artists since the eighteenth century, Wales was also to play a significant role in the British land art movement, which reached a peak in the 1970s. British land artists preferred to get away from towns, gravitating toward the unspoiled landscapes of Wales, the Lake District, or the Wiltshire Downs. Some of their work took the form of interaction with or performance in the landscape (cat. no. 85), but artists like David Nash and Richard Long also made art using the materials—the earth, trees, and stones—of the land around them (cat. nos. 87, 88, and fig. 8). Much of this work is

permeated by a spirit of romantic escapism and evokes a tradition of British landscape painting stretching back to the Shoreham paintings of the visionary artist Samuel Palmer during the 1820s. At the beginning of the twenty-first century, young artists continue to find inspiration in the landscape of Wales; their work encompasses a range of media, from paint to video.[41] At the National Eisteddfod, Wales's great festival of language and culture, in 2013, the Young Artist Scholarship was awarded to Becca Voelcker. One of Voelcker's works is a film study that captures the colors of Parys Mountain, the site of the great copper mine that had filled John "Warwick" Smith with awe over two hundred years before (cat. no. 51). Like so many before her, Voelcker has found Wales both an "inspiration and a starting point…and a point of return."[42]

Catalogue

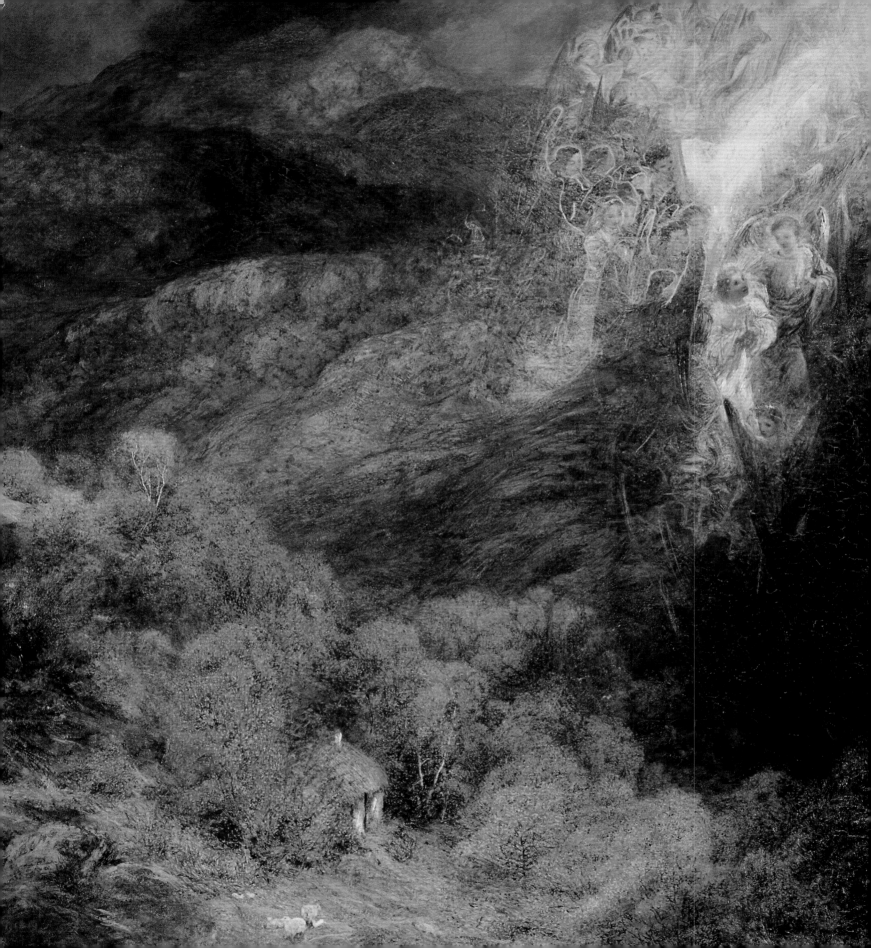

Notes on the Catalogue

Catalogue entries were written by the following staff members of Amgueddfa Cymru–National Museum Wales:

B.D.	Bryony Dawkes, Partnership Projects Curator
M.E.	Mark Etheridge, Curator, Industry
O.F.	Oliver Fairclough, Keeper of Art
J.R.K.	John R. Kenyon, former Librarian
B.M.	Bethany McIntyre, Senior Curator, Prints and Drawings
M.M.	Melissa Munro, Senior Curator, Contemporary Art
A.P.	Anne Pritchard, Senior Curator, Historic Art
N.T.	Nicholas Thornton, Head of Fine Art
C.T.	Charlotte Topsfield, former Assistant Curator, Prints and Drawings

Most works are on view at all venues; if specified, the following references indicate exclusive presentation at the venues named:

Norton	Norton Museum of Art
Frick	The Frick Art and Historical Center
Utah	Utah Museum of Fine Arts
Princeton	Princeton University Art Museum

Previous. Lionel Walden,
Steelworks, Cardiff, at Night, 1895–97
(cat. no. 55, detail)

Left. Henry Clarence Whaite,
The Shepherd's Dream, 1865 and later
(cat. no. 25, detail)

Classical Visions and Picturesque Prospects

1

Claude Gellée, Le Lorrain
(1604/5–1682)
*Landscape with St. Philip
Baptizing the Eunuch*, 1678

Oil on canvas
34 ⅝ × 56 in. (88 × 142.2 cm)
Amgueddfa Cymru–
National Museum Wales
Purchased with the
assistance of the Art Fund,
1982
NMW A 4

In the right foreground, St. Philip the Evangelist, dressed in red and blue, baptizes the kneeling figure of an Ethiopian eunuch and court official. The subject is taken from Acts of the Apostles, 8:26–40. Commanded by an angel, Philip journeyed from Jerusalem to Gaza. On the way, he met the eunuch sitting in a chariot reading the prophecies of Isaiah. When the eunuch asked him to explain the significance of the text, Philip convinced him that the prophecies had been fulfilled in the life and death of Christ, and baptized him as a Christian at a nearby stream. According to legend, this event marked the founding of the Ethiopian Church.

Framed by trees, this afternoon scene is set in one of Claude's most beautiful panoramic landscapes, which extends to the sea beyond. The distant town is probably intended to represent Gaza, Philip's destination. With the exception of the bridge behind the eunuch's elaborate horse-drawn chariot (adapted from the Ponte Nomentano near Rome), this carefully composed landscape is entirely imaginary.

Together with his older contemporary Nicolas Poussin, Claude perfected an idealized classical landscape where nature is carefully arranged for effect. His work was especially popular in eighteenth-century Britain and strongly influenced Richard Wilson, who urged his pupils to "rival Claude" (Jones 1951, 10).

Claude spent almost all his working life in Rome. This picture was painted in 1678 for Cardinal Fabrizio Spada (1643–1717), who had been papal nuncio in 1672–74 in Turin, where he was successful in converting to Catholicism some of the region's Calvinists. Its subject probably refers to this missionary activity. Spada also commissioned a companion work, *Landscape with Christ Appearing to Mary Magdalene* (now Städel Museum, Frankfurt). A morning scene completed in 1681, this depicts Mary Magdalene as the first Christian convert. Both paintings left Italy in 1798, and were later owned by William Beckford (1759–1844), the Gothic novelist, art collector, and creator of Fonthill Abbey. —O.F.

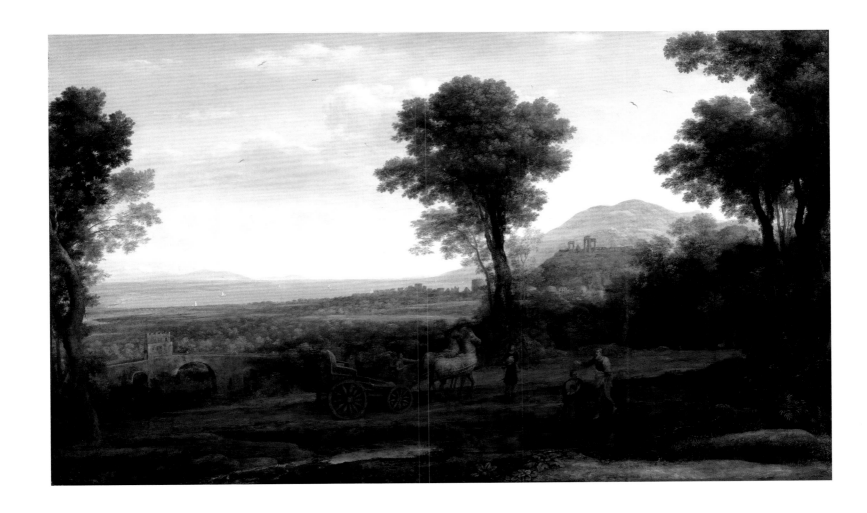

2

Salvator Rosa (1615–1673)
Rocky Landscape with Herdsmen and Cattle, 1660s

Oil on canvas
21 ¾ × 27 ½ in.
(55.2 × 69.9 cm)
Amgueddfa Cymru–
National Museum Wales
Bequeathed by Sir Claude
Phillips, 1925
NMW A 8

Salvator Rosa's works represent the antithesis of the calculated balance of Nicolas Poussin's compositions and the pastoral beauty of Claude. Stunted trees cling precariously to the rock face, and the sharp edges of unforgiving crags jut out at unsettling angles. These were motifs Rosa used repeatedly, founded on meticulous studies from nature. Rather than finding inspiration in the traditional classical landscapes of the Roman Campagna, Rosa sought the rugged grandeur found in Italy's mountain regions. Terms such as "terrific beauty" and "savage wildness," which he used to describe the area surrounding the Velino falls near Terni in a letter of 1662, might seem more at home amid nineteenth-century Romanticism.

Rosa's perception of the picturesque fit well to the British landscape, especially to the wild mountains and coasts of Wales. In the eighteenth century, many artists returning from their Grand Tour of Italy were strongly influenced by his work. Richard Wilson, for example, transformed the genre of British landscape painting by applying the principles of Italian art, often with allusions to Rosa. His impact is also visible in some of the exhibition pieces painted by Wilson's pupil Thomas Jones. The storm-swept trees, dramatic cliffs, and primeval figures of *The Bard* (cat. no. 5) are typical Rosa motifs. While Jones's painting clearly dictates the story of a recognized Welsh legend, however, the success of informal landscapes such as the present painting lay in the subtlety of narrative.

Although the title of this work might imply something benign, the imagery harbors a sense of unease common to many of Rosa's paintings. He often included bandits or other menacing figures in his landscapes to heighten the feeling of suspense. Here, shadowy crevices, looming overhangs, and half-dead trees already create a setting full of uncertainty. It is the interaction between the two herdsmen, and the simple detail of the outstretched arm, that appears to confirm a more elaborate and potentially sinister scenario. The artist's own adversarial nature and notorious reputation would only have reinforced the imaginings of his audience. —A.P.

3

Richard Wilson
(1713/14–1782)
Dinas Bran Castle, near Llangollen, early 1770s

Oil on canvas
42 ¾ × 57 ¾ in.
(108.6 × 146.7 cm)
Amgueddfa Cymru–
National Museum Wales
Purchased, 1919
NMW A 3277

Despite its topographically specific title, this painting is an Italian-Welsh hybrid, as it combines the jagged outline of the thirteenth-century Welsh castle of Dinas Bran on the hill to the left with the landscape of Tivoli and the Roman Campagna.

Richard Wilson had trained in London as a portraitist during the 1730s, but in his late thirties he made a radical change of direction, becoming a landscape painter in the Grand Manner, producing pictures that were charged with allusion and meaning. He traveled in Italy between 1751 and 1756, and on his return to London he enjoyed a decade of success, painting idealized classical landscapes in the manner of Claude, set in the countryside around Rome. He was also to paint a number of British views, some of them set in his native north Wales.

In 1769 Wilson attracted the interest of Sir Watkin Williams-Wynn (1749–1789), the wealthiest Welshman of his day, who had himself recently returned from Italy. Williams-Wynn commissioned from him two great views, each 6 by 8 feet, set in the countryside near his home. *View near Wynnstay, the Seat of Sir Watkin Williams-Wynn, Bt.* and *Dinas Bran from Llangollen* were completed in 1770, and are now in the Yale Center for British Art.

Sir Watkin's *Dinas Bran* bears only an approximate resemblance to *Dinas Bran Castle, near Llangollen*, and technical examination indicates that the latter work was begun as a view of Tivoli with the Campagna beyond. The road in the foreground curving toward a bridge and the framing trees are typical compositional devices found in many of Wilson's Italian views. He subsequently painted out a roadside shrine to the left of the figure group, changed the profile of the hill to cover a group of buildings (probably the Temple of the Sybil), and added the distinctive silhouette of Dinas Bran instead, presumably to profit from the successful exhibition of Sir Watkin's picture at the Royal Academy in 1771. —O.F.

4

Thomas Gainsborough
(1727–1788)
*Rocky Wooded Landscape
with Rustic Lovers,
Herdsman, and Cows,*
1771–74

Oil on canvas
48 ⅞ × 58 ¾ in.
(124.2 × 149.3 cm)
Accepted by H. M.
Government in lieu
of inheritance tax and
allocated to Amgueddfa
Cymru–National Museum
Wales, 2001
NMW A 22780

The picture is set in a distant golden landscape and is intended to evoke a feeling of nostalgia for an imaginary rural past. The handling of paint is bold, with slabs of white, yellow, and pink impasto in the sky. The composition is centered on a herdsman who, following his cattle and a goat to a stream, has caught sight of a milkmaid seated with her wooden pail. She only has eyes for her rustic admirer, who stands nearby.

Thomas Gainsborough sometimes said that while portraiture was his profession, landscape painting was his pleasure. By 1770 his landscapes of the imagination, as he called them, were carefully composed to appeal to the emotions. They also referenced art of the past, and took inspiration from both Claude and Rubens. Unlike Richard Wilson and John Inigo Richards, two of his contemporaries included in this exhibition, Gainsborough did not accept commissions for views of country houses, and he often used models to work out an ideal composition. Nevertheless, this work draws motifs from a real landscape. Between 1758 and 1774, he was living in the fashionable West Country spa town of Bath, where his friends included Walter Wiltshire (ca. 1719–1799), who owned the nearby Shockerwick estate, which was well wooded with picturesque outcrops of rock.

Gainsborough was a frequent visitor there, and he used Wiltshire's regular "flying waggon" service to transport his paintings to London. He gave Wiltshire this picture and *The Harvest Waggon* when he left Bath for London in 1774. The latter dates from 1767, and *Rocky Wooded Landscape* appears to have been painted as a pendant to it, either in 1771 or shortly before he left for London. The pictures stayed together until 1946, when *The Harvest Waggon* was acquired by the Barber Institute, Birmingham, and *Rocky Wooded Landscape* was bought by the newspaper publisher William Berry, Viscount Camrose (1879–1956). —O.F.

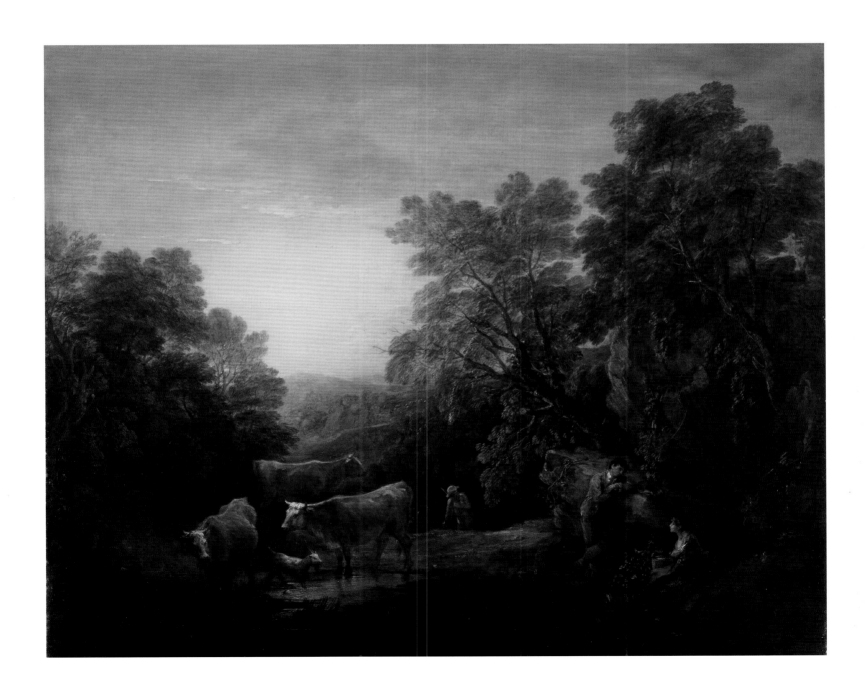

5

Thomas Jones (1742–1803)
The Bard, 1774

Oil on canvas
45 ¹⁄₁₆ × 66 ⅛ in.
(114.5 × 168 cm)
Amgueddfa Cymru–
National Museum Wales
Purchased, 1965
NMW A 85

This is an imagined landscape using motifs such as craggy peaks and wind-blasted trees culled from the paintings of Salvator Rosa. It provides a dramatic backdrop to a narrative poem by Thomas Gray (1716–1771), one of the most admired English poets of the eighteenth century. Gray had read the legendary tale of King Edward I's slaughter of the Welsh bards following his conquest of Wales in 1277–83. After hearing a recital by the Welsh harpist John Parry, Gray completed the poem, which he had begun a few years before. The poem tells how the last survivor of the bards ("the Bard") defiantly curses the approaching Plantagenet invader before throwing himself to his death in the River Conwy below.

> "Ruin seize thee, ruthless King!
> Confusion on thy banners wait...
> Helm, nor hauberk's twisted mail,
> Nor e'en thy virtues, tyrant, shall avail
> To save thy secret soul from nightly fears,
> From Cambria's curse, from Cambria's tears!"

Although Gray had never been to Wales, and his description of the landscape is entirely imaginary, the poem is intensely visual.

> On a rock, whose haughty brow
> Frowns o'er old Conway's foaming flood
> Robed in the sable garb of woe,
> With haggard eyes the poet stood;
> (Loose his beard and hoary hair
> Stream'd like a meteor to the troubled air)

As well as prophesying the fate of Edward's Plantagenet descendants, the Bard heralds the Tudors, thereby allowing the poet to present eighteenth-century Britain, created through the recent union of England and Scotland in 1707, as the legitimate heir of the ancient Celtic past.

The circle of standing stones was inspired by Stonehenge, which Thomas Jones had visited in 1769. Unaware that it belonged to a yet more ancient past, he believed that "Stupendous Monument of remote Antiquity" to be Druidic (Jones 1951, 21). By introducing it here, he merges the image of the medieval bard with that of the Celtic druids, also massacred by foreign invaders. —O.F.

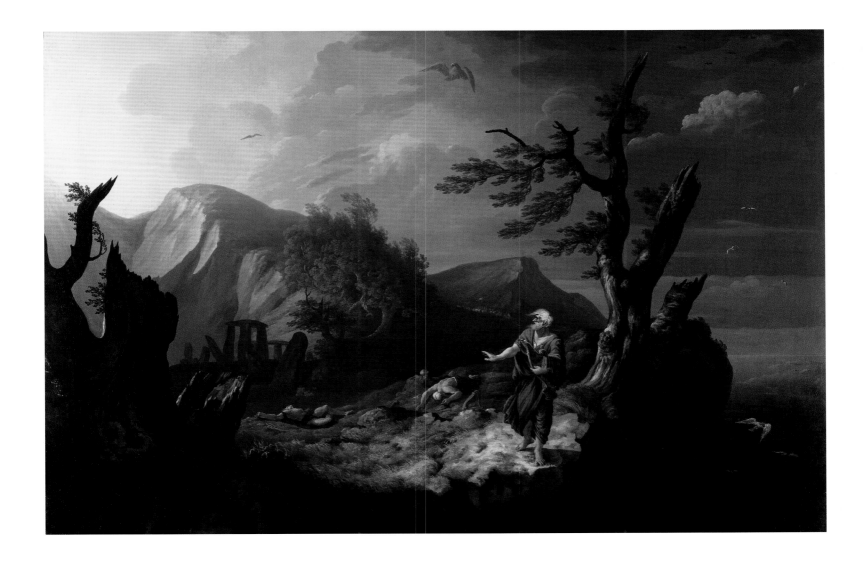

6

John Inigo Richards
(1731–1810)
Chepstow Castle,
ca. 1776

Oil on canvas
28 ¼ × 41 ¹⁄₁₆ in.
(71.7 × 104.3 cm)
Amgueddfa Cymru–
National Museum Wales
Purchased, 1945
NMW A 430

Chepstow Castle, "the gateway to Wales," was the final destination of the Wye Valley boat tour from Ross-on-Wye to Chepstow—popular with travelers from the middle of the eighteenth century and made famous by William Gilpin's *Observations on the River Wye, and Several Parts of South Wales* (1782).

Begun by the Norman baron William FitzOsbern (ca. 1020–1071), the castle was repeatedly enlarged and remained in use until the seventeenth century. It is seen here from the English bank of the Wye, on a steep limestone cliff above the river. The central rectangular building, highlighted amid a flock of birds, is the Great Tower, probably completed around 1090. The many towers of the middle and lower baileys to the left mostly date from the thirteenth century, after which the castle declined in military importance.

John Inigo Richards was a protégé of William Hogarth and trained under the landscape painter George Lambert. He was to work for most of his life as a scene painter at the Covent Garden theater, and his landscape practice competed with the demands of his theater work. His theatrical connections included a brother-in-law who was the proprietor of the Cherry Theatre in Philadelphia. His early landscapes follow the fashionable principles of picturesque composition, and suggest the influence of Canaletto's English pictures of 1746 to 1755. He exhibited regularly at the Society of Artists from 1762, and was a founding member of the Royal Academy in 1768.

Richards was a Londoner, despite his Welsh name, but may have had connections with Chepstow, as there is another version of this painting (private collection) dated 1757. The present work is probably that shown at the Royal Academy in 1776. It subsequently belonged to Richard Payne Knight (1751–1824), whose Herefordshire seat, Downton Castle, built 1774 to 1778, was one of the first castellated buildings inspired by the picturesque movement. —O.F.

7

Joseph Wright of Derby
(1734–1797)
The Lake of Albano, 1790

Oil on canvas
40 ⅛ × 49 ¾ in.
(101.9 × 126.4 cm)
Amgueddfa Cymru–
National Museum Wales
Given by F. J. Nettlefold,
1946
NMW A 109

Lake Albano is a flooded volcanic crater in the Alban Hills about twelve miles southeast of Rome, overlooked by the pope's summer palace of Castel Gandolfo. It was much admired by British visitors to the city, and the Welsh painter Thomas Jones, who also painted it, describes skirting the lake while walking to nearby Genzano in December 1776: "This walk considered with respect to its classick locality, the Awful marks of the most tremendous Convulsions of nature in the remotest Ages, the antient and modern Specimens of Art, and the various extensive & delightful prospects it commands is…the most pleasing and interesting in the Whole World" (Jones 1951, 55).

Joseph Wright arrived in Rome in February 1774. Having trained in London, he had sustained a successful career as a portrait painter in the industrial town of Derby for nearly twenty years. He is chiefly remembered today as the first British artist to depict industry and the scientific experiments of the age. However, he was also interested in developing his abilities as a landscape painter, and his visit to Italy would provide new subjects and access to a more elite market. His two-year stay provided sufficient material for him to include views of Italy in his repertoire for the rest of his life. This work is dated 1790, and was to be followed in 1792 by *Lake Albano with Castel Gandolfo* (Royal Albert Memorial Museum, Exeter).

Like Richard Wilson twenty years earlier, Wright was entranced by the beauty of Italy and profoundly influenced by Claude's paintings of the same landscape, lit by a warm southern light. This picture was long attributed to Wilson, until cleaning revealed Wright's signature. It is the largest of three known versions of the composition. A smaller painting in the Yale Center for British Art is paired with a pendant view of nearby Lake Nemi. —O.F.

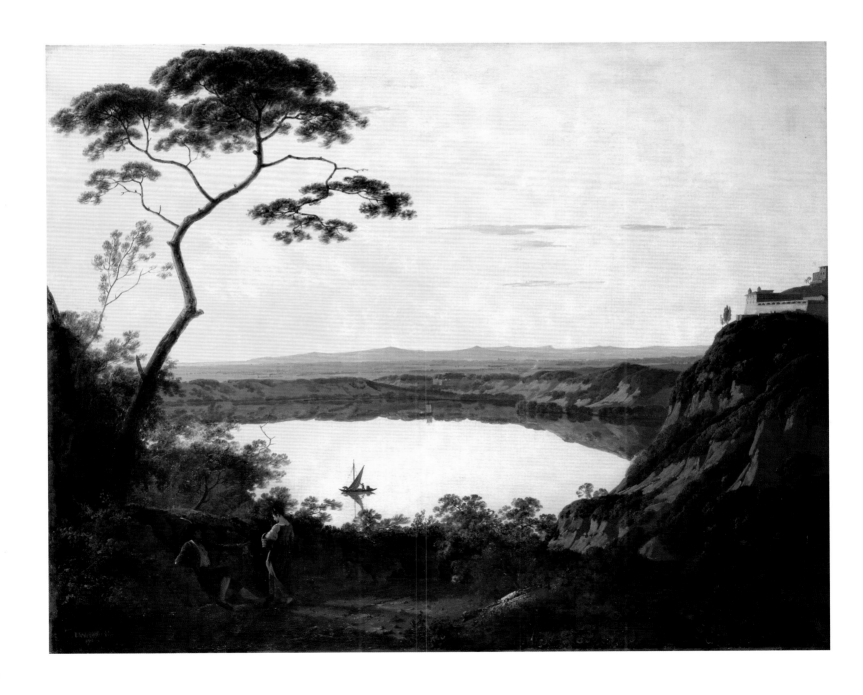

8

Thomas Barker of Bath
(1769–1847)
*The Tomb of the Horatii
and Curiatii*, 1792

Oil on canvas
22 ⁵⁄₁₆ × 16 ¹⁵⁄₁₆ in.
(56.6 × 41.4 cm)
Amgueddfa Cymru–
National Museum Wales
Bequeathed by Isaac and
Annie Williams, 1975
NMW A 454

This ancient tomb is traditionally believed to be that of three Curiatii brothers of Alba Longa and two of their cousins, the Horatii of Rome. The two sets of brothers engaged in combat to settle a war between the two cities. After two of the Horatii were killed, the third feigned flight, luring the Curiatii into pursuit and slaying them one by one. Rome emerged supreme and the older city of Alba Longa was destroyed.

A poignant symbol of the conflict between old and new, Thomas Barker's painting of these ruins recalls the lessons of history in the context of the present day. Situated on the Appian Way, once Rome's greatest strategic highway, the road is now the setting for a peasant's horse and cart which makes its way gingerly through the shadows of the tomb's crumbling towers. The delicate foliage and precarious ruins add to a sense of fragility gently reminiscent of Salvator Rosa's more sinister images of looming shadows and menacing banditti.

Barker traveled in Italy between 1790 and 1793, financed by the affluent coach-builder Charles Spackman, who told him to "make all the studies from nature you can." This oil sketch of the tomb is typical of the gentleman artist's Grand Tour of Italy. Many stopped to study this historic site, influenced by the great Italian landscapists they had seen on their travels. The tomb features in works by Richard Wilson and Thomas Girtin, among others.

Barker's family had moved from his native Wales to the Regency spa town of Bath when he was sixteen. There, Spackman's generous sponsorship allowed Barker to lead the life of a gentleman. The influence of the Bath society portraitist and landscape artist Thomas Gainsborough is prevalent in Barker's paintings. That Barker appears to have been mainly self-taught, however, makes his technical ability and stylistic flare quite remarkable. —A.P.

9

Thomas Girtin (1772–1802)
The Eagle Tower, Caernarvon Castle, ca. 1800

Watercolor and pencil
on paper
11 ½ × 17 ¾ in.
(29.3 × 44.1 cm)
Amgueddfa Cymru–
National Museum Wales
Purchased, 1970
NMW A 3368
Norton and Frick

Thomas Girtin was one of the greatest practitioners of watercolor painting and a preeminent landscape artist. He was a friend and rival of J. M. W. Turner, and together they transformed the use of watercolor. Girtin first exhibited at the Royal Academy in 1794. From that year on, in the tradition of topographical watercolorists, he made sketching tours around Britain in the summer, gathering material that he would work up into finished exhibition watercolors in the studio. Girtin sketched the tourist sites—ruined castles, abbeys, and medieval churches—and his resulting exhibition watercolors show a preponderance of architectural subjects. Girtin toured Wales several times; this watercolor is probably based on sketches from a tour in 1800. It is one of three versions of this composition (the others are in the Castle Museum, Norwich, and the Victoria and Albert Museum, London).

The picturesque view of Caernarvon Castle in its immediate landscape is taken from across the River Seiont and shows the exterior of the Eagle Tower and the Water Gate. This was a popular view with artists who painted the castle. Girtin developed a spacious Romantic style of painting that proved popular with patrons. Here he has used a palette of warm browns and reds, and much of the sheet has been given to the depiction of the cloud-filled sky.

Caernarvon Castle is perhaps the most famous castle in Wales. It was built by Edward I, during fighting between the Welsh and the English in the late thirteenth century, and took nearly fifty years to construct. The castle is embedded in Welsh history; the Eagle Tower was said to have been the birthplace of the first English Prince of Wales, Edward II. In more modern times, the castle was the setting for the 1969 investiture of Prince Charles as Prince of Wales. —B.M.

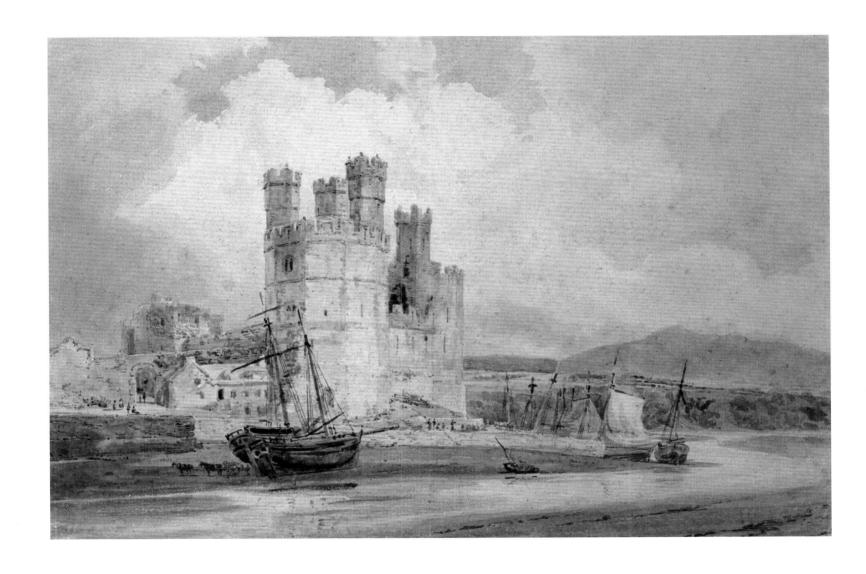

10

Thomas Girtin (1772–1802)
Near Beddgelert (A Grand View of Snowdon), 1798–99

Watercolor and pencil
on paper
23 ¼ × 34 ¹³⁄₁₆ in.
(59 × 88.5 cm)
Amgueddfa Cymru–
National Museum Wales
Purchased with the
assistance of the Art Fund,
2001
NMW A 22730
Utah and Princeton

This is one of Thomas Girtin's most important exhibition watercolors. It captures the rugged beauty of the north Wales mountains—an area that was widely visited and painted by British artists during the height of the golden age of British watercolors. The artist and the viewer are placed among the mountains, confronting the power and grandeur of the landscape.

Girtin made a tour of north Wales in 1798 and exhibited this work at the Royal Academy in the spring of 1799 under the title *Near Beth Kellert*. (It later became known as *A Grand View of Snowdon*.) It was hung near J. M. W. Turner's watercolor of Caernarvon Castle and attracted significant critical commentary. *The Morning Chronicle* wrote that the two artists "display the most promising talents in this line of the arts. Their specimens are exquisite," whereas *The Sun* commented that *Near Beth Kellert* "exhibits all the bold features of Genius. The scene here represented is highly Romantic, and the objects introduced are all in unison with the character of the piece. Mr Girtin, we predict, will stand very high indeed in professional reputation."

The title is significant, as Romantic artists became fascinated with Welsh history and legend. It translates as the "Grave of Gelert" and is the site of the legend of Gelert, the "faithful hound" of the medieval Welsh prince Llewelyn ap Iorwerth ("Llewelyn the Great"). The watercolor was commissioned by one of Girtin's most important patrons, Edward Lascelles (1764–1814). Girtin was paid 21 guineas in July 1799, and the watercolor hung as part of a rich decorative ensemble at Harewood House, until it was sold by the 4th earl in 1858.

Girtin played a pivotal role alongside Turner in the development of British watercolor painting. He died tragically young, probably of consumption, at twenty-seven. Turner was reputed to have stated, "If Tom had lived, I should have starved." Although some of the colors have faded, Girtin's masterly control of the medium on a grand scale and the visionary quality of his composition remain clear. —B.M.

11

John Sell Cotman
(1782–1842)
Cader Idris, ca. 1835

Watercolor on paper
9 ½ × 14 ¾ in.
(24.1 × 37.5 cm)
Amgueddfa Cymru–
National Museum Wales
Bequeathed by James Pyke
Thompson, 1898
NMW A 3031
Norton and Frick

This crepuscular view of the mountain Cadair Idris appears almost otherworldly in its deep colors and elusive forms. Light emerges from behind shadowy green trees reflected through the mist on the river below. The grandeur of the mountain looms from behind, conveyed in the vivid smalt blue characteristic of John Sell Cotman's late works.

The "sublime" landscape of J. M. W. Turner and Thomas Girtin is interpreted here through the vibrant palette that distinguishes Cotman's watercolors. He followed very closely in the Romantic footsteps of these two artists, enrolling at Dr. Monro's Academy in London in 1799. Like them, he also ventured on picturesque tours of Wales, in 1800 and 1802. It is thought that some works by Girtin and Cotman from Conway and Beddgelert, executed in 1800, may date from the same excursion—a trip coordinated for young artists by their patron, Sir George Beaumont. The impressive castles and dramatic mountain landscapes discovered by

Cotman during these tours would inspire him throughout the rest of his career.

Some of Cotman's Welsh subjects were developed over twenty years after his last visit to the country. Works like this one were derived partly from his early sketches and partly from memory, the link to reality at times becoming tenuous. For many years this scene was thought to be imaginary. An experimental piece, created for the artist's own pleasure, it is particularly expressive and innovative in its technique.

Cotman developed a process of adding flour or rice paste to his paints, which caused them to remain moist on the paper for longer. The versatile texture allowed him to wipe, drag, and scrape his paints in ways previously possible only in oil. This new medium also gave his colors a velvety softness that enhanced their intensity. Dispensing with the traditional pencil underdrawing, Cotman achieved an intangible quality in his images. In this case the effect renders the scene all the more ethereal. —A.P.

12

David Cox (1783–1859)
The Train on the Coast,
ca. 1850

Watercolor and pencil
on paper
10 ⅝ × 14 ⅝ in. (27 × 37.1 cm)
Amgueddfa Cymru–
National Museum Wales
Transferred from the Turner
House, 1921
NMW A 1736
Utah and Princeton

In this extraordinarily dynamic landscape, David Cox is chiefly concerned with representing the weather, light, and atmosphere. As with other watercolors he produced around this time, this work shows the confrontation of man and nature. The power of nature is all around, while man is represented by his technical achievement in the train on the horizon, its steam white against the gray clouds. The remarkable freedom of handling and strong colors lend a great immediacy to the scene.

This may not be a depiction of a particular place but rather a studio sketch, perhaps inspired by the north Wales coastline. The Chester-to-Holyhead railway opened in 1848 and was one that Cox would have been very familiar with, as he traveled regularly to north Wales. In 1844 he visited Betws-y-coed, writing, "We agree to stop a week; there is no end of the fine river scenery and rocks and mountains." Cox was so drawn to the area that he made annual summer visits there until 1856. Other artists followed, and the village has been described as Britain's first artists' colony.

The work is painted on a type of coarse paper designed as a wrapping paper that Cox discovered in 1836. He liked working with its texture and impurities, and a similar paper was later marketed as "Cox" paper.

Cox trained initially in Birmingham, moving in 1804 to London, where he took lessons from the watercolorist John Varley (1778–1842). He exhibited at the Royal Academy and became a member of the Society for Painters in Watercolor, submitting numerous works for their annual exhibitions. He also wrote several treatises on landscape painting and watercolor technique. —B.M.

13

Thomas Rowlandson
(1756–1827)
An Artist Traveling in Wales,
1799

Etching and aquatint with
hand coloring on paper
13 3/16 × 15 3/8 in.
(33.5 × 39 cm)
Amgueddfa Cymru–
National Museum Wales
Purchased, 1927
NMW A 13683
Norton and Frick

This work is a humorous comment on the picturesque movement of the late eighteenth and early nineteenth centuries. Being waved off, an artist sets off into the hilly landscape in search of the picturesque. He is shown riding a nag too small for him, heavily weighted down with the tools of his trade— an easel by his side, a sketchbook strapped to his back—and at the mercy of the elements, with only a small umbrella to ward off the rain. In the past it has been suggested that this is a self-portrait. However, it is more likely that the man is a type rather than a particular person. The artist in search of idyllic landscape will encounter hardship and a lack of comforts on his journey.

Thomas Rowlandson was one of Britain's foremost draftsmen and printmakers and a celebrated social satirist. He set off on a sketching tour of Wales in August 1797 with his friend and patron Henry Wigstead, whose subsequently published journal gives a fascinating insight into the journey. The weather was appalling, with incessant rain. Rowlandson and Wigstead entered Wales near Welshpool and there took "leave of the luxuries of the other side of the Severn." They went up to the mountains of north Wales and down the coast to Carmarthen and across to Cardiff, Chepstow, and Tintern. Wigstead admired the landscape, finding that its natural beauties "cannot be sufficiently revered and admired." However, he also found plenty to complain about: "Nor can the bad accommodation at most of the receptacles for the traveller, and the insolence and inattention of their proprietors, joined to the filthiness of their attendants, be sufficiently censured. No possible excuse can be made for the dirtiness, every where predominant.…"

This print was engraved by Henri Merke and published by Rudolph Ackermann (1764–1834) on February 10, 1799. Ackermann was the founder of the popular *Repository of Art* (London) and published many of Rowlandson's prints. —B.M.

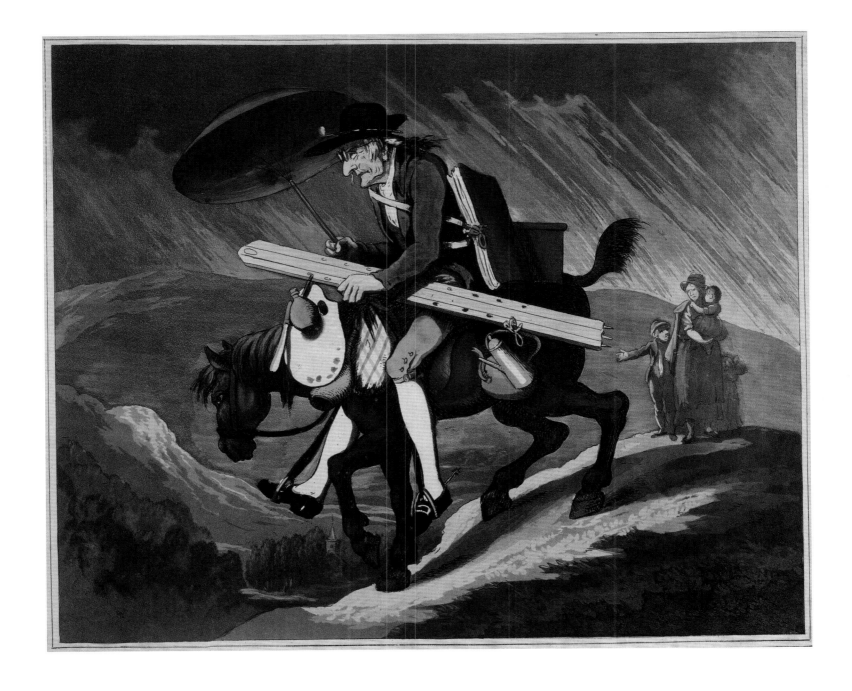

14

William Combe (1742–1823)
*The Tour of Doctor Syntax,
In Search of the Picturesque:
A Poem*

4th edition, published 1813
by R. Ackermann, London
9 ½ × 6 ⅛ × 1 ⅛ in.
(24 × 15.5 × 3 cm)
Amgueddfa Cymru–
National Museum Wales
Library (151046)
Utah and Princeton

Plate shown: "Doctor Syntax
Tumbling into the Water,"
hand-colored aquatint by
Thomas Rowlandson

In this book, William Combe satirized the pictur-esque art movement as expounded, initially, by the Reverend William Gilpin in the late eighteenth century through his *Observations on the River Wye, and Several Parts of South Wales* (1782) and other books of this genre.

The tour down the Wye in particular became extremely popular, and numerous accounts survive from the late eighteenth century and the first half of the nineteenth, both in published form and in manuscript. The high point of the excursions was the ruins of the Cistercian abbey of Tintern. The ruins were the subject of numerous paintings at this time, notably those by J. M. W. Turner, Michael Angelo Rooker, and John "Warwick" Smith.

Combe's parody of the picturesque, *Doctor Syntax*, first appeared in 1812 and chronicles in comic poetry the adventures of the eccentric cleric Doctor Syntax. The verses were enlivened by the drawings of Thomas Rowlandson, published as hand-colored aquatints. Rudolph Ackermann commissioned the drawings first, and afterwards approached Combe, then resident in the King's Bench Prison, to provide the letterpress.

Such was the popularity of the book that it went into several editions, the ninth being published in 1819. *The Second Tour of Doctor Syntax, In Search of Consolation* appeared in 1820, with *The Third Tour of Doctor Syntax, In Search of a Wife* issued the following year. —J.R.K.

Turner and the Sublime

15

Joseph Mallord William
Turner (1775–1851)
Ruined Farmhouse, ca. 1795

Watercolor and pencil
on paper
7 $^{15}/_{16}$ × 10 $^{5}/_{16}$ in.
(20.2 × 26.3 cm)
Amgueddfa Cymru–
National Museum Wales
Bequeathed by James Pyke
Thompson, 1898
NMW A 1749
Norton and Frick

J. M. W. Turner was the foremost British painter of the first half of the nineteenth century. He was born in London and showed a precocious talent for art. Turner trained under the architectural draftsman Thomas Malton (1748–1804), performing humble tasks such as coloring engravings, before entering the Royal Academy Schools in 1789. He began exhibiting there only a year later. Turner had a lifelong engagement with watercolor and painted almost exclusively in that medium until 1796. He was familiar with the work of topographical artists such as Paul Sandby (cat. no. 50) as well as that of Richard Wilson (cat. nos. 3, 30), the pioneer of landscape painting as an expression of mood and atmosphere. This is an early watercolor of a crumbling building that Turner may have seen on his sketching tour in 1795, which took him to parts of north Wales. The half-timbered farmhouse dates to the second half of the seventeenth century and is the type of building that could have been found in Montgomeryshire or Denbighshire. At this stage Turner was still very much painting in a topographical tradition and was yet to realize the powerful, atmospheric landscapes with which he made his name. —B.M.

16

Joseph Mallord William
Turner (1775–1851)
Marford Mill, ca. 1794–95

Watercolor with stopping
out and pencil on paper
10 $\frac{9}{16}$ × 7 ¾ in.
(26.9 × 19.7 cm)
Amgueddfa Cymru–
National Museum Wales
Given by subscribers, 1923
NMW A 1746
Utah and Princeton

Early in his career, J. M. W. Turner embarked on a succession of tours throughout Britain in search of antiquities and other topographical subjects. He was interested in producing work for the fashionable antiquarian market. Turner first visited Wales in the summer of 1792, and in 1794 he returned while on a tour chiefly of towns in central England. He had been commissioned by the publisher John Walker to make small views of ancient buildings and towns to be engraved. The course of the tour took him into Wales to Llangollen, Valle Crucis, and Flint. At Rossett in Denbighshire, on the road between Wrexham and Chester, he sketched this tumble-down half-timbered water mill, previously used to grind corn. That sketch (Tate, London) was used as the basis for this finished watercolor, which he exhibited at the Royal Academy in 1795.

The landscape of Wales, particularly the grand scenery of north Wales, was to have a huge impact on Turner's vision. In this work Turner has focused in on the mill and has captured all its rustic qualities in intense detail. It is a thoroughly picturesque view.

Turner was only nineteen years old when he painted this work, yet it shows great subtlety and sophistication. Even in these early years Turner's painting methods were inventive—he was constantly experimenting and evolving new techniques. His mastery of watercolor painting is seen in the different textures of the mill walls, the surrounding vegetation, and particularly in the depiction of the reflections in the water work. Here Turner has employed "stopping out," a technique where gum is used in certain areas as a resist to prevent subsequent washes covering it; the resist is then removed or washed away to reveal the original paper. —B.M.

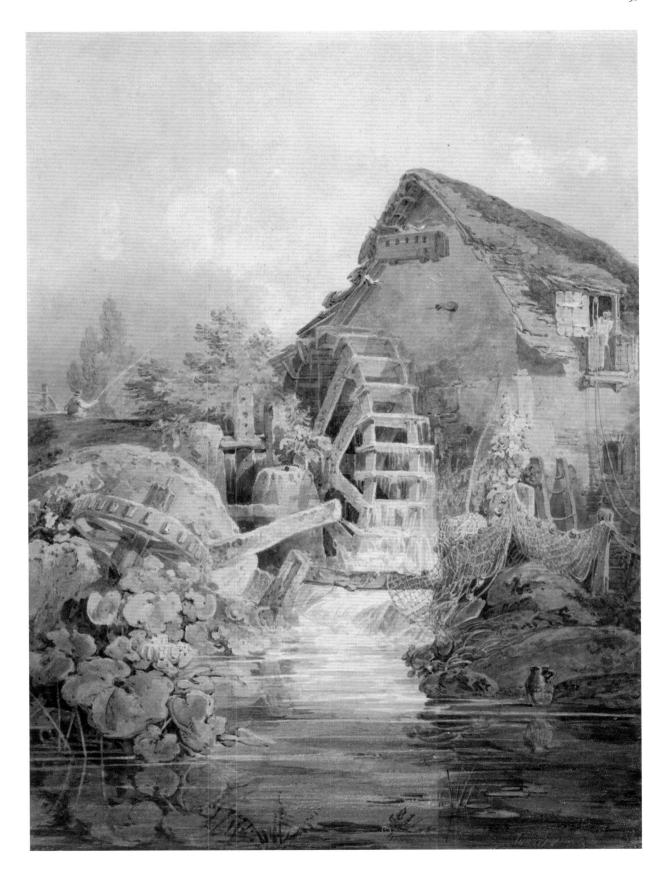

17

Joseph Mallord William
Turner (1775–1851)
*Transept of Ewenny Priory,
Glamorganshire*, ca. 1797

Watercolor with scratching
out and stopping out and
pencil on paper
15 ¹³⁄₁₆ × 21 ¹⁵⁄₁₆ in.
(40.1 × 55.7 cm)
Amgueddfa Cymru–
National Museum Wales
Bequeathed by James Pyke
Thompson, 1898
NMW A 1734
Norton and Frick

J. M. W. Turner has captured a powerful, atmospheric view of the south transept of Ewenny Priory in the Vale of Glamorgan. This exhibition watercolor is based on a drawing in a sketchbook made while Turner was touring south Wales in 1795 (Tate, London). Turner visited Wales five times in eight years during the 1790s, gathering material for future paintings and watercolors. The priory church of St. Michael, Ewenny was founded by William de Londres, Lord of Ogmore. It was built in about 1115–20 as a Benedictine foundation for a prior and ten to fifteen monks. The effigy of a knight on the tomb to the right of the work is probably that of Sir Paganus de Turberville of Coity, a twelfth-century benefactor of the priory.

When exhibited at the Royal Academy in 1797, this highly finished work marked Turner out as a pioneering talent in the medium of watercolor. One contemporary critic wrote, "In point of color and effect this is one of the grandest Drawings we have ever seen; and equal to the best Pictures of Rembrandt." The bold use of light and the exaggerated perspective show the influence of both Rembrandt and Giovanni Battista Piranesi. The way Turner manipulated the watercolor to create luminous effects may also show the influence of the Swiss artist Abraham-Louis-Rodolphe Ducros (1748–1810). Turner would have had the opportunity to see work by all these artists in the collection of the antiquarian and amateur artist Richard Colt Hoare (1758–1838) at Stourhead, Wiltshire, while staying there in 1795. —B.M.

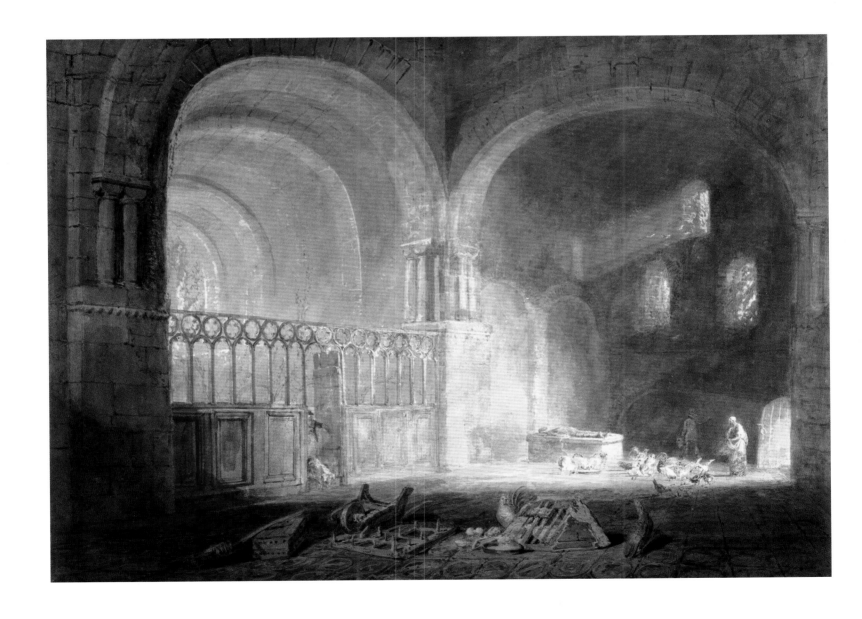

18

Joseph Mallord William
Turner (1775–1851)
*Llandeilo Bridge and
Dynevor Castle*, 1796

Watercolor on paper
13 ⅞ × 17 ¾ in.
(35.3 × 45.1 cm)
Amgueddfa Cymru–
National Museum Wales
Purchased, 1938
NMW A 1738
Utah and Princeton

A fine stone bridge, broken in the middle and repaired with a wooden causeway, separates the distant view of Dynevor Castle, on the hill to the right. In the foreground, women wash their clothes in the river. Like many of J. M. W. Turner's watercolors, this Romantic scene juxtaposes the past with the present and alludes to Turner's interest in Welsh history and legends. However, it also has another interest: the effect of light. The setting sun, dipping behind the hill, has its own poetic appeal. It bathes the scene in a rich, sumptuous glow and casts a dramatic diagonal shaft of light down the slope of the hill.

The watercolor was made during or shortly after Turner's tour of south Wales in 1795, and was exhibited at the Royal Academy in 1796. Turner's tour was well planned. He wrote out an itinerary and noted down recommendations from a guidebook. Starting from Bristol, England, he traveled through Newport and Cardiff to Swansea and Pembrokeshire in west Wales, and returned through the market towns of

Llandeilo and Llandovery to Brecon and Hereford. He took two sketchbooks of differing sizes with him, making sketches in the smaller one and more carefully worked drawings in the larger one. However, Turner did not make drawings in the sketchbooks on the return part of the journey, and there is not an "on-the-spot" study for this work.

During museum conservation treatment in 1993, a second watercolor of the same subject was discovered pasted face-up to the back of this work. The second sheet is far less finished, but it duplicates the main composition and uses broad, deep colors in the hill and foreground. It is unclear exactly why Turner stuck one image onto the other, but it may have been an experiment in luminosity and light reflection. It was perhaps his intention that the deep colors would be visible, adding a tonal richness and intensifying the brightness of the setting sun. Turner was continually experimenting with techniques to extend the possibilities of watercolor painting. —B.M.

19

Joseph Mallord William
Turner (1775–1851)
Source of the Arveiron,
probably 1803

Watercolor with scratching
out and stopping out and
pencil on paper
11 × 15 ⅝ in. (28 × 39.7 cm)
Amgueddfa Cymru–
National Museum Wales
Transferred from the Turner
House, 1921
NMW A 1750
Norton and Frick

J. M. W. Turner's early sketching tours were mainly around the British Isles. The Napoleonic wars with France had made travel to the Continent almost impossible since 1793. However, a short period of peace following the Treaty of Amiens in 1802 allowed Turner to make his first tour to the Continent. He spent three months traveling around France and Switzerland, and returned with a vast number of sketches. He cut out many of his best drawings from his sketchbooks, worked them up, and mounted them in a separate album charting the course of the tour.

Turner traveled through the Alps, some of the time climbing by foot. This work shows the River Arveyron, which emerges from a grotto-like vault (Grotte d'Arveyron) at the foot of the Glacier du Bois, below the Mer de Glace, near Chamonix in the Alps. The two small figures and a minute snake in the foreground indicate the awe-inspiring scale of the landscape. It is based on a drawing in Turner's

"St. Gothard and Mont Blanc" sketchbook (Tate, London) from his 1802 European tour.

Back in Britain, Turner received numerous commissions for images from this tour. This work was one of a number commissioned by Walter Fawkes (1769–1825), who went on to become Turner's great friend and patron. Between 1803 and 1819, Fawkes bought nineteen Alpine subjects. In 1803, Turner exhibited a work at the Royal Academy entitled *Glacier and Source of the Arveiron, Going Up to the Mer de Glace*. This has traditionally been identified as a watercolor at the Yale Center for British Art (*Mer de Glace, in the Valley of Chamouni, Switzerland*), but the art historian Eric Shanes has suggested that the exhibited work was in fact the present watercolor, dating it to 1803. Both works were owned by Fawkes and were exhibited together in 1819. Neither exactly matches the Royal Academy title or the titles of the works when they were shown in 1819. —B.M.

20

Joseph Mallord William
Turner (1775–1851)
*Rudesheim, Looking towards
the Binger Loch*, 1817

Watercolor and bodycolor
with scratching out on paper
prepared with gray wash
8 7/16 × 13 11/16 in.
(21.4 × 34.7 cm)
Amgueddfa Cymru–
National Museum Wales
Transferred from the Turner
House, 1921
NMW A 1754
Utah and Princeton

This work (along with cat. no. 21) is from a series
of fifty watercolors of scenes of the Rhineland that
J. M. W. Turner executed for his patron Walter Fawkes
immediately after a sketching tour in 1817. This was
Turner's first Continental tour following the Battle of
Waterloo in 1815. Turner consulted guidebooks
in preparation for the tour, including the illustrated
volume *Views Taken on and near the River Rhine,
at Aix la Chapelle, and on the River Maes* by the
Reverend John Gardnor (1729–1808), published
between 1788 and 1791. Gardnor had toured the Rhine
in 1787, and as well as exhibiting subsequent works at
the Royal Academy he published a set of aquatinted
views. Turner made extensive notes in one of his
sketchbooks of sites to visit and views to find.
Appreciation of the Rhineland had been developing
as a result of a growing interest in the sublime and the
picturesque. The landscape has all the required
elements—winding rivers, towering cliffs, castles, and
historical legends.

Turner has taken a low, broad viewpoint for this
watercolor. The art historian Cecilia Powell has
identified the exact location. The view is downstream
toward the start of the Rhine gorge with the town of
Rüdesheim in the distance, on the right, at the bottom
of the hill. The buildings of the town are reflected in
the river. In the center is the white tower known as the
Mäuseturm, the site of the legend of Bishop Hatto,
who was reputedly eaten by rats in the tenth century
as punishment for the way he treated his subjects. The
still water in the foreground is in sharp contrast to the
drama of the looming clouds in the expansive sky.
Turner has used extensive "scratching out" through-
out this work to create highlights. —B.M.

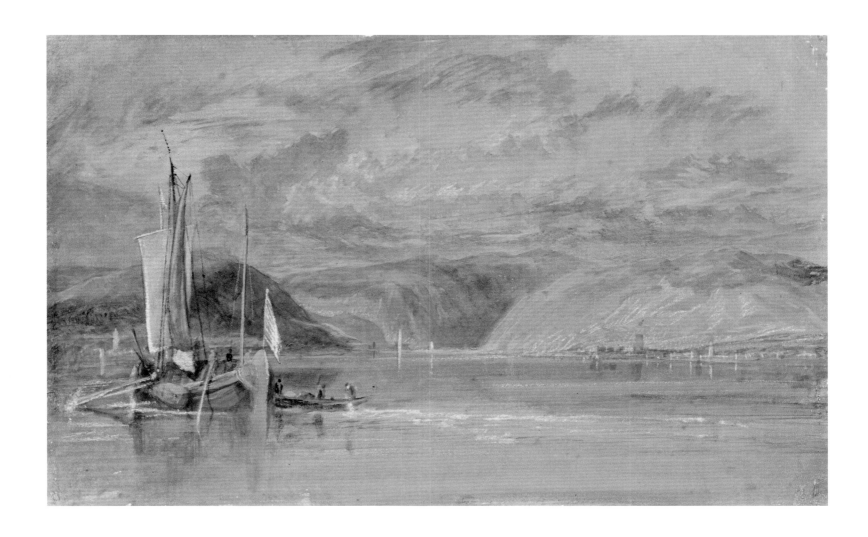

21

Joseph Mallord William
Turner (1775–1851)
*The Bishop's Palace,
Biebrich*, 1817

Watercolor and bodycolor
with scratching out on paper
prepared with gray wash
9 ¼ × 13 ¹¹⁄₁₆ in.
(23.4 × 34.7 cm)
Amgueddfa Cymru–
National Museum Wales
Transferred from the Turner
House, 1921
NMW A 1752
Norton and Frick

The conclusion of the Napoleonic wars in 1815 meant artists such as J. M. W. Turner could travel to the Continent for the first time since 1803. Turner was an insatiable traveler who made sketching tours almost every summer. In 1817, he traveled to the Continent on a tour that took him to Belgium, stopping off at the site of the recent Battle of Waterloo, the Rhineland, and Holland. Turner bought three sketchbooks of different sizes for the trip, which he filled with a huge number of pencil drawings (Tate, London). This work (together with cat. no. 20) is one of a series of watercolors from the Rhine sketches that Turner immediately set about creating on his return to Britain. Almost as soon as they were finished, Turner sold the entire series of fifty works to his patron Walter Fawkes for around £500.

Turner made further copies of some of the compositions for other patrons. There is a second version of this watercolor (British Museum, London), which was painted in 1820 and purchased by the Swinburne family, friends of Fawkes. Whereas the original watercolors are renowned for their immediacy and were once thought to have been produced "on-the-spot," the second versions are more elaborate and detailed than the first.

The sumptuous Biebrich palace, seen here in the distance on the right bank of the river, is a Baroque residence built in 1702 in the city of Wiesbaden, Germany, that was renowned for its vast and beautiful gardens. In the foreground, men work on a long wooden jetty projecting into the river, while a boat is being loaded on the left. In the distance, Turner has used the technique of "scratching out" to create the effect of the rising chimney smoke, which draws the eye to the vast, elaborate sky, to which Turner dedicated more than half the sheet of paper. —B.M.

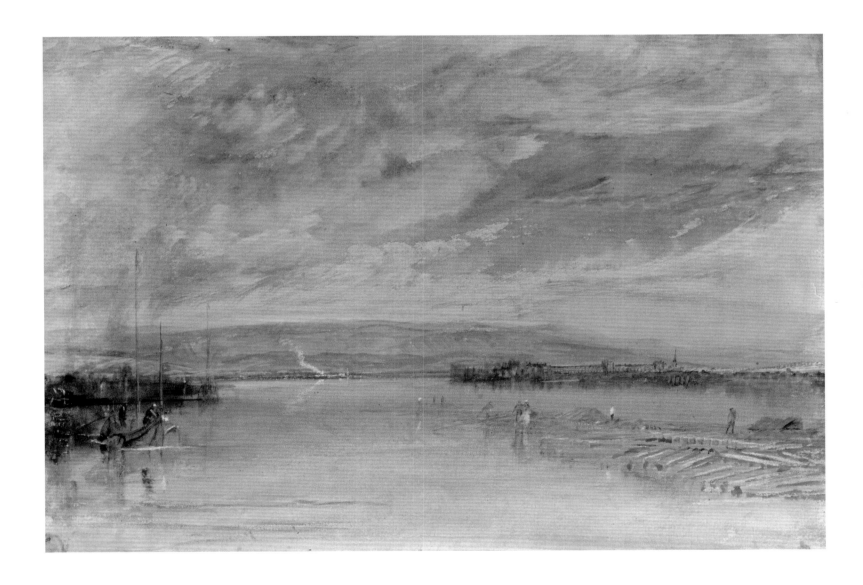

22

Joseph Mallord William
Turner (1775–1851)
Flint Castle, 1835

Watercolor with scratching
out and sponging out and
pencil on paper
10 ⅞ × 15 ¹³⁄₁₆ in.
(27.7 × 40.1 cm)
Accepted by H. M.
Government in lieu of
inheritance tax and
allocated to Amgueddfa
Cymru–National Museum
Wales, 1982
NMW A 1757
Utah and Princeton

This watercolor was owned by the influential writer and critic John Ruskin (1819–1900), who championed J. M. W. Turner's work. He wrote, "This is the loveliest piece of pure water-colour painting in my whole collection; nor do I know anything elsewhere that can compare, and little that can rival, the play of light on the sea surface and the infinite purity of playing colour in the ripples of it as they near the sand."

Turner, more than any other artist, transformed watercolor painting in Britain. He raised the status of the medium and expanded its technical possibilities. His great confidence in and mastery of the medium are particularly evident in the reflection of the setting sun, which has probably been achieved by using a wet sponge to reveal an underlying wash of pale orange. He has also used "scratching out," where he creates highlights by scraping the pigment to reveal the white paper below, probably using his sharpened thumbnail. The colors, tones, and composition combine to create a dreamlike, almost visionary scene.

The ruined medieval castle of Flint is seen in the background, a modern wreck juxtaposed in front of it. On the beach in the foreground a mother and her children approach a shrimper. Turner visited Flint while on tour in north Wales in 1794, 1798, and 1799. He probably relied on sketches from these visits, as well as his memory, for this work. His early sketching trips to Wales influenced his art throughout his career. The image was engraved by J. R. Kernot and published in the *Picturesque Views in England and Wales* series in 1836, Turner's longest and most ambitious watercolor engraving project. It is one of the finest images made for that series. —B.M.

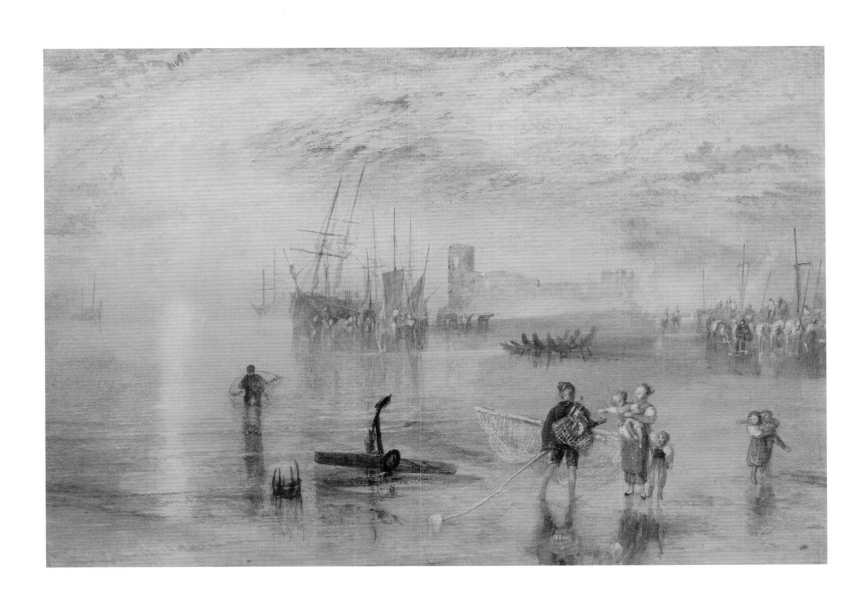

23

Joseph Mallord William
Turner (1775–1851)
The Storm, 1840–45

Oil on canvas
12 ¾ × 21 ⅛ in.
(32.5 × 53.8 cm)
Amgueddfa Cymru–
National Museum Wales
Bequeathed by Margaret
Davies, 1963
NMW A 509

The sea as subject matter ran through J. M. W. Turner's entire career, and in his later marine scenes he produced some intensely dramatic images that were the embodiment of the sublime. In *The Storm*, a stricken boat is engulfed by waves, its ropes flailing like tentacles. The sails, which have come adrift, can be seen to the left, while the masts and bow of a larger vessel are silhouetted against the skyline. A group of figures huddle together at the back of the broken vessel, or possibly in a separate boat. The overwhelming sensation is of a combination of spray, wind, and sea mist, through which only colors and vague forms are visible. The light source that emanates from the upper right of the canvas thus renders the sea in the lower left a deep, dark, terrifying green.

A label on the back of the work reads, "Said to have been painted by Turner during the Storm which raged on the day in which the Princess Royal was born, Nov 21 1840." This refers to the storm that broke out on November 13, 1840, and caused the loss of the vessel *Fairy* along with all hands. There is no evidence to support this association, though the subject would certainly have appealed to Turner, who may have heard of it from contemporary accounts. A companion piece to *The Storm*, *The Morning after the Storm* (not to be confused with *The Morning after the Wreck*, cat. no. 24), is also in the collection of National Museum Wales and shows figures trawling through debris on the beach, possibly at Margate, the seaside town on the south coast of England where Turner spent many of his later years. —B.D.

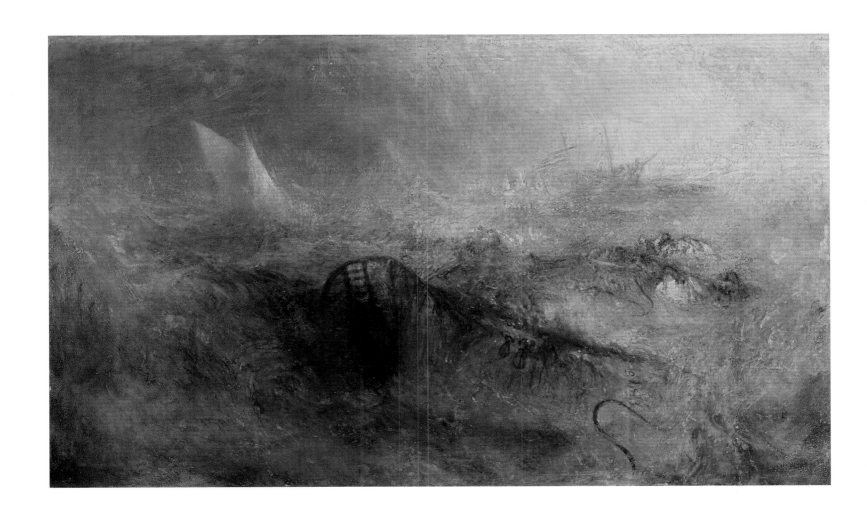

24

Joseph Mallord William
Turner (1775–1851)
The Morning after the Wreck,
ca. 1840

Oil on canvas
15 ¼ × 24 ⅜ in.
(38.7 × 61.8 cm)
Amgueddfa Cymru–
National Museum Wales
Bequeathed by Gwendoline
Davies, 1951
NMW A 436

From the 1830s on, J. M. W. Turner was a regular visitor to the seaside town of Margate in Kent, on the south coast of England, where he made numerous depictions of the view outside the window of his lodgings, the scene on which this painting is most probably based. It was given to his landlady and mistress, Sophia Booth, and was later sold at Christie's as *Off Margate, A Hazy Morning*, which may have then led to the current titling. However, recent scholarship suggests that the light source to the west shows that this work is in fact an evening scene, not a morning one as traditionally thought.

It is unlikely that *The Morning after the Wreck* depicts an actual event, and Turner scholars have suggested that it is more likely an amalgam of his lifetime's experience of seashore activity. The work shows the foreshore view of the beach at Margate, on which indistinct figures huddle together,

picking over the debris that litters the sand. Turner's watercolor-like treatment of oil paint is particularly in evidence here, in the fading suggestion of a harbor wall to the far left of the canvas and in the shadowy form of the central ship, which, like his *Fighting Temeraire* of 1839 signals the end of an era. The suggestion that this scene is in fact that of sunset and an ending, rather than the historically assumed sunrise, does indeed fit more coherently with this inference.

Although this painting chimes visually with other views of Margate and includes a hint of a harbor like the one there, the location cannot be precisely identified. Ian Warrell has noted that although the canvas size Turner used for this work was convenient for *plein air* sketching, the image itself is more of an "evocative meditation," most likely developed in the studio. —B.D.

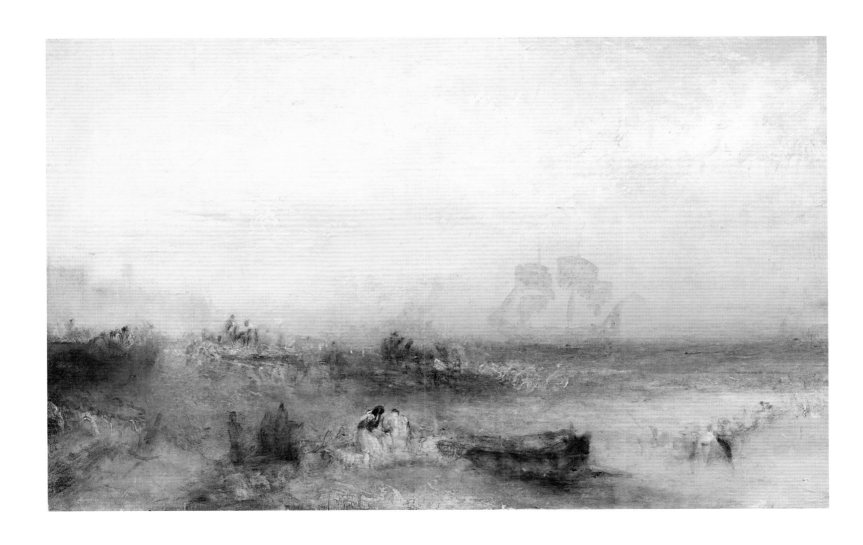

25, 26

25
Henry Clarence Whaite
(1828–1912)
The Shepherd's Dream,
1865 and later

Oil on canvas
40 ³⁄₁₆ × 26 ¹⁄₁₆ in.
(102 × 66.2 cm)
Amgueddfa Cymru–
National Museum Wales
Purchased, 2001
NMW A 19777

26
Henry Clarence Whaite
(1828–1912)
The Storm, 1865 and later

Oil on canvas
28 ⅛ × 9 in. (71.4 × 22.8 cm)
Amgueddfa Cymru–
National Museum Wales
Purchased, 2001
NMW A 19779

These are two of four surviving parts of a large narrative painting called *The Penitent's Vision* (see below), begun in 1862 and set, like much of Henry Clarence Whaite's work, in the landscape of the Conwy Valley in north Wales. During the later 1850s, the Manchester-born Whaite was on the periphery of the Pre-Raphaelite circle. He enjoyed some success, and the critic John Ruskin praised his painting *The Barley Harvest*, which was exhibited at the Royal Academy in 1859 ("perhaps…the most covetable piece of landscape of this year…" [Ruskin 1903–12, 14:229–30]). He had work shown at the academy in 1860 and 1861, and his large landscape *The Rainbow* (now Nottingham Castle Museum) was enthusiastically received in 1862.

The development and iconography of *The Penitent's Vision* is complex, as Whaite reworked it early in 1865, following his mother's death, on a theme from *The Pilgrim's Progress.* He wrote, "What a sublime subject for a picture—A Christian entering the Gates of Paradise—but how overwhelming the thought of it…have been trying today to suggest

the gate of heaven for Christian to enter" (diary, February 14, 1865; see Lord 1998, 86).

It combined truth to observed nature with overt Christian mysticism, a combination that contemporaries found hard to accept. The *Manchester Examiner and Times* praised the landscape element, but commented: "Seraphic processions may occasionally sweep over Welsh hills and dales, but ordinary imaginations will find some little difficulty in accepting the idea. Now-a-days people prefer landscape pure and simple.…"

The Penitent's Vision was Whaite's first professional failure, as it was rejected by the Royal Academy in 1865. He appears to have cut it up in 1883, and made a number of alterations to its four constituent parts. *The Shepherd's Dream*, into which he introduced the figure of the sleeping shepherd to provide a focal point, and *The Awakening of Christian*, which depicts Christ (the Shining One) freeing Christian from the net cast by the false prophet, were from the left of the original canvas; *The Storm* and *The Owl* were originally the upper and lower sections of the right-hand side. The first two were shown at the Royal Academy in 1884. —O.F.

Henry Clarence Whaite (1828–1912).
The Penitent's Vision, 1862–65.
Oil on canvas. Photograph ca. 1865,
7 ⁶⁄₁₆ × 11 in. (18.7 × 27.9 cm).
Amgueddfa Cymru–National Museum
Wales, NMW A 22522

25

26

27

Edward Lear (1812–1888)
Kinchinjunga from Darjeeling, 1877

Oil on canvas
46 × 68 ½ in. (117 × 178 cm)
Amgueddfa Cymru–
National Museum Wales
Purchased with the assistance
of the Art Fund, 2006
NMW A 28349

Kanchenjunga is the world's third highest peak, with an elevation of 28,169 feet. It is situated in the eastern Himalayas on the border between Sikkim and Nepal, 46 miles north-northwest of Darjeeling (now Darjiling). In the spirit of the sublime, Edward Lear's painting seeks to evoke both admiration and terror. Range upon range of snowy peaks contrast with the lush vegetation of the narrow valley in the foreground.

Lear is best known today as the author of nonsense verse, including *The Owl and the Pussycat* (1867), but he was an outstanding painter of landscapes, particularly of out-of-the-way places. Before leaving Britain for India in 1873, Lear had been commissioned by Henry Bruce (1815–1895), Lord Aberdare, to paint an Indian scene of his choice. Arriving in Darjeeling in January 1874, he decided that Kanchenjunga should be his subject.

However, he found the vast scale of his subject daunting: "Kinchinjunga is not—so it seems to me—a sympathetic mountain; it is so far off, so very god-like & stupendous, & all that great world of dark opal valleys full of misty, hardly to be imagined forms, besides the all but impossibility of expressing the whole as a scene—make up a rather distracting and repelling whole" (diary, January 18, 1874; Noakes 1985, 155).

Lear wrote to Aberdare in September 1875, "I intend that the 'Kinchinjunga' shall be so good a picture that nobody will ever be able,—if it hung in your Dining room—to eat any dinner along of contemplating it—so that the painting will not only be a desirable but a highly economical object." It was dispatched in May 1877, and Lear wrote to Lady Aberdare in August, "I hope you will kindly write me a line…to tell me how you like it. All I beg of you particularly is this,—that if it stands on the ground, you will put up a railing to prevent the children… falling over the edge into the Abyss" (Dehija and Staley 1989, 31). —O.F.

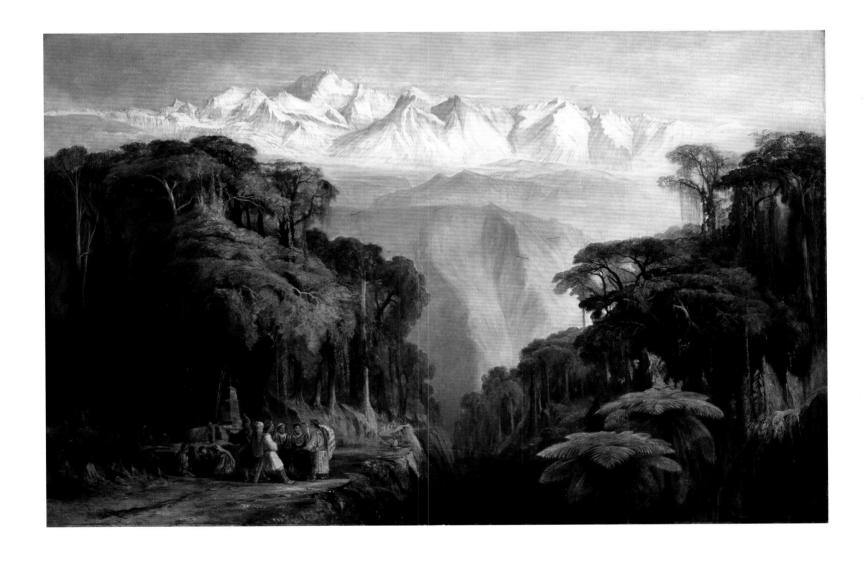

Truth to Nature

28

Hendrik Danckerts
(ca. 1625–1680)
Caerphilly Castle, ca. 1670

Ink and wash on paper
11 × 16 ⅞ in. (28 × 43 cm)
Amgueddfa Cymru–
National Museum Wales
Purchased, 2010
NMW A 29603
Norton and Frick

Caerphilly Castle was built beginning in 1268 for Gilbert de Clare, Earl of Gloucester and Lord of Glamorgan, to secure the northern flank of his lordship in the face of the growing power of the Welsh prince Llewelyn ap Gruffydd ("Llewelyn the Last"). Following Edward I's conquest of Wales and Llewelyn's death in 1282, Caerphilly lost its original purpose and fell into decay. After Windsor, it is the largest castle in Britain, and was defended by concentric walls within a series of artificial lakes. This view was taken from the southeast, with Caerphilly's celebrated leaning tower on the right. On the back of the sheet is a drawing of the North Dam and Gatehouse (see below). Together the two drawings match up to make a panoramic view of the castle and the surrounding countryside.

Hendrik Danckerts was born into a family of Dutch Catholic artists, probably in The Hague, and was in Italy with his brother Jan from 1653 to 1657. He had settled in London by the autumn of 1664. Danckerts had trained as an engraver, but he soon established himself as a successful painter in oils of topographical and idyllic landscapes. He received many commissions while in Britain. His most important patron was King Charles II who, from 1665 to 1667, commissioned some large classical landscapes and a view of the recently completed canal works at Hampton Court. These were followed by a series of paintings of the palaces and fortresses of his realm. Danckerts also undertook work for many of the nobility and gentry, and made a visit to south Wales in about 1670. He clearly examined the ruins of Caerphilly in some detail, as two further drawings are in the Yale Center for British Art; he is not known to have produced any oil painting on the subject, however. —O.F.

Drawing of the North Dam
and Gatehouse on the verso
of *Caerphilly Castle*

29

Francis Place (1647–1728)
Tenby, 1678

Ink on paper
3 ⅝ × 12 ⅝ in. (9.2 × 32.1 cm)
Amgueddfa Cymru–
National Museum Wales
Purchased, 1931
NMW A 3354
Utah and Princeton

Tenby (in Welsh Dinbych-y-pysgod, "the little town of the fishes") is a seaside town in Pembrokeshire in southwest Wales. Its castle sits prominently on a headland overlooking the beach and causeway that lead to St. Catherine's Island opposite. Francis Place's panoramic view depicts the neglected walls of the castle and its square tower, which has since collapsed. On top of the island on the right are the medieval ruins of St. Catherine's Chapel, which were replaced by a large fort in the nineteenth century. On the beach, incidental figures lend scale to the landscape.

Purely documentary, the drawing is remarkably free of historical narrative. While in the eighteenth and nineteenth centuries Tenby became a destination for seaside leisure, in the seventeenth century it was not so amenable. Tenby Castle had been held by the Parliamentarians for most of the Civil Wars (1642–51). In 1648, it was occupied by a unit of Royalist rebels for ten weeks before they were starved into submission. Since then, outbreaks of the bubonic plague had decimated the town's population and its economy.

We know from Place's correspondence of the period that this sketch, and others from the same sketchbook, were carried out on a tour of Wales and the southwest of England in 1678. For Place and his companion William Lodge, who were essentially gentleman tourists, the expedition along the south Wales coast in 1678 was not without risk. The pair was even jailed for a night on suspicion of being Jesuit spies amid the anti-Catholic hysteria of the Popish Plots.

Supported by his father's wealth, Place traveled extensively in Britain to pursue his passions for sketching and angling. Perhaps due to his drawings being executed for intellectual rather than commercial purposes, they demonstrate a delicately informal and fluid technique. Like the sketch of *Caerphilly Castle* by his contemporary Hendrik Danckerts (cat. no. 28), Place's drawings are finely detailed topographical panoramas that extend seamlessly over several pages of a sketchbook. He was very much influenced by master printmaker and London topographer Wenceslaus Hollar, who was an early friend and mentor. —A.P.

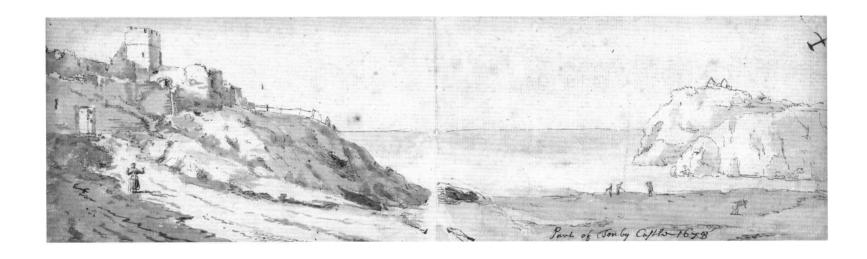

Part of Tenby Castle 1678

30

Richard Wilson
(1713/14–1782)
Dover Castle, ca. 1746–47

Oil on canvas
35 ⅝ × 46 in.
(90.5 × 116.8 cm)
Amgueddfa Cymru–
National Museum Wales
Purchased with the support
of subscribers, 1928
NMW A 66

The view is across the roofs of the port town of Dover, in Kent, looking east toward the castle perched high on the celebrated white cliffs. Dover Castle, one of the largest in Britain, had been rebuilt in the 1180s, when King Henry II added the massive keep and a series of concentric walls. It guards the shortest crossing point to mainland Europe, and over the centuries the defenses were enlarged and improved. It was therefore still in use in Richard Wilson's day—new barracks had just been built within its walls—and it retained a military role into the mid-twentieth century.

Wilson painted three similar views of Dover in about 1746 (one now in the Yale Center for British Art), probably following a commission from Lionel Sackville, 1st Duke of Dorset (1688–1765) and constable of Dover Castle, as a print after it, dated April 1747, is dedicated to the duke. The composition is strikingly original. Rather than contriving a conventional bird's-eye view, Wilson painted a panoramic scene that centers on the distant castle with its flag-topped keep under a great expanse of sky. Full of dramatic contrasts of light and shade, the work suggests a familiarity with seventeenth-century Dutch painting, especially the townscapes of Jacob Ruisdael, and with contemporary Italian views of the Bay of Naples. A single tiny ship under sail emphasizes the expanse and emptiness of the sea.

The artist himself is seated painting at the lower left, implying the picture was executed from nature. The foreground figures of genteel tourists and laboring quarrymen, and incidental details such as rustic fencing and washing on a line, may reflect the influence of Canaletto, who had arrived in London in May 1746. He was to stay in England for nearly a decade, his presence helping to raise the status of landscape painting there. Wilson, meanwhile, was to travel to Italy in 1750, returning as an erudite landscape painter in the Grand Manner. —O.F.

31

Thomas Jones (1742–1803)
A View in Radnorshire,
ca. 1776

Oil on paper
9 × 12 ⅝ in. (22.8 × 32.1 cm)
Amgueddfa Cymru–
National Museum Wales
Purchased, 1954
NMW A 86

This beautifully fresh image of clouds scudding across the hillscape of mid-Wales probably dates from 1776. This was the year of Thomas Jones's departure for Italy, where he produced the strikingly modern oil sketches around Naples and Rome for which he is perhaps best known (see cat. no. 32). *A View in Radnorshire* is much in the same style, but painted rather closer to home, in the landscape around Pencerrig, the estate owned by the artist's family on the Wales–England border. Jones was a pupil of Richard Wilson, from whom he learned the Grand Manner of landscape composition in the tradition of Poussin and Claude. However, when freed from the constraints of painting to please the public through the stylized drama of works such as *The Bard* (cat. no. 5), these private studies allowed him to exercise a more instinctive, personal engagement with nature.

Jones was painting oil sketches outdoors as early as 1772. This technique was revolutionary by the standards of the day, when almost all oil painting was carried out indoors, from studies. Jones's are among the earliest British examples of this type of *plein air* oil sketch, and many, such as this, were executed on a low-grade brown wrapping paper, which would have been far more manageable than working directly on canvas. While the prominent whaleback ridge of the Carneddau hills can be seen in this image, the sketch is essentially an exercise in atmospheric nuance. The sky accounts for almost three-quarters of the picture, seeping downward into the landscape through the shadows cast by the clouds that gather across the quiet terrain. Jones's sketches of this type have a naturalistic directness and a modernity that looks forward to the nineteenth-century French *plein air* painting of Corot and the Barbizon School. —B.D.

32

Thomas Jones (1742–1803)
Buildings in Naples, 1782

Oil on paper
5 ⁹⁄₁₆ × 8 ½ in.
(14.2 × 21.6 cm)
Amgueddfa Cymru–
National Museum Wales
Purchased, 1954
NMW A 89

This compelling view was painted from the roof terrace of Thomas Jones's lodgings opposite the Dogana del Sale in Naples. It shows a rooftop view of the city, but the painting is dominated by the humble Neapolitan house opposite—the real subject of this work. The artist has captured in minute detail the texture of the crumbling wall, the half-shuttered windows, and the doorway, all bathed in sunlight. This is one of a number of oil sketches that surfaced on the art market in 1954 and completely changed Jones's reputation. The sketches are characterized by their humble subjects and compositional cropping, which give them a startlingly modern appearance. These works show the artist painting his daily surroundings. Not meant for exhibition or sale, they were personal works, made for his own enjoyment. Today they are prized as some of the most innovative pictures of their time.

Jones had been a pupil in the studio of Richard Wilson. Here he learned the Grand Manner of landscape composition, which he adopted in his own larger landscape paintings, such as *The Bard* (cat. no. 5). Like his teacher Wilson, Jones was drawn to Italy, and set off in October 1776. He wrote that it was "a favourite project that had been in agitation for some Years, and on which my heart was fixed" (Jones 1951, 37). He stayed in Rome and Naples, returning home in 1783. The collection of National Museum Wales also has a sketchbook full of meticulous pencil studies from his time in Italy. While he made a living from selling large, carefully composed landscape canvases, it is the small oil studies that are Jones's best-known artistic legacy. —B.M.

33

John Constable (1776–1837)
A Cottage in a Cornfield, 1817

Oil on canvas
12 ⅜ × 10 ¼ in.
(31.5 × 26.3 cm)
Amgueddfa Cymru–
National Museum Wales
Purchased with the assistance
of the Art Fund, 1978
NMW A 486

John Constable's spontaneous technique has established him as one of the most celebrated landscape painters of the nineteenth century, rivaled only by his contemporary J. M. W. Turner. Constable's later influence has been so great that his way of depicting the English countryside now seems commonplace. At the time, though, his detailed portrayal of nature and skillful use of color were completely original, and he often struggled to find a market in Britain for his work. During the 1820s, he also exhibited in France, where his effects of light and atmosphere were more enthusiastically received.

The subject of this small painting is a Suffolk cottage in a field that he had often passed as a boy on his way from his father's house in East Bergholt to school in Dedham. It is high summer, with the wheat ripening and meadow flowers in bloom behind the gate into the field. In 1815, Constable was still struggling to find an original manner of painting his native scenery, but he was just beginning to attract the attention of critics, who characterized his work as "natural," "fresh," and "truthful." However, rural life was hard in Suffolk, and the painting conveys a sense of isolation—almost of neglect—and of the passage of time.

Despite its naturalism, the evolution of this image was surprisingly complex. Constable drew the scene in the summer of 1815, and began an oil painting twice the size of this one. He had trouble with the tree on the right, and abandoned the larger painting (Victoria and Albert Museum, London), returning to it only in 1833. When he painted this smaller version, which was exhibited at the Royal Academy in 1817, he made many minor changes that produced a tidier, more formal composition. While its small size might suggest that he worked on it outdoors, the problematic tree was replaced by a quite different one, apparently taken from a favorite engraving after Titian, and he probably painted it in his London studio. —O.F.

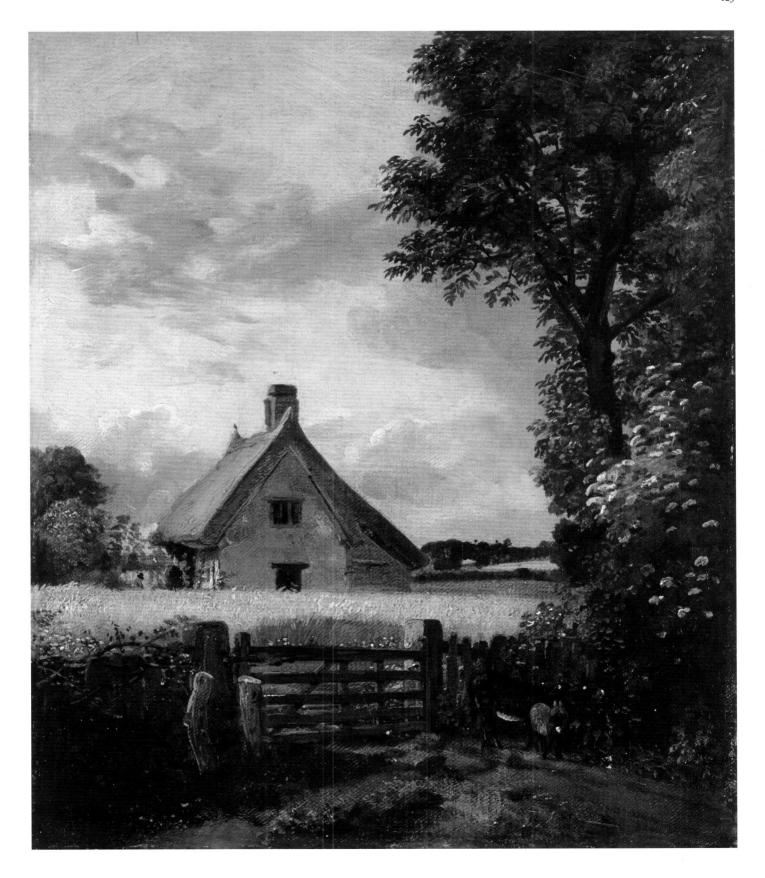

34

Ford Madox Brown
(1821–1893)
*View from Shorn Ridgway,
Kent*, 1849

Oil on canvas
8 ¼ × 12 ³⁄₁₆ in. (21 × 31 cm)
Amgueddfa Cymru–
National Museum Wales
Given by Sylvia Crawshay,
1990
NMW A 363

This bucolic landscape scene depicts Shorn Ridgway in Kent, the British county known as "the garden of England," and is a study for the background landscape in Ford Madox Brown's ambitious painting *Chaucer at the Court of Edward III*, painted between 1845 and 1851 (Art Gallery of New South Wales, Sydney). Although not an official member, Brown was closely associated with the Pre-Raphaelite Brotherhood and adopted the aesthetic of "truth to nature," one of the group's core tenets, in addition to their interest in literary and historical subjects.

Brown's original plans for *Chaucer* had been for an image set "amid air and sunshine." He described the painting as "the first in which I had endeavoured to carry out the notion, long before conceived, of treating light and shade absolutely, as it exists at any one moment, instead of approximately, or in generalised style" (Treuherz 2011, 132). The scale and subject matter of *Chaucer* rendered this overarching vision unachievable, but Brown was able to at least partially fulfill his aim by painting the background landscape directly from nature. Brown would have known the location from visiting his daughter at school in Gravesend, and he saw it as ideal for his depiction of old England.

"Truth to nature" turned out to be not quite so straightforward—*View from Shorn Ridgway* eventually appeared in *Chaucer* in reverse, to accommodate the formal requirements of the scene. Brown also added in a medieval sower and plowman to lend further historical detail. *View from Shorn Ridgway* would have been finished in the studio, and it has been suggested that the figures at the foreground left were probably added in 1873 to increase the painting's commercial appeal. This revised composition recalls Brown's famous *An English Autumn Afternoon, Hampstead—Scenery in 1853*, in the unusually high perspective of the artist, hovering above the backs of the figures who sit and survey their own expansive view of the landscape. —B.D.

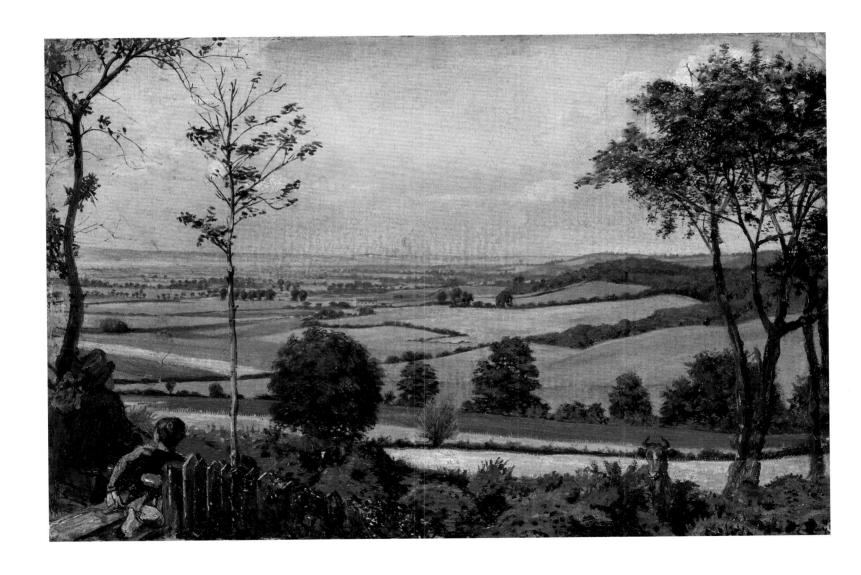

35

William Dyce (1806–1864)
*Welsh Landscape with Two
Women Knitting*, 1860

Oil on board
13 ½ × 19 ½ in.
(34.3 × 49.5 cm)
Amgueddfa Cymru–
National Museum Wales
Purchased with the
assistance of the National
Heritage Memorial Fund,
the Art Fund, the estate of
Alan Thomas, and other
donors, 2010
NMW A 29527

William Dyce was one of the busiest and most influential British painters of his day. He was an important supporter of the Pre-Raphaelites' ambition to revive English art through a sincere truth to nature, and it was Dyce who first introduced the critic John Ruskin to their work.

In the autumn of 1860, Dyce and his family stayed for six weeks at a hotel in Llanrwst in the Conwy Valley. He was fascinated by the geology of Snowdonia, recording that:

The mountains are generally more rugged, stony and precipitous, more awful and more terrible looking than anything I know of in Scotland.… [I]n Wales, the material being slate rock, it does not crumble like granite…but splits and tumbles down in huge flakes which leaves the peaks…as sharp and angular as if they had never been acted upon by the atmosphere at all. (Letter to R. D. Cray, October 20, 1860; Pointon 1979, 173)

This picture, which was painted on his return to London and draws on his sketches, was calculated to appeal to the mid-Victorian market. Dyce wrote to Cray of his holiday, "I have got some materials which I hope to turn to good account…these trips for a change of air always pay," and added, referring to *Pegwell Bay* (Tate, London), his best-known work, "I made £400 from my trip to Ramsgate two years ago…and I hope to make an equally good thing out of the Welsh excursion."

The painting is a romanticized Victorian view of "wild Wales" and its "unspoiled" people. The younger woman is dressed in the recently revived Welsh national costume, which in reality was only worn on special occasions. Both women are knitting stockings from scavenged scraps of wool, even though this was an occupation for the home that had largely disappeared in the face of mechanization by 1860. The work is full of contrived contrasts—between age and youth, and between transitory humans and ancient geological formations—while the sickle moon suggests the cyclical progression of the universe. —O.F.

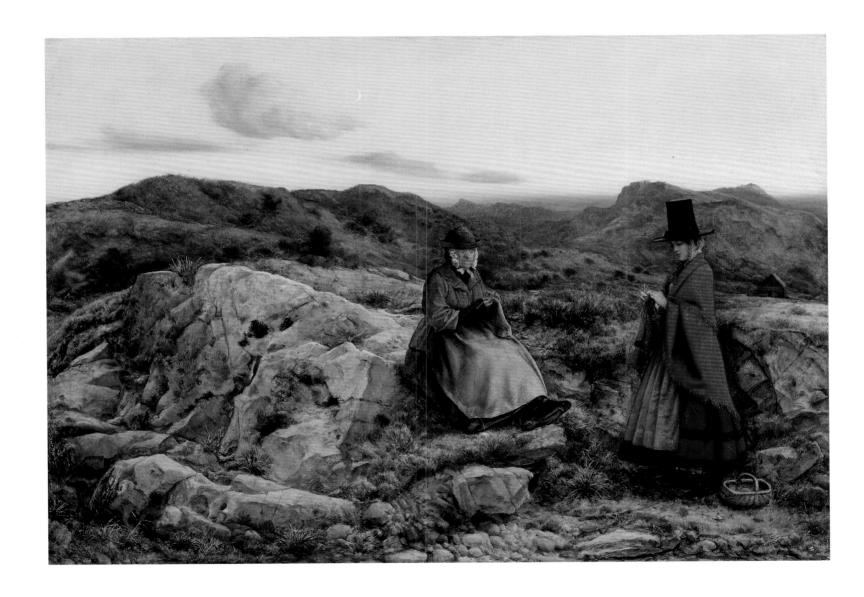

36

John Brett (1830–1902)
*Forest Cove,
Cardigan Bay*, 1883

Oil on canvas
15 ³⁄₁₆ × 30 ⅛ in.
(38.5 × 76.5 cm)
Amgueddfa Cymru–
National Museum Wales
Purchased, 1985
NMW A 182

John Brett first visited Wales in 1866, and over the course of forty years he produced as many as two hundred views of the Welsh land- and seascape. He had read John Ruskin's pamphlet on Pre-Raphaelitism in 1852 calling for "truth to nature" in art and felt it contained much "earnest, sound, healthy truth." Like William Holman Hunt, Brett pursued a scientific rendering of nature, and in the late 1850s he painted two significant Pre-Raphaelite works—*The Stonebreaker* (1858) and *Val d'Aosta* (1859)—both brimming with geological detail. From the late 1860s on, Brett focused almost exclusively on marine scenes, painted with the same keen eye for the natural world.

Forest Cove, now known as Aberfforest, lies to the east of Dinas Head, the rocky peninsula at the end of Fishguard Bay on the west coast of Wales, where the Brett family spent a happy holiday in 1882. Based on sketches made on the spot, this painting was most likely produced in Brett's London studio the following year; his studio logbook indicates that this was the first of six pictures commissioned in 1882 by Dr. Watt Black, a Scottish surgeon and keen patron of the artist.

Brett favored the double-square-format canvas used in this work, believing that "all paintable phenomena in nature occur within an angle of about 15 degrees above and below the horizon." The panoramic effect afforded by such a format was ideal for marine painting. His distinctive use of color has a startling luminosity, achieved by adding a coat of white priming to the existing white ground of commercially prepared canvases. This was a technique also used in the works of Holman Hunt and Ford Madox Brown. For the Pre-Raphaelite artist, the clarity of detail, color, and light enabled by this technique allowed for a truer representation of the natural world. —B.D.

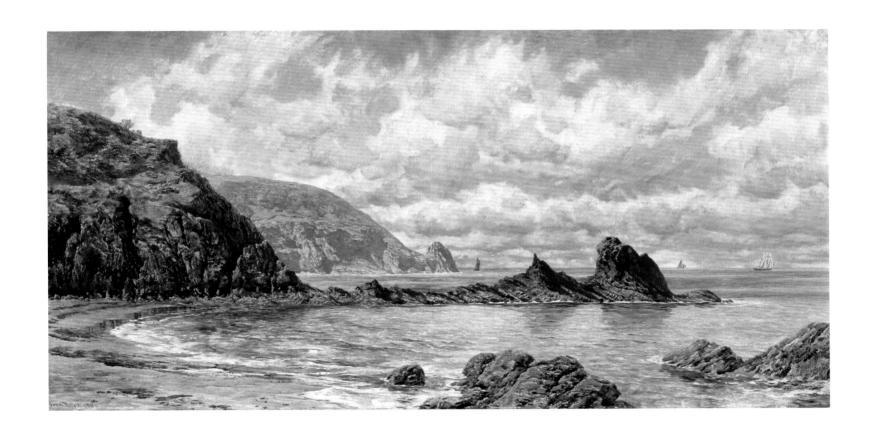

37–40

The Reverend Calvert Richard Jones was an early practitioner of photography, credited with taking the first photographic print in Wales. He was born into a wealthy family in Swansea, and was a friend and collaborator of both John Dillwyn Llewelyn (cat. nos. 41–45) and the pioneer William Henry Fox Talbot (1800–1877). He was a frequent visitor to Fox Talbot's home at Lacock Abbey in Wiltshire, where he learned the calotype or talbotype process—the process for making paper negatives invented and patented by Fox Talbot in 1839.

Both the possibilities and the questions raised by the brave new world of photography are reflected somehow in these four images, particularly *Study of Two Gentlemen in Front of Heathfield*, Jones's own house on the edge of Swansea, which has a wonderfully experimental quality. Although Calvert Jones has positioned the figures to look as deceptively casual as possible, their appearance could not be further away from two gentlemen taking a spontaneous rest against a fence. The work delightfully articulates a certain tension between the two opposing claims of photography in the nineteenth century: the idea of a highly constructed art form to rival painting, and the immediacy of a casual snapshot of a particular moment.

The remaining three images show Jones experimenting with "traditional" landscape subjects. The sharp, static detail of *Brecon Castle and Bridge* is given texture and dynamism by the fast-flowing river, which cannot be captured by the new technology. The image is dominated by the romantic ruin of the Great Hall of Brecon Castle, which overlooks the bridge over the River Honddu as it joins the River Usk. Just to the left is the Brecon Castle Hotel, one of the premier hotels in the town. Calvert Jones was in Brecon in September 1846 visiting his wife's aunt. He took over forty views, and it is possible that this photograph was taken then. *Three Canals, Brecon*, conversely shows with what clarity the camera could represent light and reflection on water. Jones's clever composition splits the image at the water line, creating a mirror image—it is, essentially, a reflection within a reflection. Using traditional landscape composition, *Ilfracombe Church* is constructed around the road that snakes through the image. However, the modernity of the photographic medium is reflected in what appear to be lampposts lining the road, contrasting with the ramshackle cottage and ancient architecture of the church. —B.D.

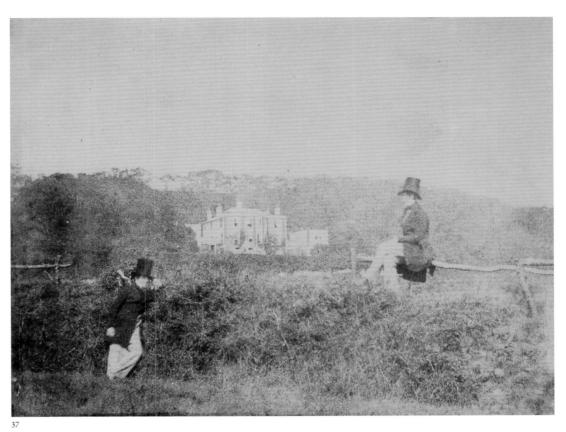

37

38

39
Calvert Richard Jones
(1804–1877)
Brecon Castle and Bridge,
ca. 1846

Salted paper print from
calotype negative
6 ⅛ × 7 ½ in.
(15.6 × 19.1 cm)
Amgueddfa Cymru–
National Museum Wales
80.91/356
Utah

40
Calvert Richard Jones
(1804–1877)
Ilfracombe Church, 1846–47

Salted paper print from
calotype negative
6 ⁹⁄₁₆ × 8 ⅜ in.
(16.7 × 21.3 cm)
Amgueddfa Cymru–
National Museum Wales
80.91/149
Princeton

39

40

41–45

41
John Dillwyn Llewelyn
(1810–1882)
In Three Cliffs Bay, 1854

Salted paper print from
collodion glass negative
8 ⅞ × 7 ¾ in. (22.5 × 19.7 cm)
Amgueddfa Cymru–
National Museum Wales
80.91/68
Norton

42
John Dillwyn Llewelyn
(1810–1882)
The Owl's Oak, Penllergare,
ca. 1854

Albumenized salted paper
print from calotype paper
negative
11 ¼ × 15 in. (28.7 × 38.1 cm)
Amgueddfa Cymru–
National Museum Wales
80.91/54
Frick

John Dillwyn was born at The Willows, Swansea, in January 1810. In 1817, his family moved to the nearby estate of Penllergare (which he inherited at the age of twenty-one, taking the surname Llewelyn). It was at Penllergare that Llewelyn was to produce many of his photographs in the 1850s. In 1833, he married Emma Thomasina Talbot, a cousin of the pioneer photographer William Henry Fox Talbot.

Llewelyn was extremely interested in science, botany, and astronomy, and constructed both an orchid house and an observatory on the grounds at Penllergare. It seems quite natural then, with his interest in science and his family connection to Fox Talbot, that he took up photography almost from its inception. A founding member of the Photographic Society of London, he exhibited regularly in their early exhibitions.

He was especially talented at capturing fleeting phenomena, such as waves, cloud movement, and steam. The invention of the collodion process in 1851 and his use of a shutter on his lens allowed for far more rapid exposures. At the Paris exhibition in 1855, he was awarded a silver medal for his "Motion" series, which included a photograph of breaking waves in Caswell Bay, Gower. In 1856, he invented the Oxymel process, a development of the collodion process that used a solution of acetic acid, water, and honey to preserve images. This meant that glass negatives could be prepared in advance and exposed in the camera as

required. Landscape photographers could finally do away with the need for portable laboratories and darkroom tents.

Other family members seem to have shared his enthusiasm for photography. Both his wife and his daughter Thereza helped in the processing of photographs, and Thereza became an accomplished photographer in her own right.

All the images in this exhibition are of places Llewelyn knew well. Three Cliffs Bay on the south Gower coast is a short distance from Caswell Bay, where the family had a seaside house. That photograph contrasts the smooth water and sand with the surrounding rough rocks, while a solitary female figure stands at the side of the composition and gives scale. Llewelyn photographed the ancient oak on the Penllergare estate known as the Owl's Oak many times. As a keen botanist, he had carefully managed and planted up the woodlands there. This photograph is signed and was exhibited at the Photographic Society Exhibition of 1854. He also made a number of photographs of the two lakes he constructed at Penllergare from 1839. In a carefully staged photograph of the Upper Lake he has placed an umbrella, deck chair, and basket on the path, and shows the old stone steps and bridge at the farthest end of the lake. The view of the rapids over the River Dulais was taken on or near Llewelyn's Ynysygerwn estate a few miles away in the scenic Vale of Neath. —M.E.

41

42

43
John Dillwyn Llewelyn
(1810–1882)
*The End of the Upper Lake,
Penllergare*, ca. 1852

Salted paper print from
calotype paper negative
9 ⁵⁄₁₆ × 11 ¹¹⁄₁₆ in.
(23.6 × 29.7 cm)
Amgueddfa Cymru–
National Museum Wales
80.91/10
Utah

43

44
John Dillwyn Llewelyn
(1810–1882)
Caswell Bay, ca. 1854

Albumenized salted paper
print from calotype paper
negative
11 ³⁄₁₆ × 14 ¹⁵⁄₁₆ in.
(28.4 × 38 cm)
Amgueddfa Cymru–
National Museum Wales
80.91/45
Princeton

45
John Dillwyn Llewelyn
(1810–1882)
*Rapids on the Dulais—
Neath Valley,
Glamorganshire*, ca. 1852

Salted paper print from
calotype paper negative
11 ⅛ × 15 ¹⁄₁₆ in.
(28.3 × 38.2 cm)
Amgueddfa Cymru–
National Museum Wales
80.91/522
Princeton

44

45

46–48

46
Roger Fenton (1819–1869)
Melrose Abbey, South Transept, 1856

Salted paper print from collodion glass negative
16 11/16 × 14 1/4 in.
(42.3 × 36.2 cm)
Amgueddfa Cymru–
National Museum Wales
NMW A 1831
Norton

Although the photographic career of Roger Fenton lasted for only twelve years, he is acknowledged as one of the most important photographers of the nineteenth century. Originally trained in Paris as a painter, in 1851 he abandoned his brush and began to experiment with the newly invented process of photography, developing it as an art form through a fusion of the scientific process and a keenly aesthetic eye. His work encompassed landscape, architecture, and portraiture, and he became a pioneer war photographer through his images of the Crimea in 1855.

Architecture, however, was undoubtedly Fenton's favorite photographic theme, and he made more images of buildings than of any other class of subject. The majority of these were celebrated "picturesque" sites. It is perhaps no surprise that Fenton favored such images: he had trained as an artist in the 1840s, when the cult of the picturesque view, replete with ruins, was at its height. The faded grandeur of such architectural detail—broken lines enhanced by moss

and ivy and walls topped with twisting bushes—provided variety through irregularity, a variety that, as these images show, was well exploited by the clarity of the photographic image.

Fenton's choice of Melrose Abbey in Scotland could well have been influenced by Sir Walter Scott's narrative poem *The Lay of the Last Minstrel*, which described the moonlit abbey. Taken during the day by photographic necessity, it is a highly evocative image, showing the ruins of the south transept, the detail of the elegant Gothic tracery brought into focus by the light, while the enigmatic figures milling by the gravestones suggest an unknowable narrative. Likewise, the ivy-clad edifices of Haddon Hall, a fortified medieval manor in Derbyshire, and the fifteenth-century Welsh castle at Raglan are both studies in the textural contrast between the lush, rambling foliage and the ancient stone. Fenton posed five figures in front of the gatehouse at Raglan, which was one of the sights of the Wye Valley tour that remained popular into the age of photography. —B.D.

R. Fenton 1856

47
Roger Fenton (1819–1869)
Raglan Castle, 1856

Salted paper print from
collodion glass negative
12 ⁵/₁₆ × 15 ¾ in.
(31.2 × 40 cm)
Amgueddfa Cymru–
National Museum Wales
80.91/355
Frick

48
Roger Fenton (1819–1869)
*Haddon Hall from the
Terrace*, 1859

Albumenized print on paper
9 ¹¹/₁₆ × 11 ¾ in.
(24.5 × 29.8 cm)
Amgueddfa Cymru–
National Museum Wales
NMW A 1834
Utah

47

49

Stanley Spencer (1891–1959)
Snowdon from Llanfrothen,
1938

Oil on canvas
20 1/16 × 30 in.
(50.9 × 76.2 cm)
Amgueddfa Cymru–
National Museum Wales
Purchased, 1938
NMW A 2166

Stanley Spencer was one of the most unusual and singular artists working in Britain during the first half of the twentieth century. A "modern Pre-Raphaelite," he is celebrated for his religious figure subjects, which he transported to the contemporary world of his hometown of Cookham in Berkshire. During the 1930s, financial difficulties brought about by his complicated private life and his resignation from the Royal Academy forced him to establish a reluctant, but commercially successful, career as a painter of landscapes.

The village of Llanfrothen lies to the south of Mount Snowdon on the outskirts of the Snowdonia National Park in north Wales. In August 1938, Spencer traveled there to visit his ex-wife Hilda and her mother, who were staying with a friend. Between August and October, he painted two canvases of the surrounding landscape—this, and *Landscape in North Wales* (Fitzwilliam Museum, Cambridge).

Spencer's landscapes were painted in front of the subject in scrupulous detail and are meticulously, ingeniously tightly knit in their composition. Snowdonia has some of the most dramatic topography in the British Isles, but while most artists painting this subject would have made Snowdon the principal feature, Spencer chooses to relegate the mountain to a detail in the upper right corner, glowering silently amidst the gathering clouds. He instead creates a fresco-like patchwork of color and detail—fields, trees, stones, and slate, the natural forms of which are cut by the jarring straightness of the road—in an exquisite record of the landscape from ancient to modern.

Although Spencer grumbled fulsomely about the necessity of producing works such as this, he acknowledged their importance to his art, noting, "My landscape painting has enabled me to keep my bearings. It has been my contact with the world, my surroundings taken, my plumb line dropped" (Royal Academy 1980, 32). —B.D.

Picturing Modernity

50

Paul Sandby (1731–1809)
*The Iron Forge between
Dolgelli and Barmouth
in Merionethshire*, 1776

Aquatint on paper
9 ⅜ × 12 ⁷⁄₁₆ in.
(23.9 × 31.5 cm)
Amgueddfa Cymru–
National Museum Wales
Given by Sir Harry Wilson,
1936
NMW A 7272
Norton and Frick

This dramatic nocturnal view shows the forge adjacent to Dolgun Furnace near Dolgellau, on the River Mawddach, which flows through northwest Wales to its long estuary at Barmouth. Iron-smelting furnaces and forges to make wrought iron began to appear along the west Wales coast in the early eighteenth century. The area offered abundant natural resources, plentiful water power, and a seaborne trade in iron ore and finished iron. Here, the millstream powers a waterwheel, which turns a tilt hammer inside, just visible through the open doors of the forge. The smiths emerge with a barrow, silhouetted against the blazing activity within.

A reliance on water power to drive the mills, furnaces, and forges meant that they were often located in picturesque settings, not necessarily with detrimental effect. In *Observations on the River Wye, and Several Parts of South Wales* (1782), William Gilpin remarked on the many furnaces along the river and "the smoke, which is frequently seen issuing from the side of the hills and spreading its thin veil…beautifully breaks their lines, and

unites them with the sky" (Bonehill and Daniels 2009, 220). The smoke belching from the forge here contrasts dramatically with the delicate tonal washes of the sky. The relentless dynamism of the industrial foreground is set against the untouched moorland beyond to theatrical effect.

Paul Sandby's first recorded visit to Wales took place in 1770, when he stayed at Wynnstay, the country seat of Sir Watkin Williams-Wynn, instructing his host in drawing. In 1771, Sandby returned to accompany Wynn on a six-week tour of his property. The twelve aquatints that compose the set *XII Views in North Wales*, published in September 1776, record this tour. Subject matter includes ancient castles, vast parkland, tumultuous waterfalls, and sublime, open vistas. Sandby's prints became the template for viewing the Welsh landscape for the next twenty years. The introduction to Thomas Pennant's *Tours in Wales* (1778) recommended the acquisition of Sandby's prints to "those that wish to anticipate the views in the intended progress." —C.T.

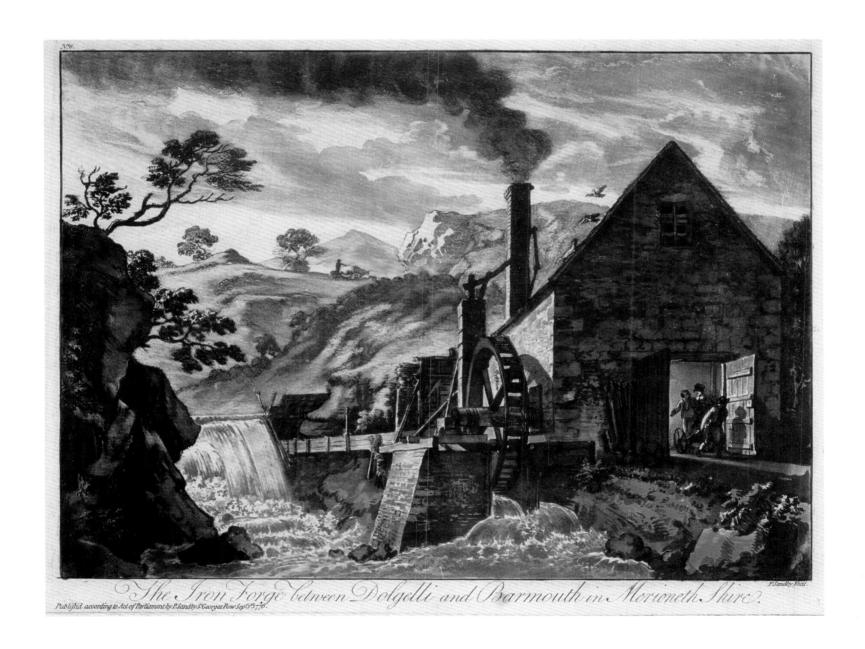

The Iron Forge between Dolgelli and Barmouth in Merioneth Shire.

P. Sandby Fecit.

Publish'd according to Act of Parliament by P. Sandby S.t George's Row Sep.t 1.st 1776.

51

John "Warwick" Smith
(1749–1831)
*Junction of Mona and Parys
Mountain*, 1790

Watercolor and pencil on
paper mounted on card
10 ¾ × 12 ¾ in.
(27.3 × 32.4 cm)
Amgueddfa Cymru–
National Museum Wales
Given by Captain Leonard
Twiston-Davies, 1932
NMW A 3198
Utah and Princeton

The great chasm of the Mona and Parys Mountain open-cast copper mines was an unprecedented sight. The epic proportions of the mines, formed of two distinct but adjoining properties, had a lasting impact on those who witnessed them. It is unsurprising that artists were drawn to such an impressive spectacle. Edward Pugh wrote about the mines in his *Cambria Depicta* of 1816, "To professional painters, this vast hollow is very little known; but I can with the greatest confidence, recommend those who are alive to, and know the value of, scenery so sublime, to spend a day or two there…" (Pugh 1816, 46–47).

John Smith himself was a practiced touring artist. Financed by the 2nd Earl of Warwick (giving him the epithet "Warwick" Smith), he traveled in Europe, Britain, and extensively in Wales. He may have been in part inspired by the pioneer of the picturesque tour in Wales, the Reverend William Gilpin, who was the brother of Smith's teacher Sawrey Gilpin, and published *Observations on the River Wye, and Several Parts of South Wales* (1782). Smith's drawings include Welsh views dating from some fifteen visits between 1784 and 1806. In 1794, he published thirteen of his Welsh landscapes in *A tour through parts of Wales, sonnets, odes and other poems, with engravings from drawings taken on the spot.* Although many artists had difficulty reconciling their perception of the picturesque with modernity, Smith embraced both natural and industrial landscapes with equal fervor.

On at least one of Smith's trips, he traveled with Lord Warwick's brother, Robert Fulke Greville, and fellow artist Julius Caesar Ibbetson, whose stirring images of these mines emphasize the danger and their vast size. While Smith's watercolor is an informative and animated depiction of mining activity, he also introduces dramatic Romantic undertones in the shadowy depths looming from the mouth of the manmade abyss. —A.P.

52

John "Warwick" Smith
(1749–1831)
Forest Works, Swansea, 1792

Watercolor and pencil
on paper
11 15/16 × 16 13/16 in.
(30.3 × 42.7 cm)
Amgueddfa Cymru–
National Museum Wales
Purchased, 1953
NMW A 17388
Norton and Frick

John "Warwick" Smith was one of the earliest British artists to explore the artistic potential of the modern industrial landscape. His inscription accompanying this work reads, "The Forest Works, for smelting copper, near Swansea / Evening effect, from the smoke of many furnaces in full working / Glamorganshire. / August 10th 1792."

At that time, Swansea was a burgeoning center for the copper industry. Ores were imported from around the world to be smelted with coal from the south Wales coal mines. Smith's view looks down the River Tawe at the Forest Copper and Lead Works, one of the most important and innovative of the smelting establishments. On the left bank were situated the older furnaces, built before 1730, while on the right was the principal site, which officially opened in 1752 and was the brainchild of Welsh engineer William Edwards. Five large conical furnaces were arranged geometrically and specially constructed to maximize the heat produced while shielding the furnace-keepers from the searing temperatures. The two sites were linked by Edwards's Beaufort Bridge, a feat of engineering in itself, which also acted as a public thoroughfare and the only reliable river crossing for many miles.

As his inscription makes clear, however, for Smith the priority lay in the overall artistic effect rather than in technological detail. It is only the smokestacks from Edwards's pioneering furnaces that are visible, for example, while the rest of the buildings are bathed in the shadow cast by rising smoke. This watercolor makes a striking contrast to the objective observations of predecessors such as Francis Place (cat. no. 29). Smith was a forerunner in the shift toward the expressive and atmospheric qualities of color. The towering plumes of windblown smoke and the somber buildings from which they rise are backlit against the evening sky. Very similar imagery was revisited regularly by later artists, as in Lionel Walden's *Steelworks, Cardiff, at Night* (cat. nos. 54, 55). The Romantic conflict of man versus nature is dramatically accentuated by the industrial age. —A.P.

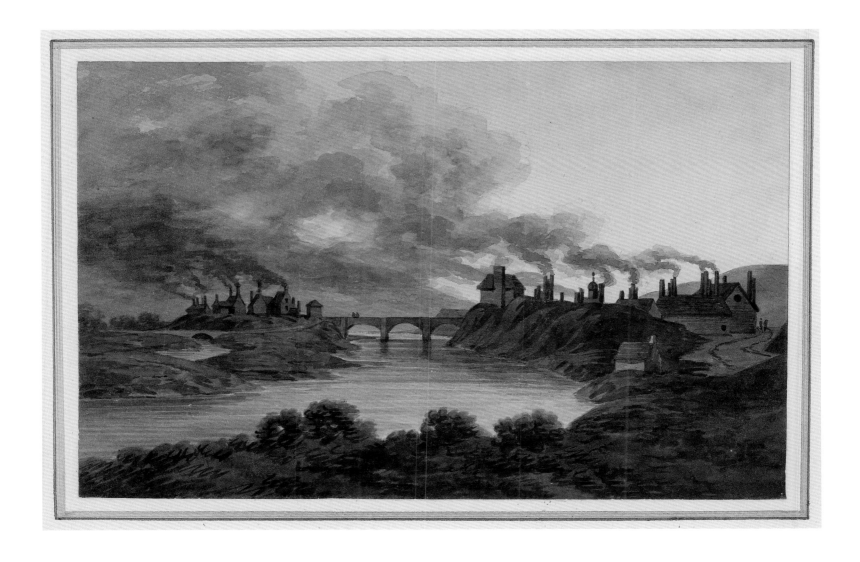

53

Thomas Hornor (1785–1844)
Rolling Mills, 1817/1819?

Watercolor and pencil with
gum arabic on paper
mounted on card
16 ⁵⁄₁₆ × 21 ⁵⁄₁₆ in.
(41.4 × 54.2 cm)
Amgueddfa Cymru–
National Museum Wales
Purchased, 1953
NMW A 3353
Utah and Princeton

The accurate depiction of the Penydarren Ironworks
at Merthyr Tydfil in this image has been dramatically
enhanced by Thomas Hornor's theatrical use of light,
which floods out of the building and the nearby
brazier. By the early nineteenth century, Wales was
the greatest iron-producing country in the world. The
industry was centered in Merthyr Tydfil, where there
were no less than seven major ironworks. Thomas
Hornor's view is both dramatic and full of detail. On
the right are rolling mills driven by a beam engine,
and tramroad railway trucks laden with bar iron. The
bar iron would be horse-hauled via tramroad and
canal to Cardiff for export.

On April 2, 1814, Hornor advertised his services
to survey estates in Wales in *The Cambrian* news-
paper. Responses came particularly from the Neath
Valley, and he was commissioned by landowners to
produce at least nine albums of views in south
Wales. *Rolling Mills* was originally pasted into
an album in the Duke of Sutherland's library.
National Museum Wales also owns an album of
twenty-five illustrations from 1816 titled
*Illustrations of the Vale of Neath with the Scenery of
Rheola and Part of the Adjoining Country*, made for
John Edwards (1772–1833). Each album contained a
map and watercolors alongside detailed descriptive
pages of the area. Hornor describes the process of
smelting iron in some detail in the text accompany-
ing this image. He worked on the south Wales
albums between 1816 and 1820. He then began the
mammoth task of making a panorama of the whole
of London from the top of St. Paul's Cathedral. By
1826, he had moved to New York, where he worked
as a topographer. —B.M.

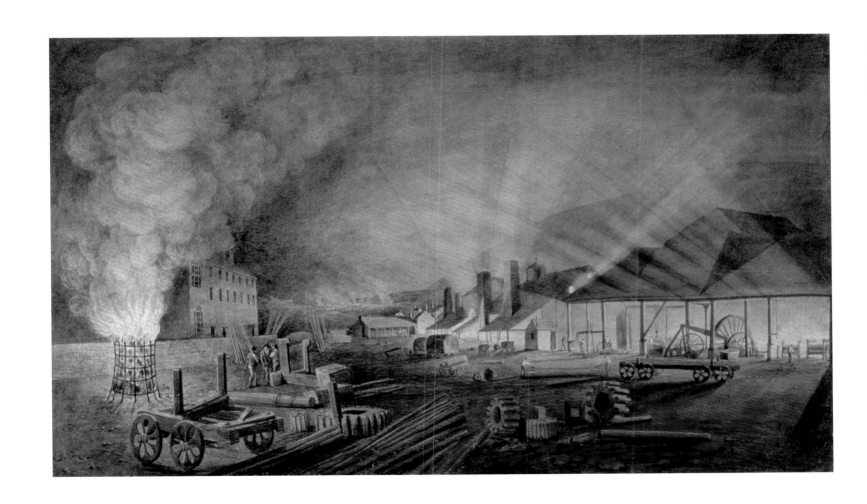

54, 55

54
Lionel Walden (1861–1933)
*Steelworks, Cardiff,
at Night*, 1895–97

Oil on canvas
8 ⅞ × 11 ¾ in.
(22.6 × 29.9 cm)
Amgueddfa Cymru–
National Museum Wales
Given by Herbert Charles
Sheppard, 1917
NMW A 2054

55
Lionel Walden (1861–1933)
Steelworks, Cardiff, at Night,
1895–97

Oil on canvas
59 ⅜ × 78 ⅞ in.
(150.8 × 200.4 cm)
Amgueddfa Cymru–
National Museum Wales
Given by the artist, 1917
NMW A 2245

A train picks up steam in the Dowlais-Cardiff Works as the blazing steel furnaces light up the night in this huge industrial scene. Opened officially in 1891 and beginning production in 1895, the steelworks was the largest and most advanced in the world. With four large blast furnaces and a dozen open-hearth stoves, it was at the forefront of modern technology. Built on the green expanse of the Cardiff East Moors next to the docks, it replaced older works located further inland. Iron ore landed at Cardiff Docks could be made into steel bars within forty-eight hours.

Lionel Walden was obviously fascinated by the industrial life and landscape of Cardiff, which he painted several times. This particular scene was first captured in the small oil sketch. It already conveys the sense of drama and energy that clearly left Walden in awe. He recaptures the full impact in the finished work by depicting it on a massive scale. The eye is led by the rail tracks through the black of a wet wind-swept night to the glowing inferno that lies beyond.

A painting thought to be the companion to this work, *Cardiff Docks*, is now in the Musée d'Orsay, Paris. It was exhibited at the Salon de la Société des Artistes Français in 1896, and purchased by the French state. Showing a similar composition, mirrored, it depicts the docks at twilight with ships' masts instead of chimneys emerging from the rain and smoke. The works represent two pillars of Wales's industrial might, appearing at the same time forbidding and enthralling.

Walden's industrial night effects echo the Thames *Nocturnes* of his compatriot James McNeill Whistler. Like him, Walden left America when he was young to study in Paris, then traveled to Britain. In 1911, he made the first of many visits to Honolulu. His volcano paintings from Hawaii are strongly reminiscent of these paintings of the steelworks in Cardiff. —A.P.

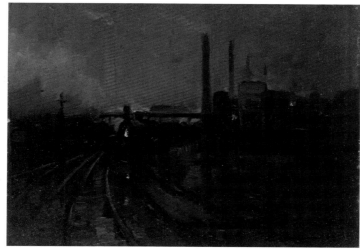

54

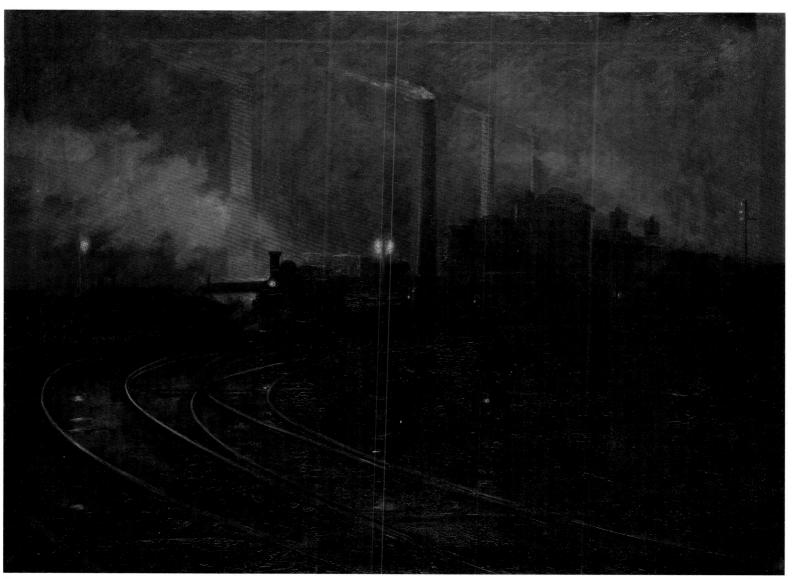

56

John Terrick Williams
(1860–1936)
Mining, 1926–33

Oil on millboard
10 1/16 × 6 1/4 in.
(25.6 × 15.8 cm)
Amgueddfa Cymru–
National Museum Wales
Purchased, 1934
NMW A 2236

For almost two centuries, mining was one of the most important industries in Britain. In terms of employment it reached its peak in 1925, when there were a recorded one and a quarter million people working in the industry. The coalfields across all corners of the United Kingdom transformed and, in many areas, came to define the landscape, and mines and miners became both landscape and social genre subjects for many artists. Although the precise location of this work has not been identified, *Mining* most likely depicts a colliery in the northwest of England.

The artist, John Terrick Williams, was born in Liverpool and trained in Paris under William-Adolphe Bouguereau. His reputation rests mainly on his luminous landscapes of Brittany and Cornwall, and so this rather monochrome, loosely painted oil sketch of pithead machinery would have been an unusual subject for the artist. However, the context for the painting's production explains the subject, as the work was bought by the National Museum of Wales in 1934 from an exhibition of posters and poster designs commissioned by the Empire Marketing Board.

The Empire Marketing Board (1926–33) was established to promote the production, trade, and use of goods throughout the British Empire. It was unusual as an example of official peacetime propaganda, and many well-known artists were invited to produce designs for the board. Although not all commissioned designs were worked up into posters, this oil sketch may have served as the basis for a poster. The subject of mining was represented in an image by the graphic artist Austin Cooper, which advertised the use of U.K. machinery in South African mines. While Cooper's poster is compositionally similar to Williams's picture, the impressionistic brushwork of the painting gives way to the stylized modernism, clean lines, and bright colors that characterized much of the graphic work created by the board. —B.D.

57

Harold Gilman (1876–1919)
Mornington Crescent,
ca. 1912

Oil on canvas
20 5/16 × 24 5/16 in.
(51.6 × 61.7 cm)
Amgueddfa Cymru–
National Museum Wales
Bequeathed by Margaret
Davies, 1963
NMW A 190

Harold Gilman was a founding member of the Camden Town Group, established in 1911 and named after the district of London where many of its artists lived and worked. The aim of the group, which included among its members Walter Sickert and Robert Bevan (cat. no. 71), was to depict the urban quotidian with a Post-Impressionist vigor; it was one of a number of early twentieth-century British groups that furthered the development of modernism in Britain. Camden Town images of London before the First World War serve as important historical documents, and demonstrate how mundane urban streets could be equally valid subjects for "landscape" painting as more traditionally picturesque scenes.

The Regency terrace of Mornington Crescent was the subject of many works by the group. During the nineteenth century it had been a comparatively smart address, yet by the time Gilman painted this work, the area had become somewhat down-at-the-heels, described in the *Sunday Times* (March 26, 1911) as a "drab and sordid neighbourhood" where shabby boardinghouses provided cheap rooms for artists and low-paid workers. Assuming the title is correct, the precise viewpoint for the location is difficult to ascertain—either from the back of the crescent or looking over from another street to the back of the crescent. It is, though, as prosaic a view as looking from a window might provide.

Much of Gilman's work at this time was of unremarkable domestic interiors, and this painting is almost like a pendant to such works, as if pivoting 180 degrees might reveal a deserted breakfast table or kitchen. Other artists who painted the crescent rendered it from the front, taking in the facade, the park in front, and figures in the street. Gilman purposely eschews such detail, and through dynamic brushwork and vibrant blocks of color creates a study of texture and form, a window into the hidden life of the city. —B.D.

58

Cedric Morris (1889–1982)
*From a Window at 45 Brook
Street, London W1*, 1926

Oil on canvas
36 ¹⁄₁₆ × 48 ⅛ in.
(91.6 × 122.2 cm)
Amgueddfa Cymru–
National Museum Wales
Purchased, 1973
NMW A 2052

From a Window at 45 Brook Street, London W1
depicts a view across the rooftops of Mayfair and
was painted from the window of the London home
of Cedric Morris's friend Paul Odo Cross. The prosaic
choice of subject recalls the work of the Camden
Town Group, and in particular the paintings of
Charles Ginner. It was painted in the same year that
Morris moved to London after spending much of the
early 1920s living and working in Paris. By this time,
after a number of years of experimentation, Morris
had arrived at his "mature style," and was determined
to firmly establish his career in the London art world.
In this year he was also elected to the Seven and Five
Society alongside his friend Christopher Wood, with
both artists being nominated and seconded by
Winifred and Ben Nicholson.

At this time, Morris's work accorded strongly with
the approach to painting expounded by the leading
figures of the Seven and Five Society, notably the
Nicholsons. Progressive artists in Britain in the 1920s
had absorbed the example of Roger Fry's *Vision and
Design* of 1920 and placed honesty, simplicity, and
directness above unnecessary finish or sophistica-
tion. *From a Window* eloquently demonstrates the
faux-naïf quality that was so fashionable at this time.
The roofs and backs of the houses create blocklike,
almost abstract patterns, while the tree branches,
framed against the sky, have a childlike directness.
Morris's style is in part due to his unusual technique;
he did not do any preliminary drawing and was said
to start a painting at the top left of a canvas and
systematically work his way across to the bottom
right—a process that one student likened to knitting.
Having established this way of working, Morris
retained a consistent style and choice of subject
matter throughout his career. —N.T.

59

Oskar Kokoschka
(1886–1980)
London, Waterloo Bridge,
1926

Oil on canvas
35 ⅛ × 51 in.
(89.2 × 129.6 cm)
Amgueddfa Cymru–
National Museum Wales
Purchased, 1982
NMW A 2162

Waterloo Bridge has been a popular subject for landscape painters including John Constable, J. M. W. Turner, and Claude Monet. In Oskar Kokoschka's painting, the bridge, the river, and the surrounding cityscape have been rendered in the artist's colorful, painterly style. Kokoschka is widely recognized as one of the leading Expressionist painters of the modern period. A truly international artist, he traveled widely, and painted a number of other river scenes in major European cities including Dresden, Prague, and Lyon.

Kokoschka first visited London in July 1925. After painting a view of Tower Bridge, he wrote to a friend: "I'm afraid I've only been able to finish one painting, because it's raining and I can't see a thing in the fog!" (Calvocoressi 1986, 312). This did not discourage him from returning the following March to the city, where, from his room at the Savoy Hotel, he painted two further views of the Thames including *London, Waterloo Bridge*. His room on the hotel's eighth floor afforded him a bird's-eye view across the bridge. This viewpoint had earlier been chosen by Monet and by Léon de Smet (cat. no. 62), and it seems likely that Kokoschka would have been aware of their paintings.

Born in Austria, Kokoschka moved to Prague in 1934 following the rise of the Nazis and then to Britain in 1938, eventually becoming a British citizen in 1947. Although he lived mainly in Switzerland from 1953 on, he did return to the subject of London and the Thames in later drawings and paintings. In *View of the Thames* of 1959 (Tate, London) he paints Waterloo Bridge from an almost identical perspective to the 1926 painting. However, in the intervening years the original bridge—designed by John Rennie and opened in 1817—had been demolished and replaced with a new design by Sir Giles Gilbert Scott that opened fully to the public in 1945. Kokoschka's Thames paintings, particularly when viewed in relation to their historic precedents, point to the dynamic modernity of London's ever-changing cityscape. —N.T.

Monet and Impressions of Britain

60

Claude Monet (1840–1926)
The Pool of London, 1871

Oil on canvas
19 1/8 × 29 5/16 in.
(48.5 × 74.5 cm)
Amgueddfa Cymru–
National Museum Wales
Purchased, 1980
NMW A 2486

The Pool of London on the Thames was the commercial gateway to Victorian London and one of the busiest ports in the world. In Claude Monet's painting the austere facade of the Customs House on the right surveys the ships congregating on the river with their valuable cargoes imported from around the globe. On the horizon traffic bustles across London Bridge while the historic towers of St. Magnus the Martyr Church and the Billingsgate Fish Market compete with ships' masts and fuming smokestacks to pierce the misty London skyline.

The Pool of London was one of only five finished works painted by Monet during his first visit to the city in 1870. At that time, he was struggling to establish his career, further hindered by the outbreak of the Franco-Prussian War in 1870. He and his young family were among thousands of French refugees who fled to England. Before leaving France, Monet wrote to the artist Eugène Boudin, saying, "the transatlantic liners are providing the service to London. Two hundred passengers are spending tonight on the quayside" (Le Havre, September 9, 1870; Wildenstein

1974–91, 1:427, no. 55). For Monet the sight of the foreign ships in London, awaiting permission to unload, must have had added personal resonance.

In contrast to the grandeur with which many Victorian artists conveyed this powerful port, the Impressionist's view is candidly everyday. It is an experiment in visual effect as well as in mood. London's notorious industrial fog produced atmospheric subtleties that were entirely new to Monet. Analysis has shown that he painted the boats over an initial layer of varnish, perhaps concerned for definition amid the muted grays. The works of his contemporary James McNeill Whistler and those of J. M. W. Turner, whose paintings Monet would have seen at the National Gallery, clearly provided some inspiration.

It was also in London that Monet met future Impressionist dealer Paul Durand-Ruel, a fellow refugee. In 1893, this painting traveled with Durand-Ruel to Philadelphia, where it was purchased by industrialist Alexander J. Cassatt, brother of the Impressionist artist Mary Cassatt. —A.P.

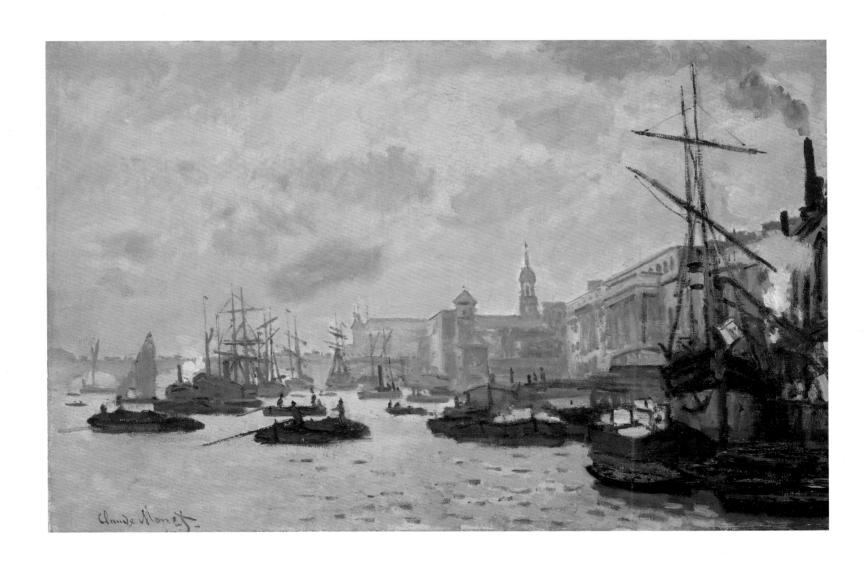

61

Claude Monet (1840–1926)
Charing Cross Bridge, 1902

Oil on canvas
25 ¾ × 32 in. (65.4 × 81.3 cm)
Amgueddfa Cymru–
National Museum Wales
Bequeathed by Margaret
Davies, 1963
NMW A 2483

Claude Monet's Thames series was begun during the autumn of 1899, continued during the winter of 1900 to 1901, and completed from memory at his home in Giverny between 1902 and 1904. Although no stranger to London, having first depicted it in 1870 as a refugee from the Franco-Prussian War (cat. no. 60), Monet produced the main body of his London views during this later period. At this time, he painted the River Thames in three series: Waterloo Bridge, the Houses of Parliament, and Charing Cross Railway Bridge. During this visit, Monet stayed at the Savoy Hotel, where his fifth-floor balcony afforded him a panoramic view of the river. It was from here that his paintings of Charing Cross with the view upstream toward the Houses of Parliament were executed. It has been suggested that this visit might have been inspired by James McNeill Whistler's 1896 lithographs of the city, in which he depicted similar views.

Monet's later paintings were concerned primarily with the articulation of atmospheric nuance. The artist was both fascinated and frustrated by the changing London weather and featured Charing Cross Bridge in no fewer than thirty-five canvases— all morning scenes. This version is one of only two that omit the detail of Cleopatra's Needle, an obelisk on the bank of the Thames. Instead, the detail is confined to the bridge, the distant Houses of Parliament, the boats, and a section of embankment, all of which act as visual anchors around which the interchangeable haze of water and sky fluctuates. To the left of the canvas, Monet has depicted the steam from a train on the railway bridge, disappearing into the mist. While some artists might consider the London fogs—known as "pea-soupers"—a hindrance, for Monet they were an intrinsic part of the landscape. "Without the fog London wouldn't be a beautiful city," he said. "It's the fog that gives it its magnificent breadth" (Sieberling 1988, 55). —B.D.

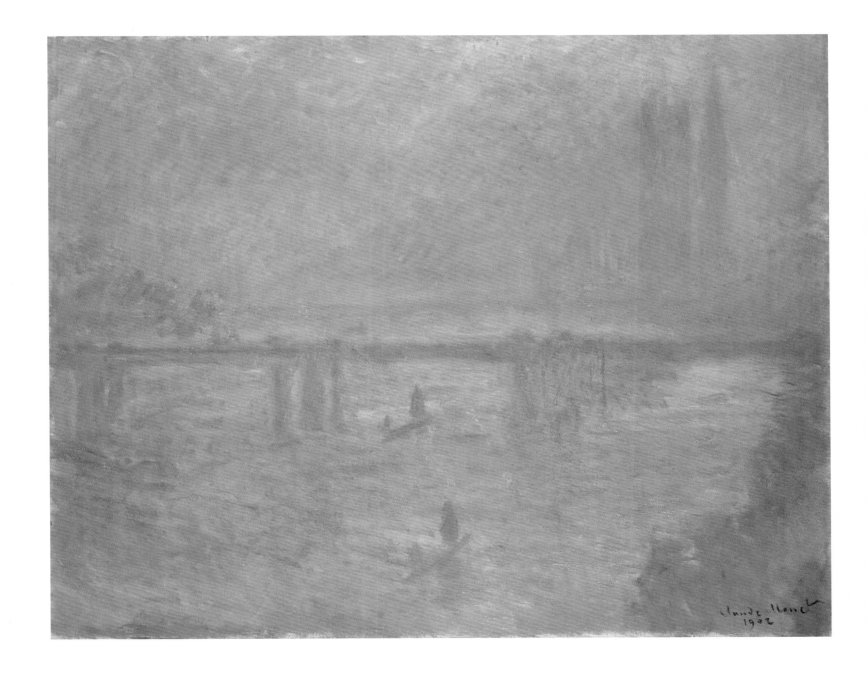

62

Léon de Smet (1881–1966)
Waterloo Bridge, 1915

Oil on canvas
20 $\frac{1}{16}$ × 26 $\frac{1}{16}$ in.
(51 × 66.2 cm)
Amgueddfa Cymru–
National Museum Wales
Given by Sir William
Goscombe John, 1939
NMW A 2154

Pushing its way through the haze, the evening sunlight glistens off Waterloo Bridge and the curve of the leafy Embankment. Fascinated by bright colors and atmospheric effects, Léon de Smet found great affinity with Impressionism as well as the Pointillist techniques of Georges Seurat and Paul Signac. Here the debt to Claude Monet's Thames series, painted around fifteen years before, is unmistakable.

De Smet chose the same viewpoint, from the Savoy Hotel, albeit much more elevated. Whereas Monet's paintings of Waterloo Bridge looked across the river to focus on the factory chimneys spewing smoke, de Smet's view is markedly different. Looking directly downriver, the industrial South Bank is pushed out of frame. Rather than smokestacks, it is the highlighted dome of St. Paul's Cathedral and the span of Blackfriars Bridge that emerge from the distant mist. These important landmarks demarcate one of the most famous and historic sightlines over the Thames. De Smet portrays the perspective of the foreign visitor absorbing the sights of the metropolis.

Like Monet on his first visit to London in 1870, de Smet was a refugee. He fled from his native Belgium after the German invasion in 1914, settling in London for the next four years. There he exhibited regularly at the Leicester Galleries and the Burlington Galleries. This painting was exhibited at the Royal Academy in 1916. It was given to National Museum Wales by the sculptor William Goscombe John in 1939 after it had been in his collection for a number of years. He described it as an "important work and I think very beautiful." —A.P.

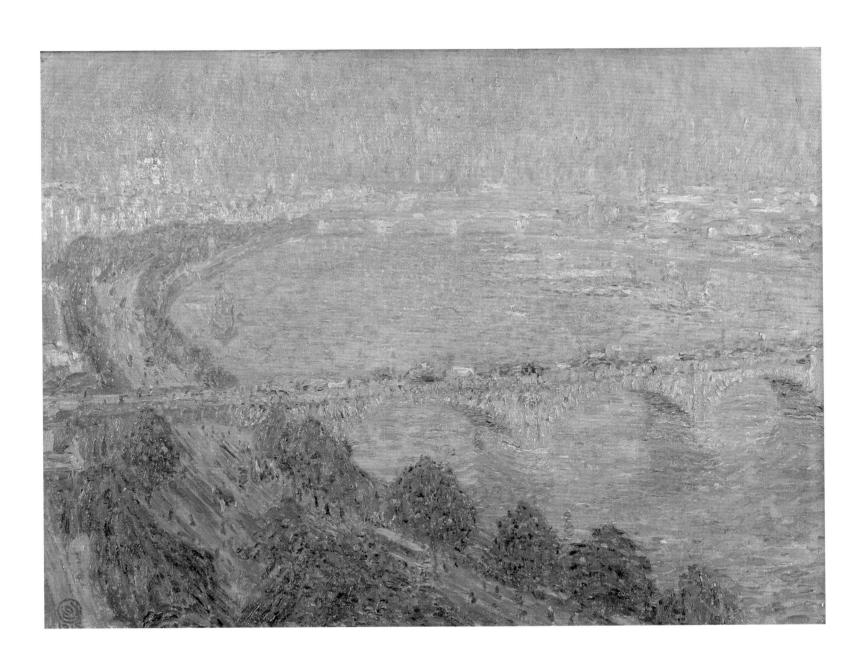

63

Alfred Sisley (1839–1899)
*Storr's Rock, Lady's Cove,
Evening*, 1897

Oil on canvas
25 ¹³⁄₁₆ × 32 ¹⁄₁₆ in.
(65.5 × 81.5 cm)
Amgueddfa Cymru–
National Museum Wales
Purchased with the
assistance of the Art Fund
(Centenary Appeal), 2004
NMW A 26362

This enormous, isolated outcrop of rock, known as "Storr's Rock," fascinated Alfred Sisley. He painted it at least five times at different times of day and in different weather conditions, carefully observing the varying tides and atmospheric effects. Here, a rose-tinted evening light shines from the west, raking over the deep crevices in the rock's surface. The contrast between the brightly sunlit areas and the long shadows cast across the beach evokes the calm of early evening and creates balance within the composition.

Sisley, who was of British descent, was the only one of the original Impressionist group to paint in Wales. In 1897, at the ages of fifty-seven and sixty-three, he and his longtime partner, Eugénie Lescouezec, traveled to Cardiff, where they were discreetly married. After painting on the nearby coast at Penarth, the couple traveled west along the south coast to Swansea and the Gower Peninsula.

There they honeymooned in the Osborne Hotel at Lady's Cove, now "Rotherslade Bay." Both the artist and his wife were in poor health, suffering from cancer at the time, and did not venture far from their accommodation. Storr's Rock was situated next to a popular bathing area directly below the hotel.

It was the first time Sisley had attempted to paint coastal views; he was more accustomed to the sedate rivers of France. He lamented the "struggle against the wind, which reigns supreme here." It is clear that he found much inspiration in Claude Monet's earlier paintings of the Normandy coast. Monet's later "series" paintings also influenced Sisley in his repetitive observation of the same site. Unlike his friend, however, Sisley remained avidly interested in the detail of the material landscape as well as human activity. In this painting the figure of a boy adds scale to the geological features and boats traverse the horizon. —A.P.

64

George Clausen (1852–1944)
Apple Blossom, 1885

Oil on millboard
9 ¹³⁄₁₆ × 8 ¹⁵⁄₁₆ in.
(24.9 × 22.7 cm)
Amgueddfa Cymru–
National Museum Wales
Bequeathed by James
Thompson, 1898
NMW A 174

This fresh depiction of apple trees in bloom was painted while George Clausen was living at Cookham Dean in Berkshire in the south of England. Clausen was a founding member of the New English Art Club, which was established in 1885, the year of this painting. As an alternative to the Royal Academy, it allowed participants to develop their interests in French art, and the influence of nineteenth-century French developments in painting is very much apparent in all aspects of this small study. Clausen studied in Paris (under William-Adolphe Bouguereau, like John Terrick Williams [cat. no. 56]), and so would have had first-hand experience of both Realism and the work of the Barbizon School, and also of Impressionist painting.

Although Clausen's style changed subtly throughout his career and also reflected currents in British art, his subject matter was resolutely that of rural labor, heavily influenced by French Realist painters such as Jean-François Millet and Jules Bastien-Lepage, who painted atmospheric, iconic images of workers in the fields. It is possible that this small work is a study for *The Shepherdess* (Walker Art Gallery, Liverpool), also painted in 1885, which depicts a young girl tending sheep in the middle of an orchard, surrounded by apple trees in blossom.

In *Apple Blossom*, the millboard support is visible beneath the oil, suggesting that the paint was applied on the spot. The rapidly applied brushwork clearly shows the influence of the Impressionists; like those artists, one of Clausen's main artistic aims was the reflection of different seasons and weather conditions and the accurate depiction of atmospheric detail. The style of this painting, however, is particularly redolent of one particular artist—the French Realist Camille Corot. It is Corot's later work that can be most clearly seen here, in the silvery branches and flashes of bright color such as the red of the chimney stack and the yellow of the buttercups. —B.D.

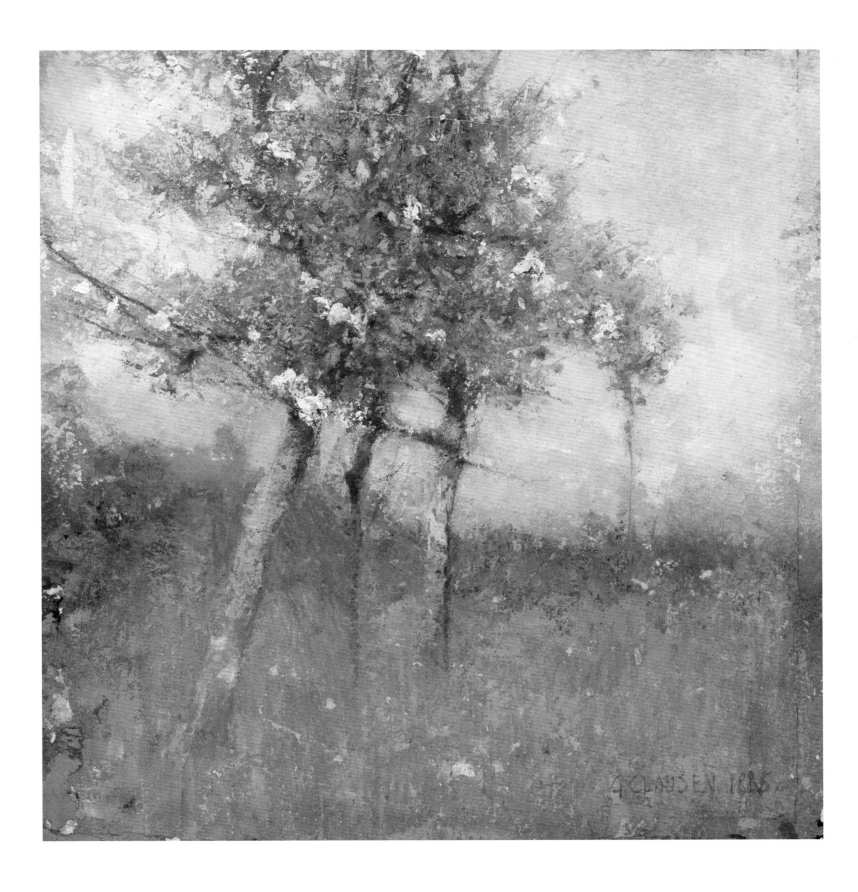

65

Sir Frank William
Brangwyn (1867–1956)
Shipping on the Thames, 1886

Oil on canvas
18 ¹¹⁄₁₆ × 22 ¹³⁄₁₆ in.
(47.5 × 58 cm)
Amgueddfa Cymru–
National Museum Wales
Purchased, 1929
NMW A 154

The artist Frank Brangwyn was born in Bruges, Belgium, and came to London in 1875. He was largely self-taught, working first with his father, an architect, and then as a draftsman under the designer and socialist William Morris from 1882 until 1884. *Shipping on the Thames* was painted at the beginning of Brangwyn's career, prior to the development of his later, distinctive style of square brushwork, sharply defined color, and flattened perspective, which gives his works the suggestion of textile.

In the late nineteenth century, the River Thames, which flows through London, was a major port and shipping route and central to the city's history and identity. Brangwyn was a keen sailor, and images of ships and vessels were a continuous thread in his career. While reminiscent of seventeenth-century Dutch marine painting, *Shipping on the Thames* is essentially an exercise in color and form. The work has an unusual perspective, in which almost half the canvas is taken up by the depiction of the deserted foreshore. The distant far shore does not present any discernible landmarks through which to pinpoint location, although the bridge just visible to the right of the canvas is possibly "New" London Bridge (built in 1825 and reconstructed in Arizona in 1967).

Shipping on the Thames is most closely related to the work of James McNeill Whistler, whose etchings of the Thames during the 1850s and 1860s (much like his Venetian etchings) depicted London as a living, working city. From 1884 on, Brangwyn was a member of the Society of British Artists, of which Whistler was president in 1886, the year of this work. While the subject matter recalls Whistler's etchings, the monochrome palette of carefully distributed browns, pinks, and grays reflects his emphasis on visual harmony, as seen in his *Nocturnes*. There are also comparisons to be drawn with Claude Monet's early views of the Thames (cat. no. 60), and Brangwyn's interest in atmospheric effects is visible in this work. —B.D.

66

Charles Sims (1873–1928)
The Kite, ca. 1910

Oil on canvas
28 ³⁄₁₆ × 35 ¹¹⁄₁₆ in.
(71.6 × 90.6 cm)
Amgueddfa Cymru–
National Museum Wales
Purchased, 1913
NMW A 208

Charles Sims was born in London, the son of a costume maker. His family intended him to become a draper, and he was sent to France at the age of fourteen to study commerce. This proved little to his taste, and he eventually entered South Kensington College of Art. Sims later studied at the Académie Julian in Paris for two years, learning the techniques of *plein air* oil painting. Like other British artists of his generation, he admired the free handling and tonal style of Jules Bastien-Lepage (1848–1884), as well as the Impressionists.

On his return to England in 1892, Sims tried to establish himself as a landscape painter, but he found greater success with figure-based compositions, particularly scenes of family life. His subjects experience landscape as an idyllic realm of golden light and innocent activities. In *The Kite*, the child is a blur of movement, entirely absorbed by flying the kite, watched intently by the woman. The low viewpoint heightens the sense of intimacy in the scene, while scintillating brushstrokes suggest the changeable light and conditions of a breezy seaside day.

Sims's often whimsical subject matter proved to be much in tune with prevailing Edwardian taste, and this, combined with his technical facility for painting lush, eternally sun-dappled landscapes, eventually brought him commercial success. His work seems to epitomize the popular view of the Edwardian age as "a long garden party on a golden afternoon" (Samuel Hynes). Tragically, Sims's later personal and professional life was far from the sunlit idyll he depicted. His eldest son was killed in active service early in the First World War, a loss from which he never recovered. Sims worked as a war artist and attempted to develop a practice as a portrait painter in the United States, but became increasingly disillusioned. He took his own life in 1928. —C.T.

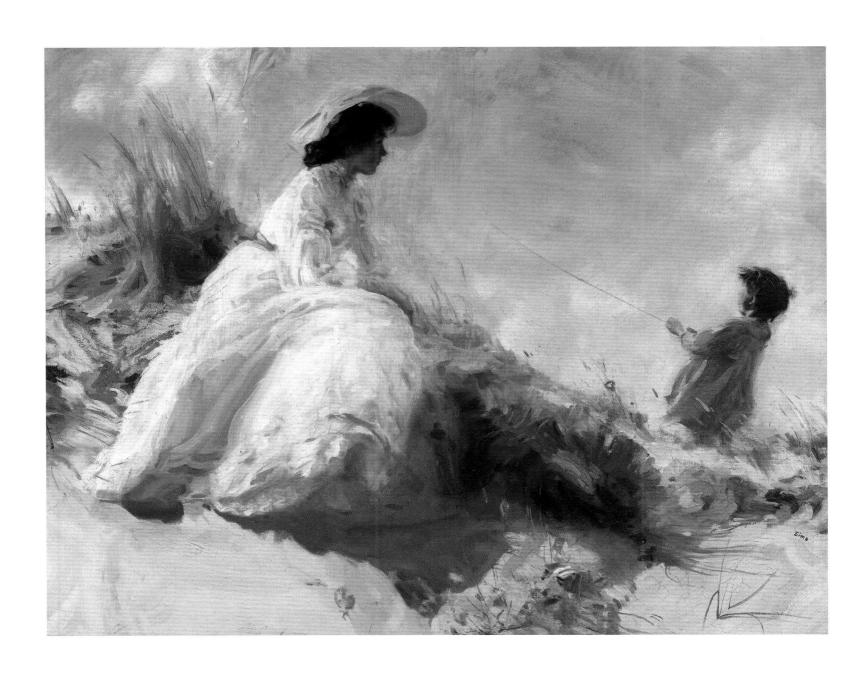

67

Christopher Williams
(1873–1934)
The Red Dress, 1917

Oil on millboard
11 ¹³⁄₁₆ × 15 ¼ in.
(30 × 38.7 cm)
Amgueddfa Cymru–
National Museum Wales
Purchased, 1935
NMW A 5148

Christopher Williams was born in the town of Maesteg in the Welsh valleys, and made his reputation from Salon-style biblical works and monumental depictions of characters from Welsh legend. It is, however, the series of *plein air* oil sketches he made on the northwest coast of Wales between the Lleyn Peninsula and Llangrannog that show him at his most inventive and experimental, even though they were never intended for public display. This image of the artist's wife, Emily, was probably painted at Barmouth (the mountain visible in the back could well be Cadair Idris [cat. no. 11]).

Notably, the work dates from the same year as *The Cornish Coast* by Laura Knight (cat. no. 68), and there is a distinct similarity between the two, both in the coastal cliff-top setting and in the bright red of the principal figures' garments. Stylistically, however, this is more reflective of the landscape work of Augustus John (cat. no. 70) and James Dickson Innes (cat. no. 69). Like John,

Williams painted directly onto millboard with a loose brushwork style that gives this work a delightfully fresh, spontaneous feel. There are a number of variations on this composition, some including the artist's son, Ivor.

The seaside location in which *The Red Dress* was painted was a popular tourist destination, and it is notable that this image of quiet leisure dates from 1917, during the First World War. The previous year, Williams had been commissioned to depict the battle of Mametz Wood at the Somme in July 1916, a particularly bloody chapter in the history of the Royal Welch Fusiliers regiment. The resulting painting was a monumental, graphic canvas whose harrowing realism made no attempt to sanitize the nature of battle. The stark contrast in every way between this official work and the relaxed, private intimacy of family studies such as *The Red Dress* demonstrates the vast difference between the public and private personae of the artist. —B.D.

68

Laura Knight (1877–1970)
The Cornish Coast, ca. 1917

Oil on canvas
25½ × 30¹⁄₁₆ in.
(64.8 × 76.3 cm)
Amgueddfa Cymru–
National Museum Wales
Bequeathed by F. H.
Lambert, 1940
NMW A 3706

Set on the brink between land and sea, two women gaze into the distance, released from the confines of the domestic sphere. Their self-possessed demeanor and sensible, bright clothes identify them as "modern" women. Laura Knight produced a number of paintings of robust women against a vertiginous backdrop of granite cliffs and brilliant sparkling sea between 1916 and 1919. The series expresses her passion for working *en plein air*, a practice she maintained despite restrictions on access to the coast during the First World War. Her women occupy and embrace the landscape; they seem to reflect something of Knight's own independent character and her delight in the Cornish coast.

Laura Knight moved to the small fishing village of Newlyn, in west Cornwall, with her husband, the painter Harold Knight (1874–1961), in 1907. The Knights had previously worked in the coastal village of Staithes, Yorkshire, and with an artist's colony at Laren in Holland. Newlyn offered spectacular coastal scenery and a lifestyle remote from urban or industrial contamination. It was home to a thriving artistic community, based around the School of Painting founded by Stanhope and Elizabeth Forbes in 1899. The Knights soon became absorbed into the social and artistic milieu. A fellow artist, Norman Garstin (1847–1926), recalled that "there came over their work an utter change in both their outlook and method: they at once plunged into a riot of brilliant sunshine, of opulent color and of sensuous gaiety."

The clear light, lush, intense colors, dramatic topography, and congenial company came together to rejuvenate and transform Knight's work. Her early Cornish scenes are breezy, impressionistic landscapes, but her paint handling later became increasingly bold. She may have been influenced by the small landscapes and figure studies of Augustus John (cat. no. 70), who worked in Cornwall in 1913. —C.T.

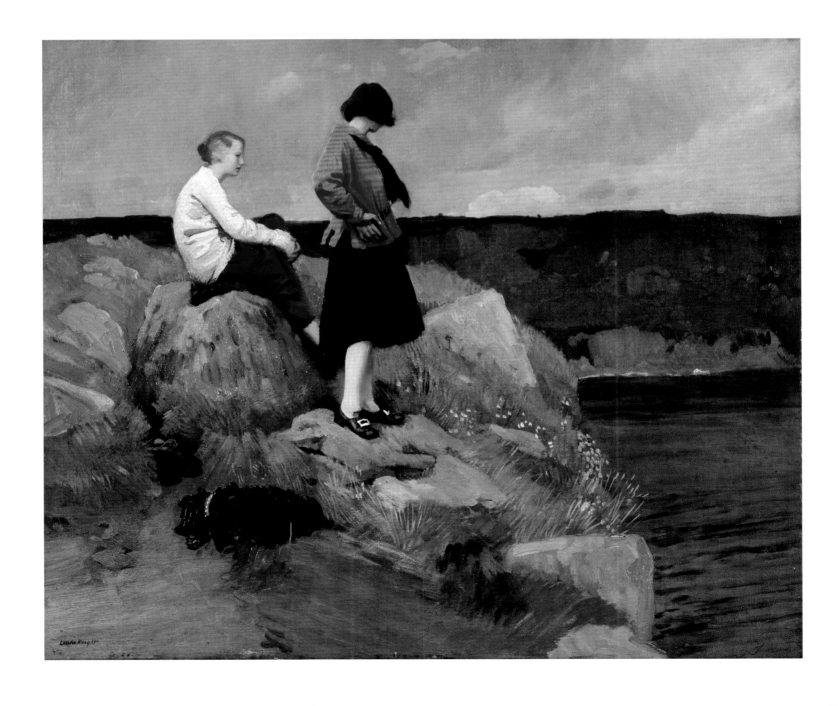

69

James Dickson Innes
(1887–1914)
Arenig, ca. 1911–12

Oil on panel
9 ¹⁄₁₆ × 13 in. (23 × 33 cm)
Amgueddfa Cymru–
National Museum Wales
Bequeathed to the
Contemporary Art Society
by Sir Edward Marsh and
presented to the National
Museum of Wales, 1954
NMW A 202

James Dickson Innes discovered the remote Arenig mountains, situated near Bala in southern Snowdonia, during a tour of north Wales in 1910. The highest of these, Arenig Fawr, captivated him, and he returned to it repeatedly over the next three years. His small oils, often painted in very bright, eerie colors, catch the moment of revelation to be found in some transitory, glorious light or weather effect.

Innes was born in the industrial town of Llanelli, south Wales. In 1906, he won a scholarship to the Slade School of Fine Art in London, where he was taught by the British Impressionist painter Philip Wilson Steer (1860–1942). Steer was also a devoted follower of J. M. W. Turner and John Constable. Innes's early work was likewise influenced by the British watercolor tradition. His first visit to France in 1908 had a revolutionary impact on his work, as the stark, intense light of the Mediterranean transformed his sense of color. Suffering from tuberculosis, he worked at a furious pace. His illness did not prevent him, however, from traveling continually, painting in Wales, Collioure—the Mediterranean port closely associated with the Fauves—and the Pyrenees.

In November 1910, Augustus John exhibited his *Provençal Studies* at the Chenil Gallery in London. Rapidly executed on unprimed wood panels, using brilliant hues, these fragments of Mediterranean color and light had a profound influence on Innes's work. The following spring, the two artists traveled to Arenig together, renting a primitive cottage by a brook. John was inspired by Innes's passionately felt connection to the landscape, while Innes's technique in oils was transformed. His brushstrokes became broad and expressive, his compositions increasingly direct and simplified. His landscapes reflect some inspired inner vision of a place remote from modernity and the metropolis, "the reflection of some miraculous promised land."

Innes died in August 1914, aged twenty-seven. His brief but intensely productive career can be seen as emblematic of a certain romantic, bohemian, artistic existence that was curtailed by the First World War. It also represents a uniquely Welsh contribution to British Post-Impressionism. —C.T.

70

Augustus John (1878–1961)
The Aran Isles, ca. 1912

Oil on panel
11 ¹³⁄₁₆ × 19 ¹⁵⁄₁₆ in.
(30 × 50.7 cm)
Amgueddfa Cymru–
National Museum Wales
Purchased, 1971
NMW A 157

Augustus John was born in Tenby, a small seaside town in southwest Wales, and attended the Slade School of Art in London with his sister, the artist Gwen John (1876–1939). From 1899, he exhibited at the New English Art Club, and became one of the most celebrated artists of his time. *The Aran Isles* is an example of the artist's early, more experimental work: later in the decade he would tread a strange path between professional bohemian and new establishment, working as a society portraitist while simultaneously exercising his penchant for painting "outsiders" and large-scale fantasy works.

This landscape, which depicts tiny cottages on the windswept Irish coast, probably dates from 1912, when John visited Connemara and the Aran Isles. The image is exceptionally fresh. As was typical of John at this period, he drew directly in pencil onto unprimed plywood, the grain of which is still visible, before blocking in using unmodulated areas of color in swift, thick strokes that highlight the picture surface with the pencil underdrawing still discernible. Between 1910 and 1912, John was painting regularly with the artist J. D. Innes (cat. no. 69), and there was certainly some mutual influence in the images of the two artists, which can be seen in both works in this exhibition. John's use of color and almost naïf style here are highly reminiscent of the younger artist's work.

Although John was an excellent draftsman, he became a bold and increasingly lurid colorist. Yet this early work, painted at a time when he was concentrating on the use of three principal colors, shows an acute sensitivity in this area. It also shows the influence of French Post-Impressionism, which had a marked effect on his work (Roger Fry wanted to include him in the second Post-Impressionist exhibition in 1912). At one point he was described as, "whether he likes it or not, the leader of the [Post-Impressionist] movement in England" (Fraser Jenkins and Stephens 2004, 30). —B.D.

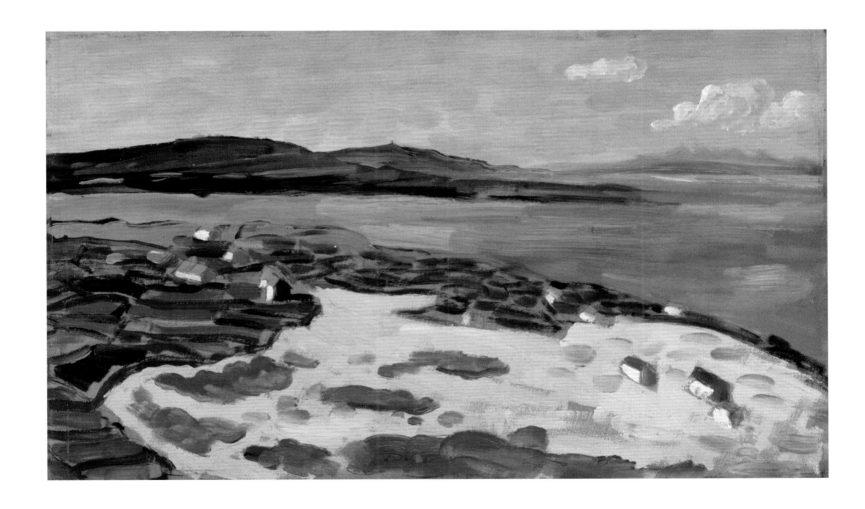

71

Robert Polhill Bevan
(1865–1925)
*Maples at Cuckfield,
Sussex*, 1914

Oil on canvas
20 ¼ × 24 ⅛ in.
(51.5 × 61.2 cm)
Amgueddfa Cymru–
National Museum Wales
Bequeathed by Margaret
Davies, 1963
NMW A 2085

Like Harold Gilman (cat. no. 57), Robert Bevan was a founding member of the Camden Town Group and a key figure in the development of modernism in Britain. In 1914, Bevan, along with Gilman and the artist Charles Ginner, formed the breakaway Cumberland Market Group, and *Maples at Cuckfield* dates from this period. It was painted at the artist's family home in Sussex, where Bevan stayed with his wife, the Polish artist Stanislava Karlowska, in the summer of 1914. It is one of three canvases dating from this stay, all depicting the same view. The work is characterized by jagged pools of shadow and angular cattle, and composed almost entirely of pale green, pink, and purple to conjure the sensation of rural hush on a hot, still day.

This painting occupies something of a midpoint for Bevan, between an earlier, softer Fauve style and a later, semi-abstract, almost Vorticist approach to the landscape. While the emphasis on angular pattern and structure is analogous with contemporary Expressionist painting, the flat, hard-edged forms and chalky palette of *Maples at Cuckfield* is most suggestive of the work of Gauguin's followers, the Nabis. In the early 1890s, Bevan had spent time at Pont-Aven, Brittany, where he had met Gauguin, and his stylistic development to an extent follows that of the older artist. Gauguin's focus on the essentials of color, surface, and form can clearly be seen in *Maples*, as can the Nabis' interest in pattern and design. Earlier oils by Bevan of this scene exist, but they display a more fluid naturalism and painterly style. This 1914 canvas sees Bevan heavily refining both color and shape, reflecting Roger Fry's aesthetic ideals of formalism, which were key to modernism in Britain in the early 1910s. —B.D.

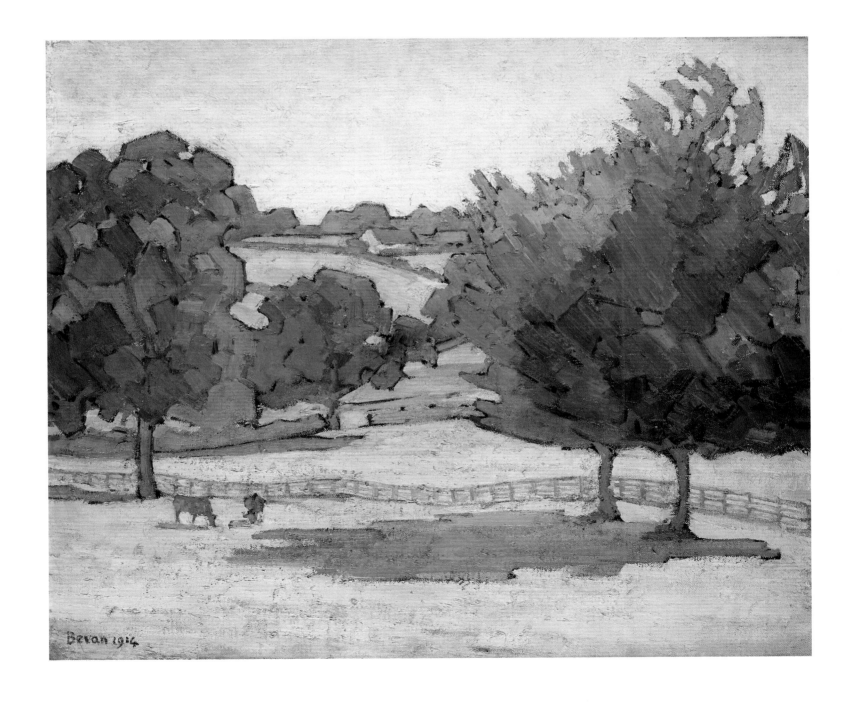

Neo-Romantic to Post-Modern

72

Samuel Palmer (1805–1881)
The Rising of the Skylark,
ca. 1843

Oil on canvas
12 ⅛ × 9 ⅝ in.
(30.8 × 24.5 cm)
Amgueddfa Cymru–
National Museum Wales
Given by Sidney Leigh
through the Art Fund, 1990
NMW A 361

Samuel Palmer was a key figure in British Romantic art and a follower of William Blake. At the village of Shoreham in Kent, Palmer produced poetic, visionary works that harked back to the medieval in both style and subject. The nineteenth-century landscape had been transformed by the Industrial Revolution, as a previously agrarian workforce found work in ever-expanding towns and cities. Palmer eschewed the "dark satanic mills" of industry, instead depicting the landscape as an archaic rural paradise, unencumbered by the cares of the outside world.

Palmer began work on *The Rising of the Skylark* in 1839, by which time he had left Shoreham and was living in London, attempting to carve out a living by producing conventional landscapes more in tune with public taste. This quietly joyful, jewel-like panel is generally viewed as an attempt to return to the ideals and idylls of Shoreham. Deriving from a sepia sketch from the early 1830s, the image of a figure observing the lark at sunrise is based on a passage from John Milton's poem *L'Allegro*:

To hear the Lark begin his flight,
And singing startle the dull night,
From his watch-towre in the skies,
Till the dappled dawn doth rise

In the earlier sketch, the figure wears a laborer's smock. For the oil, Palmer has dressed the figure in robes as if a poet, making explicit the literary associations of the painting.

While Palmer never achieved true recognition in his lifetime, his reputation was established in the twentieth century beginning with an exhibition of his work in 1926 at the Victoria and Albert Museum, London. This had a profound impact on a new generation of landscape artists such as Graham Sutherland (cat. no. 73), John Craxton (cat. no. 76), and John Piper (cat. nos. 74, 75), whose Neo-Romantic works hum with the echoes of Palmer's pastoral vision: the landscape of the imagination in an age of anxiety. —B.D.

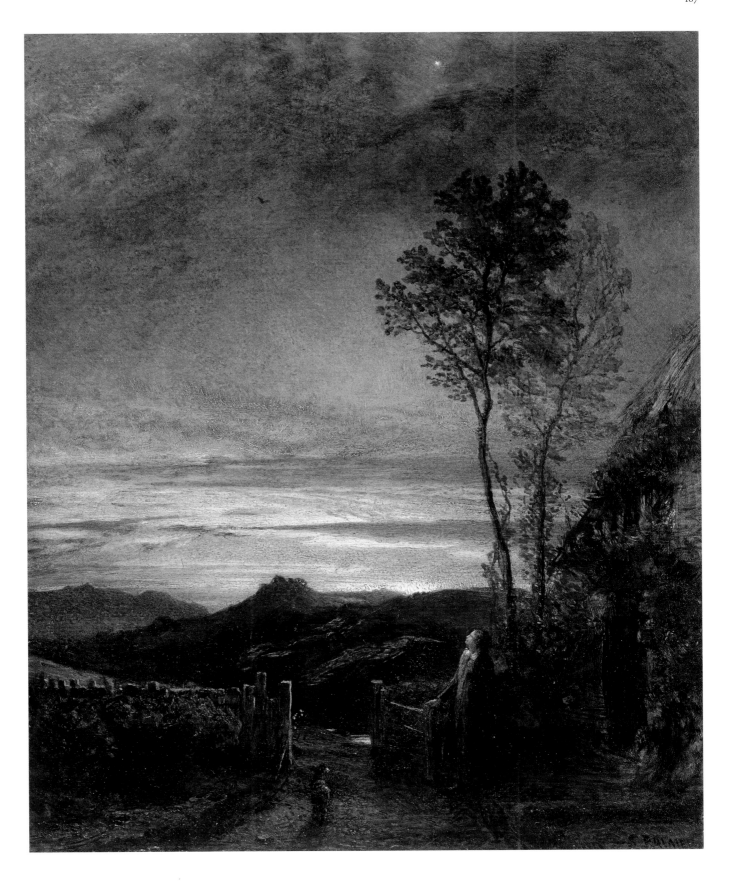

73

Graham Sutherland
(1903–1980)
*Road at Porthclais with
Setting Sun*, 1975

Oil on canvas
20 ¾ × 19 ¹³⁄₁₆ in.
(52.7 × 50.4 cm)
Amgueddfa Cymru–
National Museum Wales
Transferred by the Graham
and Kathleen Sutherland
Foundation, 1989
NMW A 2267

Porthclais is a small harbor on the St. Davids Peninsula in Pembrokeshire, the most westerly point on the mainland of Wales. Porthclais and the surrounding landscape had a profound effect on Graham Sutherland, who painted in Pembrokeshire during two periods of his life—first during the 1930s and '40s, then from 1968 until his death. *Road at Porthclais* dates from this late period, when his rediscovery of the landscape inspired his most vivid and symbolic interpretation.

Sutherland was not alone in his passion for Pembrokeshire. For a number of British landscape artists during the 1930s and '40s, including John Craxton (cat. no. 76) and John Piper (cat. nos. 74, 75), the peculiar otherness of this beautiful, remote corner of the British Isles was a haven from the anxieties of city life in the years preceding and during the Second World War. For Sutherland, the "exultant strangeness" of what he experienced in the Pembrokeshire landscape allowed him to develop his painting style, which combined the English pastoral tradition of Palmer and Blake with a keen understanding of developments in European modernism.

This image depicts what Sutherland described as "the solemn moment of sunset," as the sun sinks below the twisting roads and ancient forms of the landscape. The contrast of the murky sky with the heightened, almost acrid palette of the sun lends the work an apocalyptic drama, typical of Sutherland's work from both early and late periods.

Road at Porthclais is notable in that it reflects an interest in Cézanne that had taken root in the 1950s when Sutherland lived at Menton in the south of France. Cézanne's influence can be seen here in the controlled construction of the landscape through a dialogue of corresponding forms across the canvas. This strange and powerful painting—part observation, part memory—distinctly echoes what Roger Fry described in Cézanne as the reconciliation of "the opposing claims of design and the total vision of nature." —B.D.

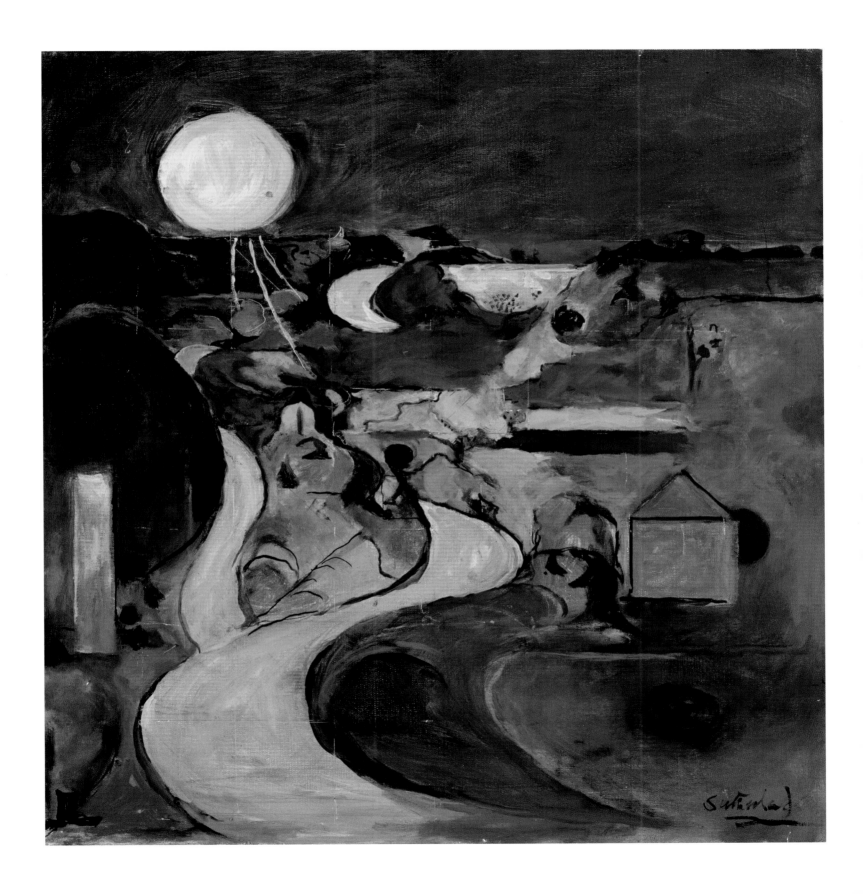

74

John Piper (1903–1992)
*Grongar Hill with Paxton's
Tower in the Distance*, 1942

Ink, watercolor, and
bodycolor on card
6 ³/₁₆ × 7 ⅝ in.
(15.7 × 19.4 cm)
Amgueddfa Cymru–
National Museum Wales
On loan from the Derek
Williams Trust
NMW A(L) 585
Utah and Princeton

This small study by John Piper depicts a dark landscape where gathering clouds envelop the towering summit of Grongar Hill. Far off in the distance, in pale muted colors, is the form of Paxton's Tower, an early nineteenth-century folly built to honor Lord Nelson. The tower, together with Drislwyn Castle and Grongar Hill, make up the three main focal points of this area of Wales. Grongar Hill lies near the River Towy, to the southwest of Llandeilo in Camarthenshire. It was once the site of an Iron Age fort and a Roman encampment, and it is also the subject of a Romantic poem by John Dyer (1699–1757). In the 1982 publication of Dyer's poem *Grongar Hill*, Piper wrote the foreword, in which he expressed his passion for this part of Wales:

> On a first camping expedition to Pembrokeshire more than sixty years ago a friend and I were astonished by the Vale of Towy, between Llandeilo and Carmarthen. It was quite clearly the Promised Land—a wide, verdant, smiling, fertile, welcoming vale that Blake might have thought up, lying between ranges of highish hills that never become mountains—and the perfect setting for classical landscapes.

Piper added that upon a second trip twenty-five years later, he found "Grongar and its surroundings have not been spoiled—they are almost as sylvan and undisturbed as they were when I was young, and the single-line railway track has not been made into a double one; it has been taken up, which I suppose would have pleased Ruskin too" (Dyer 1982, foreword). This work was painted in 1942, at the height of the Second World War, and is a study for an oil painting of Grongar Hill produced the same year.

Piper was born in 1903 in Epsom, Surrey. He studied at the Royal College of Art in London and greatly admired the landscape paintings of the Romantic artists Samuel Palmer, J. M. W. Turner, and William Blake. Inspired by these artists, Piper developed a style that became known as Neo-Romanticism. —M.M.

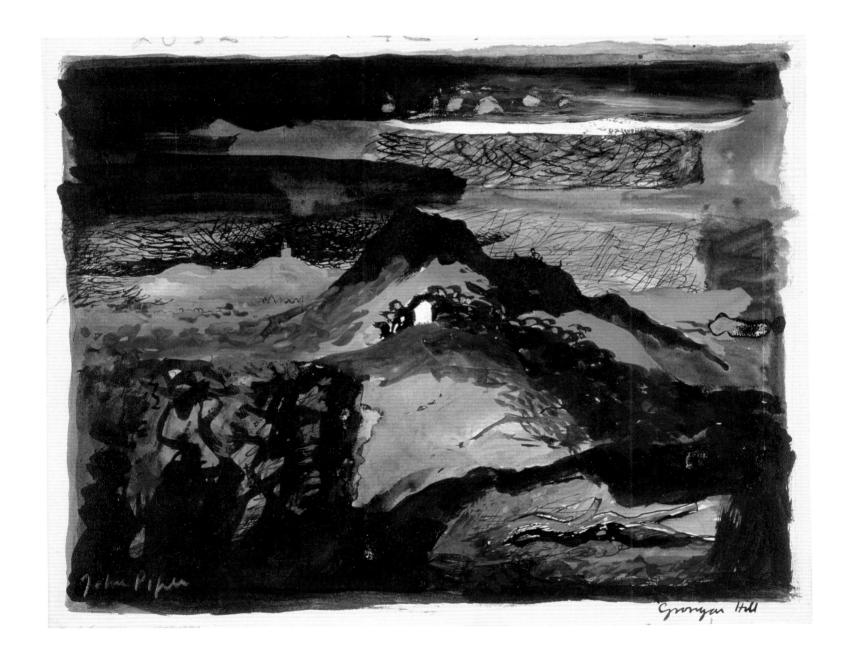

John Piper "Grongar Hill"

75

John Piper (1903–1992)
Garden Follies at Stowe,
1940s

Black chalk, India ink,
bodycolor, and watercolor
on paper
5 5/16 × 8 1/8 in.
(13.5 × 20.6 cm)
Amgueddfa Cymru–
National Museum Wales
On loan from the Derek
Williams Trust
NMW A(L) 602
Norton and Frick

Stowe in Buckinghamshire is one of the greatest English country houses of the eighteenth century. Sir John Vanbrugh, William Kent, James Gibbs, Robert Adam, and Sir John Soane—the most celebrated architects of their day—all worked there. The Temple family had acquired the Stowe estate during the reign of Queen Elizabeth I, and the house was begun by Sir Richard Temple in 1676. It remained in the Temple-Grenville family until it became Stowe School in 1923.

The landscape gardens and park are as much an attraction at Stowe as the house itself. The greatest development of the gardens occurred in the 1740s, when Capability Brown swept away the formality of the Baroque parterres and softened the landscape to create a quintessentially English garden. Many temples were built throughout the gardens, framed by long vistas, in part to reflect the family's heraldic motto, *Templa Quam Dilecta* ("how beautiful are thy temples"). In the foreground of this painting is a Gothic folly, completed around 1748. This was designed by James Gibbs and is known as the Temple of Liberty. It is an early example of Gothic Revival architecture. Here the style was used to suggest an association with the Anglo-Saxons whose free society succeeded the tyranny of the Roman Empire in Britain.

This watercolor captures the vastness of Stowe and its grounds. In the background, to the left, is the Neoclassical Queen's Temple, remodeled from 1772 to 1774, and in the center Lord Cobham's Monument. In 1939, John Piper published *Brighton Aquatints*, which was so successful that the publisher, Duckworth, proposed a sequel on Stowe. Although the book failed to materialize, Stowe became one of Piper's favorite subjects. —M.M.

76

John Craxton (1922–2009)
Landscape, 1941

Ink and oil on paper
16 × 19 ⅞ in. (40.7 × 50.5 cm)
Amgueddfa Cymru–
National Museum Wales
Purchased, 1985
NMW A 1823
Norton and Frick

The curving, wavelike forms of the hills and trees in this work create a softened romanticized landscape. The tree with its crescent-shaped branches mimicking the shape of the moon pierces the ground with its spear-shaped trunk. The predominant acidic yellow palette and the surreal organic forms appear to take inspiration from the work of Graham Sutherland.

Landscape was painted in 1941, the year John Craxton turned nineteen and was called up for military service in the Second World War. Fortunately for Craxton, his medical examination proved him unfit. Also in 1941, Craxton met Lucian Freud, with whom he would share a studio provided by their friend and patron Peter Watson. In the following year, Craxton also met John Piper, who would become a lifelong friend and to whom he would owe a great debt in terms of his stylistic development. Like Piper and John Minton, along with a generation of Neo-Romantic artists, Craxton was heavily influenced by the work of Samuel Palmer. In the catalogue to his 1967 retrospective at the Whitechapel Art Gallery, London, Craxton said:

Between 1941 and 1945, before I went to Greece, I drew and occasionally painted many pictures of landscapes with shepherds or poets as single figures. The landscapes were entirely imaginary; the shepherds were also invented—I had never seen a shepherd—but in addition to being projections of myself they derived from Blake and Palmer. (Craxton 1967, 6)

Craxton was born in London in 1922. He grew up in a household that was continuously filled with artists, musicians, art historians, and collectors. In 1940, he enrolled in drawing classes at both the Westminster and Central art schools in London. Although originally associated with the Neo-Romantics, Craxton quickly took inspiration from the work of Pablo Picasso and Joan Miró. Following the Second World War, Craxton traveled around the Mediterranean, finally settling in Crete in 1960. —M.M.

77

John Minton (1917–1957)
Welsh Landscape, 1943

Ink on paper
19 × 24 ½ in. (48.3 × 62.3 cm)
Amgueddfa Cymru–
National Museum Wales
On loan from the Derek
Williams Trust
NMW A(L) 1482
Utah and Princeton

This landscape emits an unsettling feeling with its rising hillside punctuated by sudden clefts and drops, gnarled trees and hedgerows emerging from the darkness, and a winding road that tapers off, seemingly leading to nowhere. In the left foreground sits a nude male figure with his back to us. He is turned toward what appears to be a female figure seated further away. These two nude figures provide an otherwise barren landscape with a touch of the classical idyll. The main theme of John Minton's work is the young male figure in an emotionally charged setting, which in part reflects his own homoerotic desires and fantasies.

The style, particularly the intensity of hatching in pen and ink, is reminiscent of the work of Samuel Palmer and William Blake. The quality of the line demonstrates Minton's power as a draftsman and reflects the emotional turmoil from which he suffered. It was in this year, 1943, that Minton suffered a nervous breakdown, having experienced the harshness of barracks life and fallen in love with a fellow soldier, therefore admitting his homosexuality to himself and his friends.

Minton was born in Great Shelford, near Cambridge, in 1917. He studied at St. John's Wood School of Art from 1935 to 1938. A celebrity of London bohemia and a key figure of Neo-Romanticism in the 1940s, he lived and worked with most of the younger generation of Neo-Romantics, including Michael Ayrton, Robert Colquhoun, Robert MacBryde, and Keith Vaughan. —M.M.

78

Evelyn Dunbar (1906–1960)
Baling Hay, 1940

Oil on canvas
18 1/16 × 24 in. (45.8 × 61 cm)
Amgueddfa Cymru–
National Museum Wales
Given by the War Artists
Advisory Committee, 1948
NMW A 29396

This painting is one of many commissioned during the Second World War by the War Artists Advisory Committee (WAAC). Established in 1939 by the Ministry of Information, the WAAC commissioned artists with the aims of documenting the war, raising morale, and promoting national culture. Evelyn Dunbar was one of only five women employed by the Committee (Laura Knight was another), and was sent to record the experiences of the Women's Land Army (WLA), the Auxiliary Territorial Service, and the nursing services.

In January 1943, Dunbar arrived at Usk, in Monmouthshire on the Wales–England border, to record the work of the WLA. *Baling Hay* most likely dates from this period, and serves as a record of the important work women undertook during wartime. The farm labor provided by the WLA was crucial to Britain's survival, ensuring continued food production for the U.K. population at a time when imported supplies were severely compromised. As during the First World War, the conflict of 1939 to 1945 gave many women the freedom to participate in spheres previously reserved for men, although the rigors of all-weather manual labor experienced by the WLA must have been a shock for many who signed up.

The painting shows an early mobile baling machine, into which hay was transferred via pitchfork before being mechanically baled and secured with wire. Dunbar's stay in Usk coincided with what she described as "the wettest January on record," and this is gloomily articulated through the dark clouds and the latticework of boggy footprints in the field. In what is almost a pastiche of traditional, idealized images of female pastoral labor, a bundle of wires is carried by the figure in the foreground as if it were a wheat sheaf—perhaps to emphasize how far removed from a rural idyll the experience of the WLA during wartime really was. —B.D.

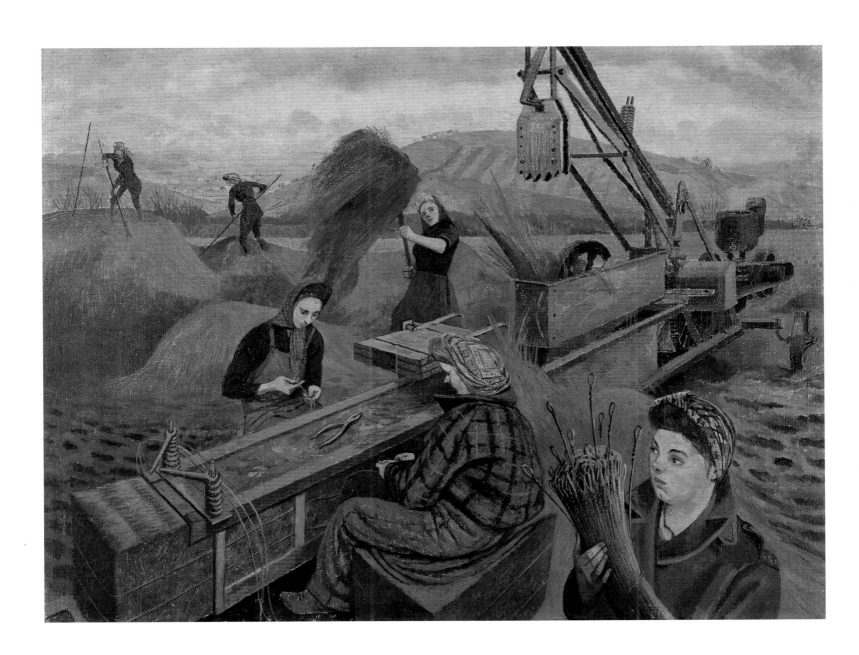

79

Cedric Morris (1889–1982)
Stoke-by-Nayland Church,
1940

Oil on canvas
23 ¾ × 31 ¹⁵/₁₆ in.
(60.3 × 81.2 cm)
Amgueddfa Cymru–
National Museum Wales
Purchased, 1944
NMW A 2042

The title of this painting points to the principal subject being St. Mary's Church at Stoke-by-Nayland. Yet the church, noted for its fifteenth-century brick tower, is of secondary importance to the pair of jays perched on the hedgerow in the foreground. This inversion of hierarchy may be a deliberate and pointed statement. Cedric Morris could be suspicious of people and institutions, but held a lifelong love and respect for nature. A renowned gardener, he surrounded himself with plants and a menagerie of exotically named pets. Birds were a particular passion, and they often featured in his paintings, with one critic in 1928 describing him as "a modern painter who can paint birds—not photographically, but with the sympathy and succinctness that we associate with early Chinese masters. Mr Morris paints living, breathing flying birds, not colored reproductions of stuffed carcasses" (Morphet 1984, 32).

In *Stoke-by-Nayland Church* Morris has combined his love of birds with his parallel interest in landscape. At the time of this painting, he had been living and working for ten years in the countryside around Dedham Vale and the Stour Valley. This stretch of lowland landscape on the Suffolk–Essex border had previously been the inspiration for many of Constable's landscapes. Indeed, Constable had sketched Stoke-by-Nayland Church in pencil and oil in the early 1810s, and produced a large, finished landscape featuring the church in 1836 (Art Institute of Chicago). Morris moved to the area having spent much of the previous decade living a bohemian life in Paris and London (cat. no. 58). Withdrawing from the metropolitan art world, he established the East Anglian School of Painting and Drawing. This idiosyncratic art school created a unique environment, much loved by students who included Lucian Freud and Maggi Hambling. —N.T.

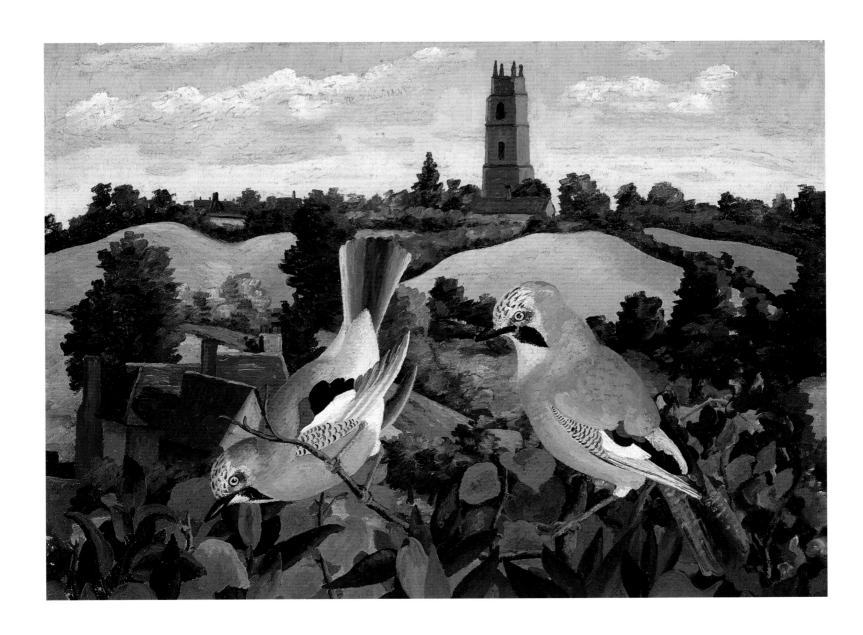

80

Ceri Giraldus Richards
(1903–1971)
Waterfall in Cardiganshire,
1947

Oil on canvas
16 × 20 ¹⁄₁₆ in.
(40.7 × 50.9 cm)
Amgueddfa Cymru–
National Museum Wales
Given by the Contemporary
Art Society for Wales, 1951
NMW A 2045

Waterfall in Cardiganshire is painted in broad, sweeping brushstrokes, conveying the impression of fast-flowing water. It is a depiction of Henllan Falls on the River Teifi in Llandysul, Cardiganshire. On this occasion in 1947, Ceri Richards was making a visit to the area to see relatives on his mother's side. There is little detailing in the rocks, which appear rather flat and semi-abstract.

The unique qualities of the Welsh landscape lent it to a Surrealist depiction, and there are elements of this in Richards's work at this time. This is similarly the case with the Pembrokeshire paintings of Graham Sutherland. Although Richards was never formally a member of the British Surrealist Group, which was established in July 1936, he did visit the International Surrealist Exhibition at the New Burlington Galleries, London, that same year. This provided him with the opportunity to view works by Max Ernst, Salvador Dalí, Pablo Picasso, and Joan Miró, among others, which had a profound influence on his own work.

Richards was born in 1903 in Dunvant, near Swansea. During his childhood, he was a gifted pianist and played the organ at Ebenezer Chapel, accompanying the choir at public concerts. This interest in music would play a major role in his work as an artist. Richards studied at Swansea School of Art and the Royal College of Art in London. While in London, he read Wassily Kandinsky's *The Art of Spiritual Harmony* in Michael Sadler's 1914 translation. Kandinsky's theories on the relationship of color and music had a significant impact on Richards's work, which is dominated by two main themes: music and poetry. —M.M.

81

John Kyffin Williams
(1918–2006)
Farmers, Cwm Nantlle, 1947

Oil on canvas
20 ³⁄₁₆ × 24 ⅛ in.
(51.2 × 61.2 cm)
Amgueddfa Cymru–
National Museum Wales
Purchased, 1948
NMW A 2616

The paintings of John Kyffin Williams, featuring the mountains and farming communities of Snowdonia, have become synonymous with the landscape and people of Wales. In *Farmers, Cwm Nantlle*, the two figures appear to emerge from the landscape. The mountains around Cwm Nantlle are set against a somber, cloudy sky, and the paint has been thickly applied. In later works, Williams would develop a more fixed style, with palette-knife marks creating staccato rhythms across the surface and olive green, gray, and ochre dominating the color selection.

Williams was born in Llangefni, Anglesey, in 1918. Educated at Shrewsbury School, he became a land agent in north Wales before joining the army in 1937. Invalided out of the army in 1941, he trained at the Slade School of Art from 1941 to 1944, and then served as art master at Highgate School from 1944 to 1973. Throughout his time in London, he regularly returned to Snowdonia to paint, eventually returning to Anglesey to live in 1973.

Perhaps because of his outspoken criticism of contemporary art, Williams is often viewed as an arch-traditionalist. Yet in the years immediately following the war, paintings such as *Farmers, Cwm Nantlle* would have been seen as modernist, influenced as much by European Expressionism as by the Neo-Romantic revival that was dominating British landscape art in the 1940s. Williams's timeless and much emulated landscapes present a very particular view of Wales, a country where, since the mid-nineteenth century, more people have worked in industry than on the land. —N.T.

82

Leon Kossoff (b. 1926)
*From Willesden Green,
Autumn*, 1991

Oil on canvas
54 1/16 × 48 1/4 in.
(137.5 × 122.5 cm)
Amgueddfa Cymru–
National Museum Wales
Purchased, 2002
NMW A 23293

London has been the principal subject and inspiration for Leon Kossoff for over sixty years. He was born and grew up in the East End, and apart from being evacuated to Kings Lynn, Norfolk, during the Second World War, he has lived and worked in London all of his life. Kossoff's favored urban subjects include railway bridges and sidings, churches, and building sites. These subjects are drawn from his immediate surroundings—places within easy reach of his studio. In this way Kossoff's city landscapes, like his figure studies of family and friends, are intensely autobiographical.

From Willesden Green, Autumn is one of a number of paintings representing the view toward the underground station at Willesden Green from the bridge near the studio the artist has occupied since 1966. The view down the track-side captures one of the indistinct areas found on the rail network where nature manages to survive alongside the modernity of the urban setting. A human presence is signaled by the three workmen standing on the track waiting for the train to pass. The landscape has been painted in a somber palette of greens, grays, and blues that capture the shifting light of an autumn day, while the painting's thick impasto and traces of paint from rapid application imbue the composition with energy.

Kossoff's choice and treatment of subject is often related to the work of his friend and fellow School of London painter Frank Auerbach (cat. no. 83). Like Auerbach, Kossoff produces his urban landscapes through a series of sketches that are then developed into the final series of paintings. Thickly painted surfaces reveal a physical engagement with surface, with the final painting often arrived at through a process of scraping down and reworking. —N.T.

83

Frank Auerbach (b. 1931)
Park Village East—Winter,
1998–99

Oil on canvas
43 ¾ × 63 ¾ in.
(111.2 × 162 cm)
Amgueddfa Cymru–
National Museum Wales
Purchased with the
assistance of the Art Fund
and of the Derek Williams
Trust, 2000
NMW A 17483

Park Village East is a street near Regent's Park, close to Frank Auerbach's studio in London. With the exception of the human figure, the inner suburbs of north London have provided the artist with perhaps his most important and enduring subject. Between 1994 and 1999, he produced a series of paintings of Park Village East, capturing the street at different times of the year. Auerbach begins a landscape by making numerous sketches in the chosen location. Six pencil and ink sketches for *Park Village East— Winter* were retained by the artist and were also acquired by the National Museum of Wales. Auerbach uses the sketches as guides to paint the final work in the studio. A process of painting and scraping down is followed by an intense period of work to realize the final composition. A painting is finished when Auerbach achieves what he describes as a "reinvention of the physical world."

The energy and immediacy of the sketches for *Park Village East—Winter* have been transferred to the final painting. The thick impasto—a characteristic of Auerbach's surfaces—gives the painting an almost sculptural presence. Together with Lucian Freud, Francis Bacon, and Leon Kossoff (cat. no. 82), he is often grouped under the label School of London. What unites these artists has been a strong commitment to figurative painting set against a wider shift toward Pop, abstraction, and Conceptual art.

Indeed, Auerbach's knowledge of and commitment to the traditions of painting are central to his practice. In *Park Village East—Winter* he openly acknowledges the composition of John Constable's *The Hay Wain,* encouraging us to see his work in relation to the grand tradition of British landscape painting. —N.T.

84

Jack Crabtree (b. 1938)
Polluted Pool at Maindee,
1974

Oil on plywood
29 ½ × 29 in.
(74.9 × 73.7 cm)
Amgueddfa Cymru–
National Museum Wales
Given by Paul Jenkins, 1975
NMW A 731

The lurid greens and yellows of this painting permeate every section of the landscape, including the dense clouds in the sky. The extension of this color beyond the "polluted pool" makes the whole landscape appear contaminated and grimy. Any plant life is near an end, with only seedpods remaining, clustered around the edges of the canvas. In the lower foreground is a startling, almost futuristic-looking figure in goggles staring back at us. Reflected in the goggles is merely a flat expanse of polluted land with nothing on the horizon. The figure is a self-portrait of the artist.

Polluted Pool at Maindee was painted in 1974, while Jack Crabtree was teaching at Newport College of Art. Maindee is an area of Newport in south Wales, once a heavily industrialized part of the country through which coal and iron ore were exported. During this time, Crabtree was interested in the impact of industry on the landscape. In 1974, he was invited to work with the National Coal Board for a year, which gave him unprecedented access to working life in the coal mines of south Wales.

Crabtree was born in Rochdale, Lancashire, in 1938. He studied at St. Martin's College of Art, London, from 1957 to 1959 and the Royal Academy Schools from 1959 to 1961. After living and working in Wales for a number of years and becoming a member of the 56 Group Wales, Crabtree later settled in France. This painting belonged to the American Abstract Expressionist painter Paul Jenkins, and was given to the National Museum of Wales in 1975, the year after it was painted. —M.M.

85

Richard Long (b. 1945)
*Snowdonia Stones
(along a five day walk
in North Wales)*, 2006

Inkjet print from 35 mm
color slide with text
39 3/8 × 48 7/16 in.
(100 × 123 cm)
Amgueddfa Cymru–
National Museum Wales
On loan from the Derek
Williams Trust
NMW A(L) 1806
Norton and Frick

This photograph and text work records an intervention in the landscape by Richard Long made while walking in Snowdonia in 2006. Below the photograph is the title and description, handwritten in pencil by the artist. The upraised stones that can be seen in the foreground have been placed in these positions by the artist. The resulting photograph is a testament not only to Long's presence in the landscape but also to the entire experience of the five-day walk.

Long is an important figure in a generation of British artists who used a conceptual approach to making art to question the values and assumptions of the traditional definitions of what art and, in the case of Long, specifically sculpture could and should be. From the late 1960s to the present day, he has used walking as a means to make art. A walk in the landscape became the realization of an idea that would be recorded by the most appropriate means

available: maps, photographs, or text. It was this early manifestation of Conceptual art in Britain that made Long's work so groundbreaking in the 1960s, releasing art, particularly sculpture, from the confines of the museum.

Not all of Long's sculptures remain in the landscape. He often brings the materials into the gallery, as he did for *Blaenau Ffestiniog Circle*, 2011 (fig. 8, p. 55), which was made specifically for the new Modern and Contemporary Art Galleries of the National Museum. The forms he chooses to depict, such as circles, lines, spirals, and crosses, are simple, and they all in some way reconnect with nature and the natural materials he is using.

Long was born in 1945 in Bristol, where he still lives and works. He studied at the West of England College of Art in Bristol from 1962 to 1965, followed by St. Martin's School of Art in London from 1966 to 1968. —M.M.

SNOWDONIA STONES

ALONG A FIVE DAY WALK IN NORTH WALES

2006

86

Hamish Fulton (b. 1946)
Cader Idris, 1987

Gelatin silver print with
text mounted on board
43 ½ × 49 ¹⁵⁄₁₆ in.
(110.4 × 126.8 cm)
Amgueddfa Cymru–
National Museum Wales
Purchased, 2005
NMW A 24387
Utah and Princeton

Cadair Idris is a mountain in the southern reaches of Snowdonia. Slightly removed from the peaks to the north, it dominates the surrounding landscape and is said to be the most visited mountain in Wales after Snowdon. Its pointed, rocky profile and the mountain lakes of Llyn Cau and Llyn y Gadair have made Cadair Idris a source of myth and legend as well as a popular subject for artists in search of the Romantic sublime. Hamish Fulton's photographic and text work can be seen as part of a strong lineage of artists who over the centuries have been drawn to this mountain, including Richard Wilson, J. M. W. Turner, and John Sell Cotman (cat. no. 11).

Fulton is a key figure in a generation of artists who emerged in Europe and the United States in the 1960s, and who tested the boundaries of art making and fundamentally questioned the assumed "objecthood" of art. In Britain many of these artists made their conceptual innovations with reference to the traditional genre of landscape. In this expanded field of art making a walk through the landscape could be the work, with photographs and text in the gallery being essentially a record or documentation of the art. Fulton remains one of the purest exponents of this form of conceptual land art, made clear in his statement: "No Walk, No Work."

Cader Idris is one of seven unique photographs taken by Fulton on hill or mountain tops during a walk "from south Wales to north east England by way of seven hill tops." The text accompanying the images also tells us that the 604-mile walk took 21 days and that Fulton also visited the Brecon Beacons, Bleaklow Head, the Cleveland Hills, the Yorkshire Dales, Helvellyn, and the Cheviot Hills. The resulting work—an extended journey across Britain—exists in the public realm only through the combination of succinct description and image. Yet the work invites us to imagine Fulton's experiences in a way that is as associative as the Romantic tradition of British landscape painting. —N.T.

CADER IDRIS

A 21 DAY 604 MILE COAST TO COAST ROAD WALKING JOURNEY

FROM SOUTH WALES TO NORTH EAST ENGLAND BY WAY OF SEVEN HILL TOPS

LATE SUMMER 1987

BRECON BEACONS CADER IDRIS BLEAKLOW HEAD CLEVELAND HILLS

YORKSHIRE DALES HELVELLYN CHEVIOT HILLS

87, 88

87
David Nash (b. 1945)
Ash Dome, 1999–2000

Two chromogenic prints
with pencil text mounted
on board
28 ⁹⁄₁₆ × 5 ⁷⁄₁₆ in.
(72.5 × 13.8 cm)
Amgueddfa Cymru–
National Museum Wales
On loan from the Derek
Williams Trust
NMW A(L) 1179
Norton and Frick

88
David Nash (b. 1945)
Ash Dome, 2000

Twelve gelatin silver prints
mounted on board
45 ¹⁵⁄₁₆ × 64 in.
(116.7 × 162.5 cm)
Amgueddfa Cymru–
National Museum Wales
On loan from the Derek
Williams Trust
NMW A(L) 1181
Utah and Princeton

In 1977, David Nash decided to produce a work that was intended as an "act of faith" in the future. He planted twenty-two ash trees in a circle nine meters in diameter at his home in Blaenau Ffestiniog in north Wales. The intention was to stay and tend the trees for the next thirty years, to make a dome that would develop and exist into the twenty-first century. He used ash trees because of their capacity to grow in a leaning fashion toward light and their resilience and ability to recover vigorously from being pruned.

Nash distinguishes between his works with the terms "coming" and "going." These two terms describe the difference between works that are trees growing (coming) or wood decomposing/degrading (going). *Ash Dome* was the first of the "coming" works, while *Wooden Boulder* is the first of the "going" works, dating to 1978, and is also represented by a portfolio of work within the collection of the Derek Williams Trust.

Ash Dome drawings and photographs document the work in progress. The two paired photographs (cat. no. 87) span the turn of the millennium, one being taken in the afternoon of New Year's Eve 1999 and the other in the morning of New Year's Day 2000. Nash often uses photography as a means of recording the development and techniques of his work.

Nash was born in Surrey in 1945. He studied at Kingston College of Art (1963), Brighton College (1964–67), and Chelsea School of Art (1969–70). Nash moved to the slate-quarrying village of Blaenau Ffestiniog in 1967 in an attempt to escape the pressures of the London art world. There he purchased Capel Rhiw, a local chapel, which became his studio space. —M.M.

87

88

Notes

Pastures Green and Dark Satanic Mills

1 Some of his collection, including opulent examples of eighteenth-century silver and ceramics and a magnificent organ from his London townhouse, are now in the collection of National Museum Wales.

2 David H. Solkin, *Richard Wilson: The Landscape of Reaction* (London: Tate Gallery, 1982).

3 See Elizabeth E. Barker and Alex Kidson, eds., *Joseph Wright of Derby in Liverpool* (New Haven: Yale University Press, 2007).

4 On Jones, see Ann Sumner and Greg Smith, *Thomas Jones: An Artist Rediscovered* (New Haven: Yale University Press / Cardiff: National Museum Wales, 2003). *The Bard* is discussed on p. 142.

5 Thomas Gainsborough to William Jackson, in John Hayes, ed., *The Letters of Thomas Gainsborough* (New Haven: Yale University Press, 2001), 68.

6 See Theresa Fairbanks Harris, *Papermaking and the Art of Watercolor in the Eighteenth Century: Paul Sandby and the Whatman Paper Mill* (New Haven: Yale University Press, 2006).

7 On Gilpin, see Malcolm Andrews, *The Search for the Picturesque* (Aldershot: Scolar Press, 1989).

8 For a discussion of Turner that does justice to this aspect of his life and work, see John Gage, *J. M. W. Turner: "A Wonderful Range of Mind"* (New Haven: Yale University Press, 1987).

9 Edmund Burke, *A Philosophical Enquiry into the Origin of our Ideas of the Sublime and the Beautiful*, ed. Adam Phillips (Oxford: Oxford University Press, 1996), 36.

10 David Hill, *Turner in the Alps: The Journey through France & Switzerland in 1802* (London: George Philip, 1992), 57–60.

11 Lawrence Gowing, *The Originality of Thomas Jones* (London: Thames and Hudson, 1985).

12 John Constable to Archdeacon John Fisher, October 23, 1821, in R. B. Beckett, ed., *John Constable's Correspondence*, 6 vols. (Ipswich: Suffolk Records Society, 1968), 6:78.

13 Christiana Payne, "Boundless Harvests: Representations of Open Fields and Gleaning in Early Nineteenth Century England," *Turner Studies* 11, no. 1 (Summer 1991): 7–15. See also Tim Barringer, "*The Wheat Field*," in Jay Clarke, ed., *Landscape, Innovation, and Nostalgia: The Manton Collection of British Art* (Williamstown, MA: Sterling and Francine Clark Art Institute, 2012), 186–205.

14 For an account of the significance of this legislation, see Philip Corrigan and Derek Sayer, *The Great Arch: State Formation as Cultural Revolution* (Oxford: Blackwell, 1985).

15 For a full discussion of these processes, see Sarah Kennel, Diane Waggoner, and Alice Carver-Kuik, *In the Darkroom: An Illustrated Guide to Photographic Processes before the Digital Age* (Washington, DC: National Gallery of Art, 2011), 35, 59.

16 See Rollin Buckman, *The Photographic Work of Calvert Richard Jones* (London: HMSO / Science Museum, 1990), and Richard Morris, *John Dillwyn Llewelyn 1810–1882: The First Photographer in Wales* (Cardiff: Welsh Arts Council, 1980).

17 Diane Waggoner, ed., *The Pre-Raphaelite Lens: British Photography and Painting, 1848–1875* (Washington, DC: National Gallery of Art, 2010).

18 The Welsh national costume seen here had only recently been revived, as part of a wider Victorian attempt to restore local traditions destroyed by urbanization. Such clothes would only be worn on special occasions, and knitting is, in any case, a strange occupation for a mountaintop.

19 John Ruskin, "The Storm Cloud of the Nineteenth Century," in *The Works of John Ruskin*, ed. E. T. Cook and Alexander Wedderburn, 39 vols. (London: George Allen, 1903–12), 34:xxii–80.

20 Claude Monet, in R. Gimpel, *Journal d'un collectionneur* (Paris, 1968), 88, trans. and quoted John House, "London in the Art of Monet and Pissarro," in Malcolm Warner, ed., *The Image of London: Views by Travellers and Emigrés, 1550–1920* (London: Barbican Art Gallery, 1987), essay 73–98, quote on p. 77.

21 Wynford Dewhurst, *Impressionist Painting: Its Genesis and Development*, 1904, quoted John Rewald, ed., *Pissarro: Letters to his Son, Lucien* (Santa Barbara, CA: Peregrine Smith, 1981), 470. See also Alan Bowness, *Impressionists in London* (London: Arts Council, 1973).

22 Desmond McCarthy, "The Art-Quake of 1910," *The Listener*, February 1, 1943, 124, quoted in Anna Gruetzner Robins, *Modern Art in Britain 1910–1914* (London: Barbican Art Gallery, 1997), 15.

23 Laurence Binyon, *The Followers of William Blake: Edward Calvert, George Richmond & Their Circle* (London: Halton and Smith, 1925). See also Colin Harrison, "The Artistic Rediscovery of Samuel Palmer," in William Vaughan, Elizabeth Barker, and Colin Harrison, eds., *Samuel Palmer 1805–1881: Vision and Landscape* (Burlington, VT: Lund Humphries, 2005), and Colin Trodd, *Visions of Blake: William Blake in the Art World, 1830–1930* (Liverpool: Liverpool University Press, 2012).

24 John Milton, *L'Allegro*, lines 41–44.

25 For a fuller version of this analysis, see Tim

izeok

Barringer, "'I am a Native, Rooted Here': Benjamin Britten, Samuel Palmer and the Neo-Romantic Pastoral," *Art History*, February 2011, 126–65.

26 John Dyer, "Grongar Hill," in *Poems by John Dyer viz. I. Grongar Hill. II. The Ruins of Rome. III. The Fleece* (London: John Hughes, 1761), 10.

27 Alastair Hicks, *The School of London* (Oxford: Phaidon, 1989).

28 Jonathan Bate, *Romantic Ecology: Wordsworth and the Environmental Tradition* (London: Routledge, 1991); Michael Wheeler, ed., *Ruskin and the Environment: The Storm-Cloud of the Nineteenth Century* (Manchester: Manchester University Press, 1995).

29 See Clarrie Wallis, ed., *Richard Long: Heaven and Earth* (London: Tate Publishing, 2009), 44.

"Hen Gymru fynyddig, paradwys y bardd"

1 From "Maen Hen Wlad Fy Nhadau," the Welsh national anthem, written in 1856. A literal translation is "Old mountainous Wales, paradise of the bard," and the poem continues, "Every valley, every cliff, to my look is beautiful."

2 For a brief account of the art collections of the National Museum, see Oliver Fairclough, ed., *A Companion Guide to the Welsh National Museum of Art* (Cardiff: National Museum Wales, 2011), 6–11.

3 "With the name of Richard Wilson the history of sincere landscape art, founded on a meditative love of Nature, begins for England: and I may add, for Europe." John Ruskin, in the lecture "The Art of England"; *The Works of John Ruskin*, ed. E. T. Cook and Alexander Wedderburn, 39 vols. (London: George Allen, 1903–12), 33:378.

4 For Richard Wilson, see David H. Solkin, *Richard Wilson: The Landscape of Reaction* (London: Tate Gallery, 1982), and W. G. Constable, *Richard Wilson* (London: Routledge and Kegan Paul, 1953).

5 Daniel Defoe, *A Tour through the Whole Island of Great Britain*, 3 vols., ed. G. D. H. Cole (1726; London: J. M. Dent & Sons, 1974), "A country looking so full of horror" (2:191).

6 Prys Morgan, *A New History of Wales: The Eighteenth Century Renaissance* (Llandybie: Christopher Davies Ltd, 1981), 67–100.

7 In his "Account of a Journey into Wales in Two Letters to Mr Bower," written in 1755; see *The Works of George Lord Lyttleton formerly printed separately: And now first collected together with some other pieces never before collected*, ed. George Edward Ayscough (London: J. Dodsley, 1776), 329–52.

8 Solkin, *Richard Wilson*, 148–49, cat. no. 7.

9 Thomas Pennant, *Tours in Wales*, 3 vols., ed. John Rhys (1778; Caernarvon: H. Humphreys, 1883), 2:392.

10 For the Wye Valley tour, see Julian Mitchell, *The Wye Tour and its Artists* (Almeley: Monmouthshire Museums Service / Logaston Press, 2010), 15–88, and Malcolm Andrews, *The Search for the Picturesque* (Aldershot: Scolar Press, 1989), 85–107.

11 Rev. William Gilpin, *Observations on the River Wye, and Several Parts of South Wales, &c., Relative Chiefly to Picturesque Beauty; Made in the Summer of the Year 1770* (London: R. Blamire, 1782), 1.

12 In a letter of August 24, 1770; see Paget Toynbee and Leonard Whibley, eds., *The Correspondence of Thomas Gray* (Oxford: Oxford University Press, 1935), 1144.

13 In a letter of July 3, 1770, quoted in C. P.

Barbier, *William Gilpin: His Drawings, Teaching and Theory of the Picturesque* (Oxford: Oxford University Press, 1963), 50.

14 See Andrews, *The Search for the Picturesque*, 108–51.

15 For Moses Griffith, see *Oxford Dictionary of National Biography*, http://www.oxforddnb.com/templates/article.jsp?articleid=11604&back=, and Donald Moore, *Moses Griffith 1747–1819: Artist and Illustrator in the Service of Thomas Pennant* (Caernarvon: Welsh Arts Council, 1979).

16 Henry Penruddocke Wyndham, *A Gentleman's Tour through Monmouthshire and Wales, in the Months of June and July 1774* (London: T. Evans, 1775), and *A Tour through Monmouthshire and Wales Made in the Months of June and July 1774 and June, July, and August 1777* (Salisbury: E. Easton, 1781). For Wyndham, see *Oxford Dictionary of National Biography*, http://www.oxforddnb.com/view/printable/30142.

17 Peter Hughes, "Paul Sandby and Sir Watkin Williams-Wynn," *Burlington Magazine* 114, no. 832 (July 1972), 459–66.

18 Uvedale Price was the author of *Essay on the Picturesque, as Compared with the Sublime and the Beautiful* (London: J. Robson, 1794).

19 For Hafod and Thomas Johnes, see George Cumberland, *An Attempt to Describe Hafod…* (London: W. Wilson, 1796), and Elizabeth Inglis-Jones, *Peacocks in Paradise* (London: Faber & Faber, 1960). Most of the estate is now owned by the Forestry Commission and managed in partnership with the Hafod Trust; see http://www.hafod.org/homepage.html.

20 The name Beddgelert ("grave of Gelert") probably refers to the burial place of an early Christian saint, but by the late eighteenth

century it was the subject of a romantic tale of a heroic hound who saved his master's sleeping son from a wolf or snake, only to be slain in error as the attacker.

21 *James Plumptre's Britain: The Journals of a Tourist in the 1790s*, ed. Ian Ousby (London: Hutchinson, 1992), 40.

22 Celebrated in the late eighteenth century as the habitation of the "female hermits" Lady Eleanor Butler (1739–1829) and Sarah Ponsonby (1755–1831); see Elizabeth Mavor, *The Ladies of Llangollen: A Study in Romantic Friendship* (London: Michael Joseph, 1971).

23 Andrew Wilton, *Turner in Wales* (Llandudno: Oriel Mostyn, 1984), 5–33.

24 Greg Smith, *Thomas Girtin: The Art of Watercolour* (London: Tate Publishing, 2002), 153.

25 Thomas Roscoe, *Wanderings and Excursions in North Wales*, 2nd ed. (London: Tilt and Bogue, [1839?]).

26 Peter Lord, *Clarence Whaite and the Welsh Art World: The Betws-y-coed Artists' Colony* (Aberystwyth: National Library of Wales, 1998), 34–59.

27 Ibid., 60–107.

28 David Cordingley, "John Brett in Wales," in *John Brett: A Pre-Raphaelite on the Shores of Wales* (Cardiff: National Museum Wales, 2001), 28–37.

29 This painting was with Artis Fine Art Ltd, London, in 2011; see also C. G. Carus, *The King of Saxony's Journey through England and Scotland in the Year 1844* (London: Chapman and Hall, 1846), 228–29.

30 Christopher Riopelle and Ann Sumner, *Sisley in England and Wales* (London: National Gallery, 2008), 30–52.

31 Gordon Baldwin, *All the Mighty World: The Photographs of Roger Fenton* (New York: Metropolitan Museum of Art, 2004), 41–46.

32 Calvert Richard Jones made a daguerreotype of Margam in March 1841 (National Library of Wales, PG00726), and there are seven calotype prints of the house dating from about 1845 in the collection of the Victoria and Albert Museum. See also Rollin Buckman, *The Photographic Work of Calvert Richard Jones* (London: HMSO / Science Museum, 1990).

33 See Noel Chanan, *The Photographer of Penllergare: A Life of John Dillwyn Llewelyn* (London: Impress, 2013).

34 For John, see Fiona Pearson, *Goscombe John at the National Museum of Wales* (Cardiff: National Museum of Wales, 1979). In a memorandum of 1913 titled "Method of Purchasing Works of Art," he described Wilson, together with John Gibson and Edward Burne-Jones, as "pre-eminent amongst artists connected with Wales."

35 Constable, *Richard Wilson*, 173, pl. 32b.

36 See Clive Adams, *Some Miraculous Promised Land: J. D. Innes, Augustus John, and Derwent Lees in North Wales 1910–13* (Llandudno: Mostyn Art Gallery, 1982), and Eric Rowan and Carolyn Stewart, *An Elusive Tradition: Art and Society in Wales, 1870–1950* (Cardiff: University of Wales Press, 2002), 62–89.

37 Oliver Fairclough, "'The Great Joy of Collecting': Modern French Art in the Davies Collection," in *Turner to Cézanne: Masterpieces from the Davies Collection, National Museum Wales* (New York: American Federation of Arts / Hudson Hills Press, 2009), 12–21.

38 Ronald Alley, *Graham Sutherland* (London: Tate Gallery, 1982), and *Sutherland in Wales: A Catalogue of the Collection at the Graham Sutherland Gallery, Picton Castle, Haverford West, Dyfed* (London: Alistair McAlpine, 1976).

39 David Fraser Jenkins and Melissa Munro, *John Piper: The Mountains of Wales* (Cardiff: National Museum of Wales, 2012), 11–21.

40 Rachel Flynn, "Archiving the Artist: The Graham Sutherland Collection at Amgueddfa Cymru–National Museum Wales" (PhD diss., University of Bristol, 2012).

41 For a recent survey of work in Wales, see Iwan Bala, ed., *Groundbreaking: The Artist in the Changing Landscape* (Bridgend: Seren / Cywaith Cymru–Artworks Wales, 2005).

42 The artist, quoted at http://www.eisteddfod. org.uk/english/2013/news-2013/?request=4413.

Right
Joseph Mallord William Turner,
Marford Mill, ca. 1794–95
(cat. no. 16, detail)

Selected Bibliography

Pastures Green and Dark Satanic Mills

Andrews, Malcolm. *The Picturesque: Literary Sources and Documents*. Firle, East Sussex: Helm, 1994.

———. *The Search for the Picturesque*. Aldershot: Scolar Press, 1989.

Barrell, John. *The Dark Side of the Landscape*. Cambridge: Cambridge University Press, 1980.

———. *The Idea of Landscape and the Sense of Place 1730–1840*. Cambridge: Cambridge University Press, 1972.

Barrell, John, ed. *Painting and the Politics of Culture*. Oxford: Oxford University Press, 1993.

Barringer, Tim, Jason Rosenfeld, and Alison Smith. *Pre-Raphaelites: Victorian Avant-Garde*. London: Tate Publishing, 2012.

Beckett, J. V. *The Agricultural Revolution*. Oxford: Basil Blackwell, 1990.

Bermingham, Anne. *Landscape and Ideology: The English Rustic Tradition, 1740–1850*. Berkeley: University of California Press, 1986.

Bindman, David. *William Blake: His Art and Times*. New Haven: Yale University Press, 1982.

Clarke, Jay, ed. *Landscape, Innovation, and Nostalgia: The Manton Collection of British Art*. Williamstown, MA: Sterling and Francine Clark Art Institute, 2012.

Daniels, Stephen. *Fields of Vision: Landscape Imagery and National Identity in England and the Unites States*. Cambridge: Polity, 1993.

Daniels, Stephen, and Denis Cosgrove, eds. *The Iconography of Landscape*. Cambridge: Cambridge University Press, 1988.

De Bolla, Peter. *The Discourse of the Sublime*. Oxford: Basil Blackwell, 1989.

Everett, Nigel. *The Tory View of Landscape*. New Haven: Yale University Press, 1994.

Foss, Brian. *War Paint: Art, War, State and Identity in Britain, 1939–1945*. New Haven: Yale University Press, 2007.

Hauser, Kitty. *Shadow Sites: Photography, Archaeology and the British Landscape, 1927–1955*. Oxford: Oxford University Press, 2007.

Hicks, Alastair. *The School of London*. Oxford: Phaidon, 1989.

Klonk, Charlotte. *Science and the Perception of Nature: British Landscape Art in the Late Eighteenth and Early Nineteenth Centuries*. New Haven: Yale University Press, 1996.

Mellor, David A., ed. *A Paradise Lost: The Neo-Romantic Imagination in Britain, 1935–55*. London: Barbican Art Gallery, 1987.

Ousby, Ian. *The Englishman's England: Travel, Taste and the Rise of Tourism*. Cambridge: Cambridge University Press, 1990.

Paley, Morton D. *The Apocalyptic Sublime*. New Haven: Yale University Press, 1986.

Paulson, Ronald. *Literary Landscape: Constable and Turner*. New Haven: Yale University Press, 1982.

Payne, Christiana. *Toil and Plenty: Images of the Agricultural Landscape in Britain, 1780–1890*. New Haven: Yale University Press, 1993.

Robins, Anna Gruetzner. *Modern Art in Britain 1910–1914*. London: Barbican Art Gallery, 1997.

Sillars, Stuart. *British Romantic Art and the Second World War*. London: Macmillan, 1991.

Staley, Allen. *The Pre-Raphaelite Landscape*. New Haven: Yale University Press, 2005.

Waggoner, Diane, ed. *The Pre-Raphaelite Lens: British Photography and Painting, 1848–1875*. Washington, DC: National Gallery of Art, 2010.

Williams, Raymond. *The Country and the City*. London: Hogarth Press, 1985.

Wrigley, E. A. *Continuity, Chance and Change: The Character of the Industrial Revolution in England*. Cambridge: Cambridge University Press, 1988.

"Hen Gymru fynddig, paradwys y bardd"

Bala, Iwan, ed. *Groundbreaking: The Artist in the Changing Landscape*. Bridgend: Seren / Cywaith Cymru–Artworks Wales, 2005.

Fairclough, Oliver, ed. *A Companion Guide to the Welsh National Museum of Art*. Cardiff: National Museum Wales, 2011.

———. "'The Great Joy of Collecting': Modern French Art in the Davies Collection," in *Turner to Cézanne: Masterpieces from the Davies Collection, National Museum Wales*. New York: American Federation of Arts / Hudson Hills Press, 2009.

Lord, Peter. *The Visual Culture of Wales: Imaging the Nation*. Cardiff: University of Wales Press, 2000.

———. *The Visual Culture of Wales: Industrial Society*. Cardiff: University of Wales Press, 1998.

Ousby, Ian, ed. *James Plumptre's Britain: The Journals of a Tourist in the 1790s*. London: Hutchinson, 1992.

Pennant, Thomas. *Tours in Wales*, 3 vols. Caernarvon: H. Humphreys, 1883. First published 1788, London. Edited by John Rhys.

Sumner, Ann. *Colour and Light: Fifty Impressionist and Post-Impressionist Works at the National Museum of Wales*. Cardiff: National Museum Wales, 2005.

Catalogue

Cat. no. 1

Jones, Thomas. *Memoirs*, printed in *The Walpole Society, 1946–1948*. London: Oliver Burridge, 1951.

Röthlisberger, Marcel. *Claude Lorrain: The Paintings*. London: A. Zwemmer, 1961.

Sonnabend, Martin, and Jon Whiteley. *Claude Lorrain: The Enchanted Landscape*. Oxford: Ashmolean Museum, 2011.

Cat. no. 2

Salerno, L. *L'opera completa di Salvator Rosa*. Milan: Rizzoli, 1975.

Scott, Jonathan. *Salvator Rosa: His Life and Times*. New Haven: Yale University Press, 1995.

Cat. no. 3

Constable, W. G. *Richard Wilson*. London: Routledge and Kegan Paul, 1953.

Solkin, David H. *Richard Wilson: The Landscape of Reaction*. London: Tate Gallery, 1982.

Cat. no. 4

Hayes, John. *The Landscape Paintings of Thomas Gainsborough*. London: Sotheby's Publications Ltd, 1982.

Sloman, Sue. *Gainsborough in Bath*. New Haven: Yale University Press, 2012.

Cat. nos. 5, 31, 32

Jones, Thomas. *Memoirs*, printed in *The Walpole Society, 1946–1948*. London: Oliver Burridge, 1951.

Sumner, Ann, and Greg Smith, eds. *Thomas Jones: An Artist Rediscovered*. New Haven: Yale University Press / Cardiff: National Museum Wales, 2003.

Cat. no. 6

Fiske, Tina. "Richards, John Inigo (1730/31?–1810)," *Oxford Dictionary of National Biography*.

Oxford: Oxford University Press, 2004. http://www.oxforddnb.com/view/article/23535.

Cat. no. 7

Barker, Elizabeth E., and Alex Kidson, eds. *Joseph Wright of Derby in Liverpool*. New Haven: Yale University Press, 2007.

Egerton, Judy. *Joseph Wright of Derby*. London: Tate Gallery, 1991.

Jones, Thomas. *Memoirs*, printed in *The Walpole Society, 1946–1948*. London: Oliver Burridge, 1951.

Nicholson, Benedict. *Joseph Wright of Derby: Painter of Light*. London: Routledge and Kegan Paul, 1968.

Cat. no. 8

McCallum, Iain. *Thomas Barker of Bath: The Artist and his Circle*. Bath: Millstream Books, 2003.

Cat. nos. 9, 10

Girtin, Thomas, and David Loshak. *The Art of Thomas Girtin*. London: A & C Black, 1954.

Hill, David. *Thomas Girtin, Genius in the North*. Leeds: Harewood House Trust, 1999.

Smith, Greg. *Thomas Girtin: The Art of Watercolour*. London: Tate Publishing, 2002.

Cat. no. 11

Kitson, Sydney D. *The Life of John Sell Cotman*. London: Faber and Faber, 1937.

Cat. no. 12

Birmingham Museum and Art Gallery. *David Cox 1783–1859*. Birmingham: Birmingham Museum and Art Gallery, 1983.

Wilcox, Scott, ed. *Sun, Wind and Rain: The Art of David Cox*. New Haven: Yale Center for British Art, 2008.

Cat. no. 13

Payne, Matthew, and James Payne. *Regarding Thomas Rowlandson, 1757–1827: His Life, Art and Acquaintance*. London: Hogarth Arts, 2010.

Cat. no. 14

Carretta, V. "Combe [*formerly* Combes], William (1742–1823)," *Oxford Dictionary of National Biography*, vol. 12, 852–56. Oxford: Oxford University Press, 2004.

Hamilton, H. W. *Doctor Syntax: A Silhouette of William Combe, Esq. (1742–1823)*. London: Chatto and Windus, 1969.

Cat. nos. 15–22

Gibbs, J. M. *James Pyke Thompson, the Turner House, Penarth, 1888–1988*. Cardiff: National Museum Wales, 1990.

Hamilton, James. *Turner and Italy*. Edinburgh: National Galleries of Scotland, 2009.

———. *Turner's Britain*. London: Merrell Publishers, 2004.

Hill, David. *Turner in the Alps: The Journey through France & Switzerland in 1802*. London: George Philip, 1992.

Powell, Cecilia. *Turner in Germany*. London: Tate Gallery, 1995.

———. *Turner's Rivers of Europe*. London: Tate Gallery, 1991.

Shanes, Eric, Evelyn Joll, Ian Warrell, and Andrew Wilton. *Turner: The Great Watercolours*. London: Royal Academy, 2001.

Solkin, David, ed. *Turner and the Masters*. London: Tate Publishing, 2010.

Wilton, Andrew. *The Life and Work of J. M. W. Turner*. London: Academy Editions, 1979.

———. *Turner in Wales*. Llandudno: Oriel Mostyn, 1984.

Wilton, Andrew, and Annie Lyles. *The Great Age of*

British Watercolours 1750–1880. Munich: Prestel, 1993.

Cat. nos. 23, 24

Butlin, Martin, and Evelyn Joll. *The Paintings of J. M. W. Turner.* New Haven: Yale University Press, 1977. Rev. ed., 1984.

Gage, John. *J. M. W. Turner: "A Wonderful Range of Mind."* New Haven: Yale University Press, 1987.

Wilton, Andrew. *Turner in his Time.* London: Thames and Hudson, 2006.

Cat. nos. 25, 26

Cook, E. T., and Alexander Wedderburn, eds. *The Works of John Ruskin.* 39 vols. London: George Allen, 1903–12.

Lord, Peter. *Clarence Whaite and the Welsh Art World: The Betws-y-coed Artists' Colony.* Aberystwyth: National Library of Wales, 1998.

Cat. no. 27

Dehija, Vidya, and Allen Staley. *Impossible Picturesqueness: The Indian Watercolours of Edward Lear.* New York: Columbia University Press, 1989.

Noakes, Vivien. *Edward Lear: 1812–1888.* London: Royal Academy of Arts, 1985.

Cat. no. 28

Gibson, Katherine. "Danckerts, Hendrick (c. 1625–1680)," *Oxford Dictionary of National Biography.* Oxford: Oxford University Press, 2004. http://www.oxforddnb.com/view/article/7103.

Cat. no. 29

Tyler, Richard. *Francis Place 1647–1728: An Exhibition Representing All Aspects of his Work.* York: City Art Gallery, 1971.

Cat. no. 30

Constable, W. G. *Richard Wilson.* London: Routledge and Kegan Paul, 1953.

Solkin, David H. *Richard Wilson: The Landscape of Reaction.* London: Tate Gallery, 1982.

Cat. no. 33

Parris, Leslie, and Ian Fleming-Williams. *Constable.* London: Tate Gallery, 1991.

Reynolds, Graham. *The Later Paintings and Drawings of John Constable.* New Haven: Yale University Press, 1984.

Rosenthal, Michael. *John Constable: The Painter and His Landscape.* New Haven: Yale University Press, 1983.

Cat. no. 34

Bennett, Mary. *Ford Madox Brown: A Catalogue Raisonné.* New Haven: Yale University Press, 2010.

Treuherz, Julian. *Ford Madox Brown: Pre-Raphaelite Pioneer.* London: Philip Wilson, 2011.

Cat. no. 35

Pointon, Marcia. *William Dyce 1806–1864: A Critical Biography.* Oxford: Oxford University Press, 1979.

Cat. no. 36

Payne, Christiana, and Charles Brett. *John Brett: Pre-Raphaelite Landscape Painter.* New Haven: Yale University Press, 2010.

Sumner, Ann. *John Brett: A Pre-Raphaelite on the Shores of Wales.* Cardiff: National Museum Wales, 2001.

Cat. nos. 37–40

Buckman, Rollin. *The Photographic Work of Calvert Richard Jones.* London: HMSO / Science Museum, 1990.

Cat. nos. 41–45

Chanan, Noel. *The Photographer of Penllergare: A Life of John Dillwyn Llewelyn.* London: Impress, 2013.

Morris, Richard. *John Dillwyn Llewelyn 1810–1882: The First Photographer in Wales.* Cardiff: Welsh Arts Council, 1980.

———. *Penllergare: "A Victorian Paradise."* Llandeilo: Penllergare Trust, 1999.

Cat. nos. 46–48

Baldwin, Gordon. *All the Mighty World: The Photographs of Roger Fenton.* New York: Metropolitan Museum of Art, 2004.

Cat. no. 49

Hyman, Timothy, and Patrick Wright, eds. *Stanley Spencer.* London: Tate Publishing, 2001.

Royal Academy of Arts. *Stanley Spencer RA.* London: Royal Academy of Arts, 1980.

Cat. no. 50

Bonehill, John, and Stephen Daniels, eds. *Paul Sandby: Picturing Britain.* London: Royal Academy of Arts, 2009.

Hermann, Luke. *Paul and Thomas Sandby.* London: Batsford, 1986.

Cat. nos. 51, 52

Gilpin, Rev. William. *Observations on the River Wye, and Several Parts of South Wales, &c.* London: R. Blamire, 1782.

Hughes, Stephen. *Copperopolis: Landscapes of the Early Industrial Period in Swansea.* Aberystwyth: Royal Commission on the Ancient and Historic Monuments of Wales, 2000.

Lord, Peter. *The Visual Culture of Wales: Industrial Society.* Cardiff: University of Wales Press, 1998.

Palmer, Marilyn, and Peter Neaverson. *Industry in the Landscape 1700–1900*. London: Routledge, 1994.

Pugh, Edward. *Cambria Depicta: A tour through north Wales, illustrated with picturesque views. By a native artist*. London: E. Williams, 1816.

Cat. no. 53
Jenkins, Elis. "Thomas Hornor," in *Glamorgan Historian 7*. Barry: Stewart Williams, 1971.

Cat. nos. 54, 55
Fairclough, Oliver, ed. *A Companion Guide to the Welsh National Museum of Art*. Cardiff: National Museum Wales, 2011.

Cat. no. 56
Public Records Office. *Buy and Build: Advertising Posters of the Empire Marketing Board*. London: Stationery Office Books, 1986.

Cat. no. 57
Arts Council of Great Britain. *Harold Gilman (1876–1919)*. London: Arts Council of Great Britain, 1981.

Baron, Wendy. *Perfect Moderns: A History of the Camden Town Group*. Aldershot: Ashgate Press, 2000.

Upstone, Robert. *Modern Painters: The Camden Town Group*. London: Tate Publishing, 2008.

Cat. nos. 58, 79
Morphet, Richard. *Cedric Morris*. London: Tate Gallery, 1984.

Tufnell, Ben, ed. *Cedric Morris and Lett Haines: Teaching Art and Life*. Norwich: Norfolk Museums Service, 2002.

Cat. no. 59
Calvocoressi, Richard. *Oskar Kokoschka, 1886–1980*.

London: Tate Gallery, 1986.
Tomes, Jan. *Oskar Kokoschka: London Views, British Landscapes*. London: Thames and Hudson, 1972.

Whitford, Frank. *Oskar Kokoschka: A Life*. London: Weidenfeld and Nicolson, 1986.

Cat. nos. 60, 61
House, John. *Monet: Nature into Art*. New Haven: Yale University Press, 1986.

Lochnan, Katharine. *Turner Whistler Monet*. Toronto: Art Gallery of Ontario / London: Tate Publishing, 2004.

Sieberling, Grace. *Monet in London*. Atlanta: High Museum of Art, 1988.

Wildenstein, Daniel. *Claude Monet: biographie et catalogue raisonné*. 5 vols. Lausanne: Bibliothèque des Arts, 1974–91.

Cat. no. 62
Fairclough, Oliver, Robert Hoozee, and Caterina Verdickt. *Art in Exile: Flanders, Wales and the First World War*. Antwerp: Pandora, 2002.

Cat. no. 63
Riopelle, Christopher, and Ann Sumner. *Sisley in England and Wales*. London: National Gallery, 2008.

Shone, Richard. *Sisley*. London: Phaidon, 1994.
Stevens, Mary Anne. *Alfred Sisley 1839–1899*. New Haven: Yale University Press, 1992.

Cat. no. 64
Bradford Art Galleries and Museums. *Sir George Clausen, R.A., 1852–1944*. Bradford: Bradford Art Galleries and Museums, 1980.

Cat. no. 65
Horner, Libby. *Frank Brangwyn: A Mission to

Decorate Life*. London: Fine Arts Society, 2006.
Horner, Libby, and Gillian Naylor, eds. *Frank Brangwyn (1867–1956)*. Leeds: Leeds Museums and Galleries, 2007.

Cat. no. 66
Reynolds, Simon. "Sims, Charles Henry (1873–1928)," *Oxford Dictionary of National Biography*. Oxford: Oxford University Press, 2004. http://www.oxforddnb.com/view/article/36107.

Cat. no. 67
Meyrick, Robert. *Christopher Williams: An Artist and Nothing Else*. Aberystwyth: National Library of Wales, 2012.

Cat. no. 68
Fox, Caroline. *Dame Laura Knight*. Oxford: Phaidon, 1988.

Knowles, Elizabeth. *Laura Knight in the Open Air*. Penzance: Penlee House Gallery, 2012.

Cat. no. 69
Hoole, John, and Margaret Simons. *James Dickson Innes (1887–1914)*. Farnham: Lund Humphries, 2013.

Cat. no. 70
Fraser Jenkins, David, and Chris Stephens, eds. *Gwen John and Augustus John*. London: Tate Publishing, 2004.

Holroyd, Michael. *Augustus John: The New Biography*. London: Vintage, 1997.

Cat. no. 71
Stenlake, Frances. *Robert Bevan: From Gauguin to Camden Town*. London: Unicorn Press, 2008.

Cat. no. 72

Campbell-Johnston, Rachel. *Mysterious Wisdom: The Life and Work of Samuel Palmer*. London: Bloomsbury, 2011.

Vaughan, William, Elizabeth Barker, and Colin Harrison. *Samuel Palmer 1805–1881: Vision and Landscape*. London: British Museum, 2005.

Cat. no. 73

Alley, Ronald. *Graham Sutherland*. London: Tate Gallery, 1982.

Hammer, Martin. *Graham Sutherland: Landscapes, War Scenes, Portraits, 1924–1950*. London: Scala, 2005.

Sutherland, Graham. *Sutherland in Wales: A Catalogue of the Collection at the Graham Sutherland Gallery, Picton Castle, Haverford West, Dyfed*. London: Alistair McAlpine, 1976.

Cat. nos. 74, 75

Dyer, John. *Grongar Hill*. Illustrated and with a foreword by John Piper. Hackney: Stourton Press, 1982.

Hussey, Christopher. "Stowe, Buckingham-shire—III: The Heroic Phase," *Country Life* (September 26, 1947), 626–29.

Ingrams, Richard, and John Piper. *Piper's Places: John Piper in England and Wales*. London: Chatto and Windus, 1986.

Spalding, Frances. *John Piper, Myfanwy Piper: Lives in Art*. Oxford: Oxford University Press, 2009.

Cat. no. 76

Collins, Ian. *John Craxton*. Farnham: Lund Humphries, 2011.

Craxton, John. *John Craxton Paintings 1941–1966*. London: Whitechapel Art Gallery, 1967.

Cat. no. 77

Minton, John. *John Minton, 1917–1957: A Selective Retrospective*. Newtown: Davies Memorial Gallery, 1993.

Spalding, Frances. *John Minton: Dance till the Stars Come Down*. Aldershot: Lund Humphries, 2005.

Cat. no. 78

Clarke, Gill. *Evelyn Dunbar: War and Country*. Bristol: Sansom and Company, 2006.

Cat. no. 80

Gooding, Mel. *Ceri Richards*. Moffat: Cameron and Hollis, 2002.

———. *Ceri Richards: The Poetic Imagination*. London: Jonathan Clark Fine Art, 2010.

Richards, Ceri. *Ceri Richards*. London: Tate Gallery, 1981.

Cat. no. 81

Ormond, John. *Kyffin Williams R. A.: A Catalogue for a Retrospective Exhibition*. Cardiff: National Museum Wales, 1987.

Sinclair, Nicholas, and Ian Jeffrey. *Kyffin Williams*. Aldershot: Lund Humphries, 2004.

Cat. no. 82

Moorhouse, Paul. *Leon Kossoff*. London: Tate Gallery, 1996.

Cat. no. 83

Lampert, Katherine. *Frank Auerbach: Paintings and Drawings 1954–2001*. London: Royal Academy of Arts, 2001.

Wiggins, Colin. *Frank Auerbach and the National Gallery: Working from the Masters*. London: National Gallery, 1995.

Cat. no. 84

Crabtree, Jack. *Jack Crabtree: Vor Ort/Face to Face*. Essen: SVR, 1978.

Cat. no. 85

Elliott, Patrick. *Richard Long: Walking and Marking*. Edinburgh: National Galleries of Scotland, 2007.

Seymour, Anne, Paul Moorhouse, and Denise Hooker. *Richard Long: Walking the Line*. London: Thames and Hudson, 2002.

Wallis, Clarrie, ed. *Richard Long: Heaven and Earth*. London: Tate Publishing, 2009.

Cat. no. 86

Tufnell, Ben, and Andrew Wilson. *Hamish Fulton: Walking Journey*. London: Tate Publishing, 2002.

Cat. nos. 87, 88

Daniel-McElroy, Susan, Sarah Hughes, and Kerry Rice. *David Nash: Making and Placing Abstract Sculpture 1978–2004*. St. Ives: Tate Gallery, 2004.

Nash, David, Sarah Coulson, and Clare Lilley. *David Nash at Yorkshire Sculpture Park*. Wakefield: Yorkshire Sculpture Park, 2010.

Nash, David, and Norbert Lynton. *David Nash*. London: Thames and Hudson, 2006.

Note: Page references in *italics* denote illustrations

Ackermann, Rudolph 84, 86
Adam, Robert 192
Apperley, Thomas 19, *20*
Auerbach, Frank 41, 206, 208
 Park Village East—Winter 41, 208, *209*
Ayrton, Michael 196

Bacon, Francis 208
Barbizon School 54, 118, 170
Barker, Henry Aston, *Panoramic View of London*
 (with Frederick Birnie after Robert Barker) 15,
 16–17
Barker of Bath, Thomas 74
 The Tomb of the Horatii and Curiatii 74, *75*
Bastien-Lepage, Jules 170, 174
Batoni, Pompeo, *Sir Watkin Williams-Wynn*
 (1749–1789), Thomas Apperley (1734–1819), and
 Captain Edward Hamilton 20
Beaumont, George 30, 80
Beckford, William 60
Bedford, Francis 51
Berry, William, Viscount Camrose 66
Bevan, Robert Polhill 156, 184
 Maples at Cuckfield, Sussex 184, *185*
Birnie, Frederick, *Panoramic View of London* (with
 Henry Aston Barker after Robert Barker) 15, *16–17*
Black, Watt 128
Blake, William 15, 39, 40, 186, 188, 190, 194, 196
 Songs of Innocence and of Experience 15, *16*
Booth, Sophia 106
Boudin, Eugène 162
Bouguereau, William-Adolphe 154, 170
Boydell, John 49
Brangwyn, Frank William 172
 Shipping on the Thames 172, *173*
Brett, John 32, 51, 128
 Forest Cove, Cardigan Bay 32–33, 128, *129*
 The Stonebreaker 128
 Val d'Aosta 128

Bridgeman, Charles 20
Brown, Ford Madox 32, 124, 128
 An English Autumn Afternoon, Hampstead—
 Scenery in 1853 124
 Chaucer at the Court of Edward III 32, 124
 View from Shorn Ridgway, Kent 32, 124, *125*
Brown, Lancelot "Capability" 20, 43, 192
Bruce, Henry, Lord Aberdare 110
Burke, Edmund 26, 34
Burlington Galleries 166, 202

Camden Town Group 156, 158, 184
Canaletto 34, 70, 116
Carus, Carl-Gustavus 51
Cassatt, Alexander J. 162
Cassatt, Mary 162
Cézanne, Paul 188
Charles II, King 112
Church, Frederic 25
Churchill, Winston 40
Claude Gellée, Le Lorrain 19–21, 22, 60, 62
 "Claude glass" 23–24
 influence 25, 26, 48, 64, 66, 72, 118
 Landscape with Christ Appearing to Mary
 Magdalene 60
 Landscape with Hagar and the Angel 30, *30*
 Landscape with St. Philip Baptizing the Eunuch
 19–20, 60, *61*
Clausen, George 37, 170
 Apple Blossom 37, 170, *171*
 In the Fields in June 37
 The Shepherdess 170
Cole, Thomas 25
Colquhoun, Robert 196
Combe, William 86
 The Tour of Doctor Syntax, In Search of the
 Picturesque 25, 86, *87*
conceptual art 42, 55, 212, 214
Constable, John 15, 29–30, 48, 122, 160, 200

A Cottage in a Cornfield 29–30, 122, *123*
 Hadleigh Castle, The Mouth of the Thames—
 Morning after a Stormy Night 30, *31*
 influence 36, 39, 43, 180, 208
 The Wheatfield 28, 29
Cooper, Austin 154
Corot, Camille 54, 118, 170
Cotman, John Sell 80, 214
 Cader Idris 12, 80, *81*
Cox, David 24, 42, 51, 82
 The Train on the Coast 24, 82, *83*
Crabtree, Jack 210
 Polluted Pool at Maindeei 210, *211*
Craxton, John 54–55, 186, 188, 194
 Landscape 194, *195*
Cross, Paul Odo 158
Cruikshank, George, *London going out of Town, or*
 the March of Bricks and Mortar 18, *19*
Curiatii brothers 74

Daguerre, Louis-Jacques-Mandé 30
Dalí, Salvador 202
Danckerts, Hendrik 112
 Caerphilly Castle 112, *113*, 114
 verso drawing of the North Dam and Gatehouse
 112, *112*
Danckerts, Jan 112
Darwin, Charles 51
Davies, Gwendoline 54
Davies, Margaret 36, 54
de Kooning, Willem 41
de Maria, Walter, *Lightning Field* 42
de Smet, Léon 160, 166
 Waterloo Bridge 166, *167*
Defoe, Daniel 46
Dickinsons' Comprehensive Pictures of the Great
 Exhibition of 1851, "General View of the Exterior
 of the Building" 33
Ducros, Abraham-Louis-Rodolphe 92

Dunbar, Evelyn 39, 198
 Baling Hay 39, 198, *199*
Durand-Ruel, Paul 162
Dyce, William 32, 51, 126
 Pegwell Bay 126
 Welsh Landscape with Two Women Knitting 32,
 126, *127*
Dyer, John 40, 190

Edwards, John 150
Edwards, William 148
Ernst, Max 202
exhibitions 22–23
Expressionism 41, 160, 184, 204

Fawkes, Walter 96, 98, 100
Fenton, Roger 51, 138
 Haddon Hall from the Terrace 138, *141*
 Melrose Abbey, South Transept 138, *139*
 Raglan Castle 138, *140*
FitzOsbern, William 70
Forbes, Stanhope and Elizabeth 178
Fox Talbot, William Henry *see* Talbot, William
 Henry Fox
Freud, Lucian 55, 194, 200, 208
Fry, Roger 36, 158, 182, 184, 188
Fulton, Hamish 214
 Cader Idris 214, *215*

Gainsborough, Thomas 15, 22, 39, 66, 74
 Rocky Wooded Landscape with Rustic Lovers,
 Herdsman, and Cows 22, 66, *67*
 The Harvest Waggon 66
Gardnor, John 98
Garstin, Norman 178
Gauguin, Paul 36, 184
Gellée, Claude *see* Claude Gellée, Le Lorrain
Gibbs, James 192
Gilman, Harold 156

Mornington Crescent 156, *157*
Gilpin, Sawrey 146
Gilpin, William 23, 49
 Observations on the River Wye, and Several
 Parts of South Wales 70, 86, 144, 146
Ginner, Charles 158, 184
Girtin, Thomas 24, 42, 50, 74, 76, 78, 80
 Near Beddgelert (A Grand View of Snowdon) 24,
 50, 78, *79*
 The Eagle Tower, Caernarvon Castle 76, *77*
Gray, Thomas 21, 47, 49, 68
Great Exhibition 33
Greville, George, 2nd Earl of Warwick 146
Greville, Robert Fulke 146
Griffith, Moses 49
Grimm, Samuel Hieronymous 49
 Caernarvon Castle 49

Hambling, Maggi 200
Hamilton, Edward 19, *20*
Hoare, Richard Colt 92
Hodges, William 23, 29
Hogarth, William 70
Holbein, Hans 34
Hollar, Wenceslaus 114
Holman Hunt, William 128
Horatii of Rome, the 74
Hornor, Thomas 150
 Rolling Mills 5, 150, *151*
Hunt, Alfred William 51

Ibbetson, Julius Caesar 146
Impressionism 17, 34, 37, 54
Impressions of Britain 162–85
Innes, James Dickson 36, 53–54, 176, 180, 182
 Arenig 36–37, 180, *181*

Jenkins, Paul 210
John, Augustus 36, 54, 176, 178, 182

Provençal Studies 180
 The Aran Isles 182, *183*
John, Gwen 182
John, William Goscombe 53, 166
Johnes, Thomas 50
Jones, Calvert Richard 31, 52, 130
 Brecon Castle and Bridge 130, *132*
 Ilfracombe Church 130, *133*
 Study of Two Gentlemen in Front of Heathfield
 31, 130, *131*
 Three Canals, Brecon 130, *131*
Jones, David 54
Jones, Thomas 29, 42, 62, 68, 72, 118, 120
 Buildings in Naples 29, 120, *121*
 The Bard 21, 29, 40, 62, 68, *69*, 118, 120
 View in Radnorshire, A 29, 118, *119*

Kandinsky, Wassily 202
Karlowska, Stanislava 184
Kent, William 20, 192
Kernot, J. R. 102
Knight, Harold 178
Knight, Laura 37, 178, 198
 The Cornish Coast 37, 176, 178, *179*
Knight, Richard Payne 70
Kokoschka, Oskar 160
 London, Waterloo Bridge 160, *161*
 View of the Thames 160
Kossoff, Leon 40–41, 206, 208
 From Willesden Green, Autumn 41, 206, *207*

Lambert, George 70
land art 42, 55, 212, 214
Lascelles, Edward 78
Leader, Benjamin Williams 53
 On the Llugwy below Capel Curig 52
Lear, Edward 110
 Kinchinjunga from Darjeeling 27, 110, *111*
Lescouezec, Eugénie 168

Llewelyn, John Dillwyn 31, 32, 52, 130, 134
 Caswell Bay 137
 In Three Cliffs Bay 134, *135*
 Rapids on the Dulais—Neath Valley,
 Glamorganshire 134, *137*
 The End of the Upper Lake, Penllergare 134, *136*
 The Owl's Oak, Penllergare 31, 134, *135*
Llewelyn, Thereza 134
Lodge, William 114
Long, Richard 42–43, 45, 55, 212
 Blaenau Ffestiniog Circle 55, *212*
 Snowdonia Stones (along a five day walk in
 North Wales) 42, 212, *213*
Lorrain, Claude Gellée, Le *see* Claude Gellée,
 Le Lorrain
Lyttleton, George, Lord 47

MacBryde, Robert 196
Malton, Thomas 88
Manet and the Post-Impressionists (exhibition) 36
Matisse, Henri 36
McCarthy, Desmond 36
Mengs, Anton Raphael, *Richard Wilson* 48
Merke, Henri 84
Millais, John Everett 32
 Portrait of John Ruskin 32, *32*
Millet, Jean-François 170
Milton, John, *L'Allegro* 39, 186
Minton, John 54, 194, 196
 Welsh Landscape 196, *197*
Miró, Joan 194, 202
modernism 54, 154, 156, 184, 188, 204
Monet, Claude 15, 34, 36, 54, 162, 164
 Charing Cross Bridge 36, 54, 164, *165*
 influence 160, 166, 168, 172
 The Pool of London 34, 162, *163*
Morris, Cedric 39, 54, 158, 200
 From a Window at 45 Brook Street, London W1
 158, *159*

Stoke-by-Nayland Church 39, 200, *201*
Morris, William 172

Nash, David 43, 45, 55, 216
 Ash Dome (cat. nos 87 and 88) 43, 216, *217*
 Wooden Boulder 216
Nash, Paul 39
 Totes Meer 39–40, *41*
 We are Making a New World 38, *38*
Neo-Romanticism 39, 54–55, 186, 190, 194, 196, 204
New English Art Club 170, 182
Nicholson, Winifred and Ben 158

Palmer, Samuel 186
 influence 39, 40, 55, 188, 190, 194, 196
 The Rising of the Skylark 39, 186, *187*
Parry, John 68
Pennant, Thomas 45, 49, 144
Photographic Society exhibitions 134
Picasso, Pablo 194, 202
picturesque, the 20, 25–26, 29, 84, 86, 138, 146, 156
 influence of 18, 36, 39, 42–43
 picturesque prospects 21–25, 62, 66, 70, 76, 80
 and Wales 45, 49, 51
Piper, John 39, 40, 54, 186, 188, 190, 192, 194
 Devil's Kitchen 44, 53
 Dickinsons' Comprehensive Pictures of the Great
 Exhibition of 1851 53
 Garden Follies at Stowe 40, 192, *193*
 Grongar Hill with Paxton's Tower in the
 Distance 40, 190, *191*
Piranesi, Giovanni Battista 92
Pissarro, Camille 15, 34, 36
Place, Francis 28, 114, 148
 Tenby 28, 114, *115*
Post-Impressionism 36–37, 54, 156, 180, 182
Poussin, Nicolas 60, 62
Pre-Raphaelites 15, 32–33, 34, 51, 108, 124, 126, 128
 influence 42, 142

Price, Uvedale 50
Pugh, Edward 146
Pugin, Augustus Charles, "Exhibition Room,
 Somerset House" (etching after) 23

Realism 170
Rembrandt 92
Richards, Ceri Giraldus 202
 Waterfall in Cardiganshire 202, *203*
Richards, John Inigo 70
 Chepstow Castle 48–49, 70, *71*
Rooker, Michael Angelo 86
Rosa, Salvator 21, 23, 48, 62, 68, 74
 Rocky Landscape with Herdsmen and Cattle 21,
 62, *63*
Roscoe, Thomas 51
Rowlandson, Thomas 24–25, 84, 86
 An Artist Traveling in Wales 25, 84, *85*
 "Doctor Syntax Tumbling into the Water" *87*
 "Exhibition Room, Somerset House" (etching
 after) 23
Royal Academy 70, 142
 exhibitions 22, 50, 64, 70, 76, 78, 82, 108, 122, 166
 Turner 90, 92, 94, 96, 98
Royal Academy Schools 88, 210
Royal College of Art, London 190, 202
Rubens, Peter Paul 34, 66
Ruisdael, Jacob 116
Ruskin, John 32–33, *32*, 34, 102, 108, 126, 128, 190
 influence 42

Sackville, Lionel, 1st Duke of Dorset 116
Sadler, Michael 202
Sandby, Paul 50, 88, 144
 Sir Watkin Williams-Wynn Sketching *51*
 The Iron Forge between Dolgelli and Barmouth
 in Merionethshire 50, 144, *145*
 XII Views in North Wales 50, 144
Sandby, Thomas 24

School of London 41, 206, 208
Scott, Walter 138
Setch, Terry 46
Seurat, Georges 166
Seven and Five Society 54, 158
Sickert, Walter 156
Signac, Paul 166
Sims, Charles 174
 The Kite 37, 174, *175*
Sisley, Alfred 51, 168
 Storr's Rock, Lady's Cove, Evening 168, *169*
Slade School of Fine Art, London 180, 182, 204
Smith, John "Warwick" 24, 86, 146, 148
 Forest Works, Swansea 24, 148, *149*
 Junction of Mona and Parys Mountain 55, *147*
Smith, Thomas, *View of Margam House,*
 Glamorgan, Looking North 47
Smithson, Robert, *Spiral Jetty* 42
Soane, John 192
Society of Artists 22, 70
Spackman, Charles 74
Spada, Fabrizio 60
Spencer, Stanley 142
 Landscape in North Wales 142
 Snowdon from Llanfrothen 6, 142, *143*
St. Martin's School of Art, London 210, 212
Steer, Philip Wilson 180
sublime, the 16, 34, 51, 80, 88–110
 Turner and the sublime 25–27
 and Wales 42, 50, 51, 214
Surrealism 202
Sutherland, Graham 39, 54, 55, 186, 188, 194, 202
 Road at Porthclais with Setting Sun 188, *189*
Swinburne family 100

Talbot, Christopher Rice Mansel 52
Talbot, Emma Thomasina 134
Talbot, William Henry Fox 30, 52, 130, 134
Thelwall, John 46

Turner, Joseph Mallord William 15, 25–27, 54,
 88–106
 and Girton 76, 78
 influence 36, 39, 42, 80, 160, 162, 180, 190, 214
 Fighting Temeraire 106
 Flint Castle 102, *103*
 Glacier and Source of the Arveiron, Going Up to
 the Mer de Glace 96
 Llandeilo Bridge and Dynevor Castle 50, 94, *95*
 Marford Mill 25, 90, *91*
 Rain, Steam, and Speed—The Great Western
 Railway 27, *27*
 Rudesheim, Looking towards the Binger Loch
 98, *99*
 Ruined Farmhouse 88, *89*
 Source of the Arveiron 26, 96, *97*
 The Bishop's Palace, Biebrich 100, *101*
 The Morning after the Storm 104
 The Morning after the Wreck 25, 26, 106, *107*
 The Storm 104, *105*
 Transept of Ewenny Priory, Glamorganshire
 25–26, 50, 82, *93*
 in Wales 50, 86
 Wilson's influence on 48

Vanbrugh, John 192
Van Gogh, Vincent 36
Varley, John 82
Vaughan, Keith 55, 196
Voelcker, Becca 55

Walden, Lionel 34, 51
 Cardiff Docks 152
 Steelworks, Cardiff, at Night (cat. nos 54 and 55)
 34, 56–57, 148, 152, *152*, *153*
Walker, John 90
Warwick, 2nd Earl of 146
Watson, Peter 194
Whaite, Henry Clarence 27, 51, 108

The Awakening of Christian 108
The Barley Harvest 108
The Owl 108
The Penitent's Vision 108, *108*
The Rainbow 108
The Shepherd's Dream 58, 108, *109*
The Storm 108, *109*
Whistler, James McNeill 34, 162, 164, 172
 Nocturnes 152, 172
Wigstead, Henry 84
Williams, Christopher 176
 The Red Dress 176, *177*
Williams, Emily 176
Williams, Isaac 53
Williams, John Kyffin 204
 Farmers, Cwm Nantlle 204, *205*
Williams, John Terrick 154, 170
 Mining 154, *155*
Williams-Wynn, Watkin 19, 20, 21, 50, 64, 144
Wilson, Richard 20–21, 29, 48, 64, 116
 influence 25, 42, 48, 88, 118, 120, 214
 Italian influence 60, 62, 72, 74
 Caernarvon Castle 53
 Dinas Bran Castle, near Llangollen 8, 21, 29, 48,
 64, *65*
 Dinas Bran from Llangollen 64
 Dover Castle 29, 48, 116, *117*
 View near Wynnstay, the Seat of Sir Watkin
 Williams-Wynn, Bt. 64
 and Wales 45, 48, 53
Wiltshire, Walter 66
Wood, Christopher 158
Wright of Derby, Joseph 21, 72
 Arkwright's Cotton Mills by Night 14, 21, 22
 Lake Albano with Castel Gandolfo 72
 The Lake of Albano 21, 48, 72, *73*
Wyllie, William Lionel, *Toil, Glitter, Grime and*
 Wealth on a Flowing Tide 34, *35*
Wyndham, Henry Penruddocke 49

Photo Credits